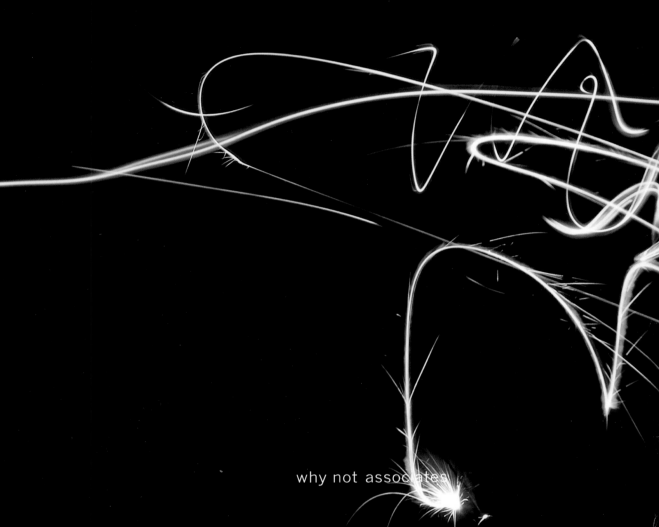

why not associates

why

not

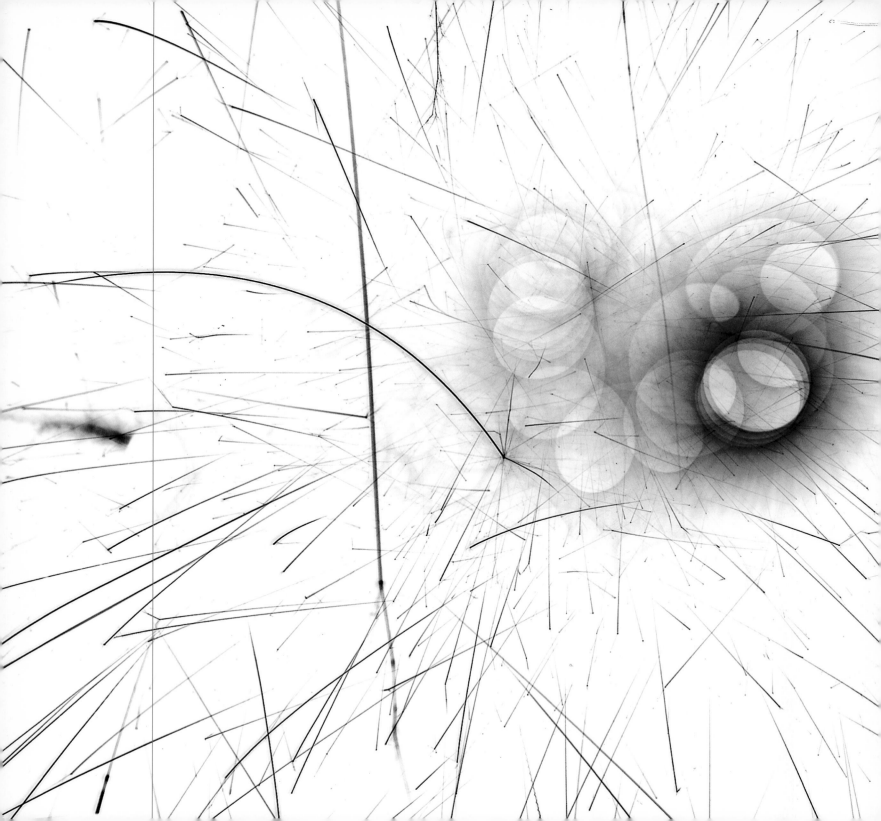

# contents

# in
# lau

introduction
liz farrelly

photography
rocco redondo

it was completely haphazard, the way why not associates started. we all sat together in the corner of the studio at the royal college of art. howard, dave, me and phil baines – but dave worked at home half the time. he'd turn up in the middle of the afternoon and say, "anybody fancy a drink?". we were left to our own devices because it was a transitional year, the first intake on the two-year ma. gert dumbar would jet in. he'd come upstairs and say, "if you find a fridge i'll fill it with beer", and at the end of the day he'd have a drink with us, but he never talked much about design. it was always drinking and women. he was the first designer i met who wasn't po-faced, he enjoyed what he did and that attitude of having a bit of fun was inspirational....anyway, the day we effectively left college we started working together.
andy

at the time we left college there seemed to be two routes to take, either you work for the mainstream...michael peters, fitch, dda etc, ... or you did trendy stuff for record companies and "style" mags. we were more interested in doing something unusual with seemingly normal clients....andy was hell bent on designing soap powder packaging, that seemed like a much bigger challenge than doing the cover of an album where you can really just do what the hell you want.
david

why not started by accident, which is really quite fitting. i got offered a freelance job designing a magazine because i'd done some layouts for an exhibition. i had to tell the client i couldn't do it, but i could put a team together who would. basically, andy and dave taught me the mechanics of design. i was in the graphic design department at the rca, but only because i figured it was the best place to make commercial film and video.
howard

# the ten years since punching

their graphic design business, why not associates have amassed a body of work which is both unique in its diversity and awesome in its innovation. back then, the why nots were three. like all graphic design studios, their numbers have fluctuated, but there will always be two...that is, two chief protagonists, andy altmann and david ellis, who studied graphic design together at saint martin's school of art in london. they met howard greenhalgh while he was at the london college of printing and the trio completed their education with master of arts degrees in graphic design from the royal college of art, under the professorship of gert dumbar, the maverick godfather of dutch design. on graduating in 1987, they moved into archer street studios, a thriving enclave of designers amid soho's seedier industries...and, a decade later, they are still there.

suddenly we were getting all this work but we didn't even have a name. i'm going to have to get this story right....back at college there was a guy called john, who'd been a taxi driver for seventeen years. a brilliant bloke. he was really into "ideas" graphics, the 60s stuff and was writing a thesis on bob gill circa fletcher forbes and gill. meanwhile we were doing all these odd things. we didn't quite know what we were doing, and he'd be asking, what on earth is that? why have you done that? blah, blah, blah. and apparently one of us said, well why not? and in his thesis he wrote about the "bob-gill attitude", and then he labelled his contemporaries as having the "why-not attitude", mentioning howard, dave, phil and me. people started to pick up on the name and call us the why not boys. our accountant said, you've got to give yourself a name. we suggested "why not international" because our first client was american, but he reckoned that would put us in a difficult tax bracket, so he said, why not call yourselves why not associates? it was nice because why not is so irreverent and associates makes it almost respectable. i hate it now, but it expresses an attitude we had which john picked up on.

andy

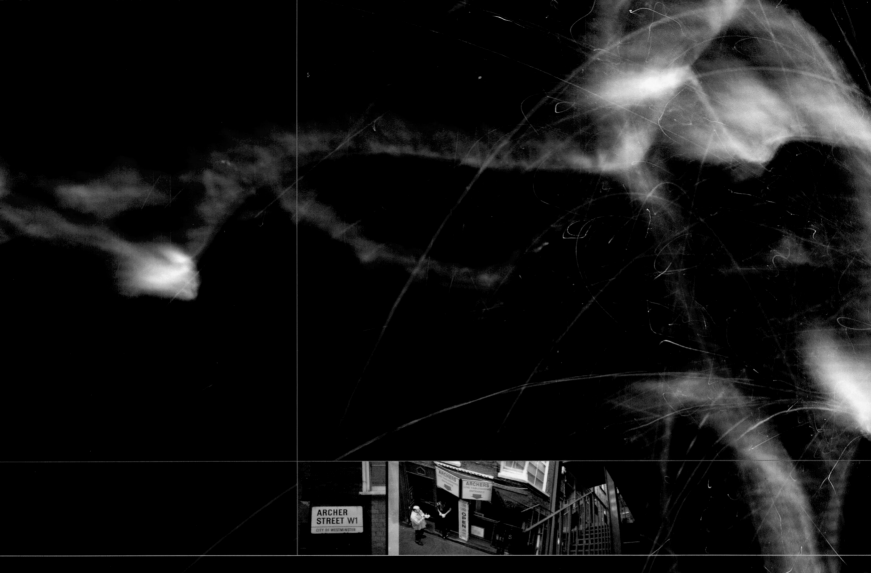

while howard concentrated on shooting commercials and music videos, and set up the independent production company why not films in 1990 (eventually leaving the associates in 1993 to run why not films single-handedly), andy and david hired help. over the years they've nurtured a host of burgeoning talents, including jonathan barnbrook, arguably the most innovative type designer working today, and graham wood, award-winning advertising director and founding member of the phenomenally successful multi-disciplinary team tomato. the idiosyncratic chris priest, famed for his wit and mayhem, stayed for four years, the longest stint of any junior, before being lured away by the bright lights of advertising. today, all three have gone on to become well-known names in their own right while the originals run an internationally acclaimed studio, aided and abetted by two younger associates, patrick morrissey and iain cadby.

there came a point when we needed to sort out a studio and a photocopier. the bank said, write a business plan, so dave's friend dudley helped him make it up over a long lunch and we came out with more money than we needed. we bought the best black and white copier canon made, and we'd blow up typesetting as large as possible. we did the banners for the ica's modern chair exhibition in one weekend, on the studio floor, sticking bits of paper down. sometimes you think the client won't let you go so far, but in the end you're pleasantly surprised. it happened with the ica banners which were pretty illegible, but they thought they were a bit tame!
andy

i taught david letter press at the rca, and he started off setting type in six point. insane. and he never got his damn shirt dirty. when david and andy started why not there were discernible differences in their work. david's was always sweeter and more polished, like david. and andy's work was rougher. but later it amazed me how they could work interchangeably on the mac. they've blended together quite well now.
phil baines

when i saw the why nots' work, for the first time i thought, wow it's ok to enjoy yourself doing graphics. so inspiring. it's not so much how it looked as their attitude, that you could approach things in any way. we forget that they were one of the first groups to have such a strong personal ethos.
graham wood

what did i learn? that design can be fun, it's good to be playful but that doesn't mean it has to be arbitrary. and we talked a lot about football.
jonathan barnbrook

they never plan anything, it's in their heads, and they might casually mention an idea in the pub. but their approach seems to be working. it's totally anti-corporate, it's the personal touch. i'm just gritting my teeth hoping we don't grow too big and have to do crap work just to survive.
pat morrissey

they've carved a niche for themselves – post-modern modernism – and the work has changed, from process-design to idea-design. but we've got a mad twist, more colour, playful, and exciting. why should something be boring and conventional when it can be about diversity of form, format, composition? a bit of originality..it's a personal adventure being part of why not associates.
iain cadby

credited with moving goalposts and reinventing the wheel, the why nots
have also, not insignificantly, rewritten the graphic design rule-book. they
stress that their contribution to the heated debate concerning typography
and legibility was by accident rather than intent; their work said all they
wanted to say on the subject. likewise, beyond theory and rhetoric, they have
left a second far-reaching legacy as techno-friendly innovators. one of the first
multi-media design studios in london, their preference for time-based
solutions, unbridled enthusiasm for the earliest apple macs and howard's
experiments with video demonstrated the possibilities of a wide range of
technologies while most designers were either baulking at the financial
investment involved or worrying about the implications for the "profession"
of desktop publishing, as it was then known. the why nots' techno-friendliness
was, and still is, informed by their creative curiosity which marries a penchant

just trying to read my way through the first
sixteen pages of what seemed like typographical
masturbation almost sent me blind.
mike dempsey, review of typography now:
the next wave, blueprint magazine 1992

there is nothing straightforward about the
"communication" occurring here. the
undecorated, amusing, graphically direct ideas
beloved by designers from fletcher/forbes/gill to
the partners have been cast aside. in their place
come multi-layered text zones and image-fields
of mind-boggling complexity and
doubtful legibility.
rick poynor, blueprint magazine 1991

the first time i used a mac was for an
illustration for letraset. i went back to the rca
and richard doust showed me through the
program and i thought, bloody hell we better get
one of these, so we went and bought one.
five grand, just for the box. we've spent a
fortune on technology because we never waited
until it got cheap. you have to get on the
bandwagon, so we've always tried to get the
best we can, first.
david

the way we worked was, we'd ask, what's the
attitude, the personality, what is the client like,
does he need to push it, do we need to push
him, do we need to pull a stunt, try to upset the
client, what are we going to do, where are we
coming from? and then it'd get down to, what
elements do we need? dave was always the
methodical one who could take a rational view.
andy was the one who wanted to put a stick in
the works or add some humour, and i was the
one who wanted to make a film of it.
howard

why not has never really been a design
company. it's a confusion of everything, you
could call it a mini multi-media office if you like.
i see it as a base where we can all operate from.
its a darkroom, an apple mac, a sythesiser, a
room where we can slap paint around. don't ask
me where it will all end up. i haven't a clue.
howard, direction magazine 1990

we met graham wood in a pub in new york
recently. he said, "i'm really grateful for that bit
of advice you gave me". what bit of advice?
"always do your personal work and make sure
you keep doing it". i see something like soccer
wonderland as almost personal. i'd have done it
for free....at saint martins i had my personal
work and then all the other "normal" graphics
which they made us do, and the two were very
separate, and i wanted to make them meet, but
i couldn't because i hadn't learnt all the rules
well enough to break them. the rca was the time
those things came together, and by the end i
had a folio which i liked. when we put our work
together it was, this is what we do, this is how
we're going to approach it....
andy

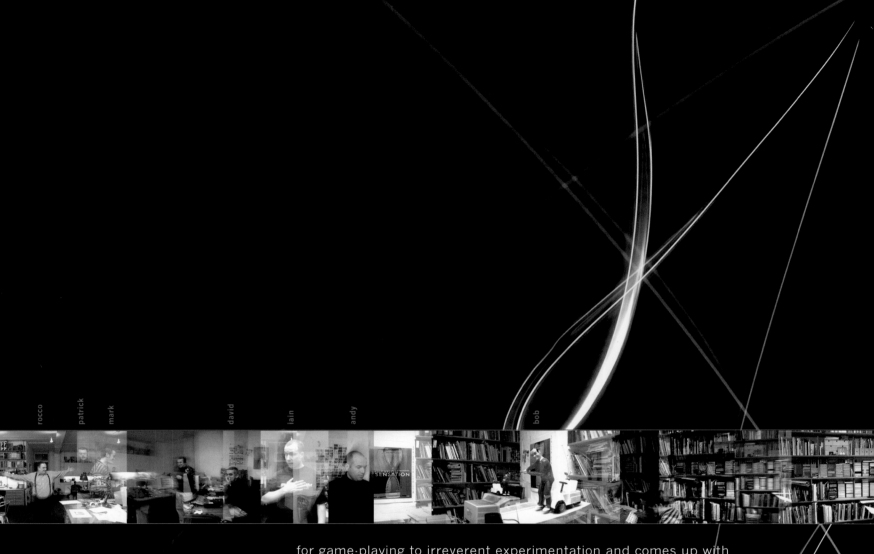

rocco    patrick    mark    david    iain    andy    bob

for game-playing to irreverent experimentation and comes up with unprecedented solutions.

none of this went unnoticed in the design press. back in 1991 an enthusiastic commentator in blueprint ensured the why nots a place in the history of design as headline members of the "new wave" brat pack, along with 8vo, siobhan keaney and cartlidge levene...while also prompting much hype about london-as-home-of-cutting-edge-design. enfants terribles eventually grow up, but today the why nots still make good copy. perennially busy and talkative, they have never felt the need to employ a receptionist to stall callers. they crop up in the most unlikely places working on projects both prestigious and bizarre: from promotional graphics for the headline-grabbing sensation exhibition at the royal academy of arts to soccer wonderland, a book of football memorabilia and memories compiled by photographer and

nigel coates asked us to design his stationery and graphics for the situationists exhibition at the pompidou centre. although people might think those panels are just mark-making. the process is actually about the particular way the situationists worked.

with nigel's stationery, we showed him some photograms, he liked them but suggested we add a sense of the human body to the images...so we projected the photograms onto this great body. we changed the design, to get to a point where we solved a problem, and nigel was happy.
andy

with typography now, the book, we wanted the introduction to work in various ways. people tend to look at the work featured first and settle down to the text later, so we asked rick poynor to go through it with a highlighter picking out words and sentences which we could take out of context. then the reader could scan the text and get a notion of the meaning at a glance before deciding to settle down and read the whole essay in greater detail.
david

a key moment for why not was designing the queen's anniversary stamps. we knew there were certain areas we couldn't stray into but we desperately wanted to solve "the problem", which was to make a series of stamps about the queen that didn't look kitsch, that represented her various roles, that looked as if we designed them and could be proud of, but that your mum would like. so we had to step outside what we were doing, it's all in the way the type and image merge and the emotional strings that can be pulled. we used a conventional typeface, but did something slightly odd with it...the little key lines and the use of gold and silver to lend a regal touch to a modern layout. we were under pressure to create a uniform type treatment for every stamp, so we kept ignoring that request until the deadline meant it had to go to print as it stood. it was rick poynor in eye magazine, who said that we had the "popular touch". we just try to think into the client's, and more importantly the audience's head.
david

here, it seems certain, lies one of the reasons for their commercial survival against the odds. not only blessed with the popular touch, but they genuinely believe it should be possible to have their creative cake and eat well on it too.
rick poynor, eye no.7 vol.2, 1992

ipswich fan julian germain; from designing a set of stamps commemorating the fortieth anniversary of the queen's coronation for the royal mail to laying out a complete issue of time magazine; from directing a televised election broadcast for tony blair's new labour party to advertising a leading brand of vodka. they've worked for the world's most demanding institutions, both public and commercial, and addressed the widest audiences.

but across the diversity there is a common strand. "working with the why nots you know you'll get more than you bargained for", comments architect nigel coates of branson coates, who commissioned their graphics for the situationist exhibition at the pompidou centre in paris. "it's like a 'think and do tank'...a meeting of fertile, intelligent minds. their design is arresting but has many deeper layers."

design commentator rick poynor once called that personal engagement

the ultimate example of an "idea" was the sensation poster. it's the right image for that show because its about context. seemingly innocuous images and objects transformed by the context in which they are presented. we thought about the aggressive nature of the work, a lot of which is to do with bodies and everyday objects. we all sat round and discussed it. we don't do that enough anymore, but the old adrenalin came back. the idea was skin, that's where sensations come from. someone said heat, and immediately we could see those shapes in our heads.
andy/david

because our client list is so varied we're able to indulge in different levels of madness...knowing where to pitch it on a sliding scale between complete clarity and bloody mayhem.
david

you learn to know how far you can go. every job has a line you can push right up to, and to get the best results you'd be standing on it. step over and you've blown it, and the knack is knowing. i think dave and me know when something's right. i guess we've got similar tastes in what we're looking for in a piece of work. developing it and pushing it towards a point when we think we have something.
andy

‘ you see things ’

which characterises their work "the popular touch". always critical of self-conscious designery design, they make an effort to listen, attempt to understand a client's needs and then imagine how an end-user might react to the solution. they aim to push a client to the limit without overstepping the mark, to create a solution which, as poyner wrote, is a "retinal reward": formally innovative, appropriate but never patronising or self-indulgent.

set them an impossible task – "we like tight briefs" reveals Andy (oh, really...) – and they'll convert it into a problem waiting to be solved. from exhibition graphics elucidating the erotic in neon and perspex – designed for a gallery with no walls – to a pavement of quotes celebrating birds – carved in stone and cast in metal – they render communication out of chaos. whether they're slapping paint about, editing television titles on a super-computer, ripping up paper, building giant collages or messing around in darkrooms with

the sebastian spreads were the first photos...
a mad montage...which we did with rocco redondo...a big spaniard on a little moped. we transformed the supplied head shots into a photocopy and papier maché model held together with bluetack. we only had one light, but we used lots of little stands and broken mirrors, and bounced light onto the model. we made it up as we went along because they gave us such crap images of hair styles which we spent our lives trying to distort, by making 3-d sets or projecting them, or using the image artist computer back on the rca. you pressed the distort button and waited about two days for anything to actually happen.

andy

you never know what will happen working with dave and andy. nothing's pre-set, it's not like advertising where everything's laid out beforehand. but they are very fast at making up their minds. i provide them with choices and then move around, photographing different angles. it's very abstract. andy says something like, rocco don't worry about that shadow in the corner, i'll throw some heavy graphics at it.

rocco redondo

working with rocco, he lets us do anything, he isn't precious about his images, but he is also good at incredibly complicated stuff, like smirnoff, our first big advertising job. the agency had booked space on the london underground to put the letters s-m-i...going down the escalators. they commissioned us to do one mad shot, but we said, what a waste, and off the top of our heads suggested 3-d letters. they said, do it! so we asked david greenwood to make the letters. when we were shooting in rocco's studio his daughter's toy helicopter was lying around, so we put it on a piece of wire and held it right up to the camera. we were adding an extra bit of humour that you might just catch, and it'd make you smile, you can do nothing better than make someone laugh. there are extras hidden in our work, and a lot of chance involved.

andy

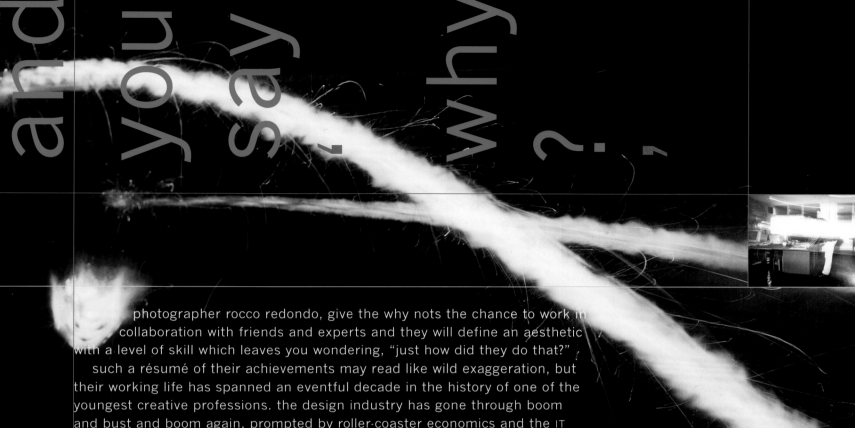

photographer rocco redondo, give the why nots the chance to work in collaboration with friends and experts and they will define an aesthetic with a level of skill which leaves you wondering, "just how did they do that?"

such a résumé of their achievements may read like wild exaggeration, but their working life has spanned an eventful decade in the history of one of the youngest creative professions. the design industry has gone through boom and bust and boom again, prompted by roller-coaster economics and the IT revolution. along came the apple mac, various techno off-shoots and assorted gizmos – scanners, colour printers, avid, harry, henry and hal, cd-rom, modems, isdn links and the internet – all of which made it possible to leave college, set up a studio, design and earn. determined never to work for the big bland consultancies, the why nots set up on their own in order to apply their brand of humour, invention and integrity to real-world projects, proving

when next asked us to design the a few sections of the directory we looked at it and thought, its pretty difficult to produce anything very different from what they already have because it's such a tight selling space. so we contacted them and suggested our talents would be better used designing the cover and intro pages. thankfully they agreed and the only brief was, "take us in a new direction".

the next directory got us noticed by other designers, and it helped us get jobs we'd never have been considered for. before that we were thought of as a trendy little graphics outfit. doing that kind of typography for a client like next really excited us because we were hitting a whole different audience, it got to a lot of people and felt like we were achieving something new.

david

# but i dream things that never were ...

that designers with attitude could break out of the trendoid ghetto
of designing youth-oriented record sleeves and style mags.

the fact that the why nots were schooled in design before the mac went
mega meant they knew the rules...and that they deliberately set out to break
them. long before the deconstructive capabilities of the mac made it easy,
they were layering, chopping, flying and scattering words and letter forms,
manipulating text in order to communicate meaning. while painstakingly
mastering the technical skills, the why nots made the link between cause and
effect. cutting up type by hand may be time-consuming, but the effort affords
rather more contemplation than comes with the push of a button – and it
shows. using type to communicate in their own sweet way, andy and david
favoured the classic english fonts, "especially those of mr gill", aiming to
prompt readers to take a closer look, to really read, by turning copy into

we were just trying to enjoy ourselves, and
although the work has always contained visual
ideas, many of the marks were there because
we thought, that's a beautiful way of working.
we weren't justifying each mark...but it pisses
me off that people think because we're called
why not that we do things without
actually thinking.
the clients always direct the work. the spark, the
impetus comes from the problem.
because we've got a folder full of "interesting"
work clients come to us knowing full well what
they'll get, so that eighty percent of the time we
do what we want to do, but all the time you have
to consider their needs or you might as
well be a painter.
andy

# and i say 'why not?'

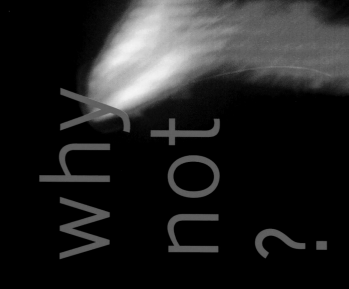

george bernard shaw

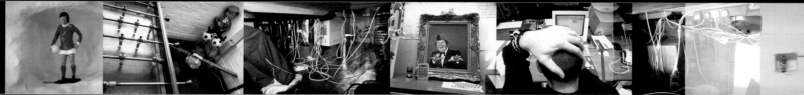

concrete poetry. their mainstream break came with the brief to design a mail-order catalogue for high-street fashion chain next. millions of catalogues landing on doormats up and down the country introduced an unsuspecting audience to a new language of typo-anarchy. such freestyle interpretation led to accusations of butchery, but the final word in the legibility debate is interpretation and that, like beauty, is in the eye of the beholder.

over those same ten years, just as the ways and means of creating design have altered beyond belief, so too have the methods by which audiences consume the end result – see, read, interface with the mass media and collate information. increasingly, we have access! these days the computer-literate public needs convincing that we can't do better than the creative professionals. more than ever, we want to be surprised.

dismissive of an old guard for whom a one-liner masquerades as the big

when I was asked to contribute a few words to the introduction of this manual of graphic art cunningly designed to lead students, young and old, astray...a devilish grin began to grow across my face. this was an opportunity to tell the truth (I growled) about what it was really like to be part of that motley crew of vagabonds. the late nights without refreshment. the beatings and worst of all. how mr altmann would torture me with his comedy routine...over and over again, but I thought. no. I'll lie instead.

i remember back in 1990. the degree show over, and I was wandering around thinking about getting a portfolio together when a friend of mine came to me and said. "hey chris, d'you 'member those crazy guys who came in and set that 'represent yourself' project?" "no. I was on the roof that day, remember." replied, oblivious. "why not!! you know. one's bald, plays football very badly i've heard. one really likes his wine and goes under the name of the tinkerer, and there is another one. but he's got curly ginger hair...well I've heard they're looking for a good football player. go for it chris and take your work along. run like the wind and don't look back. good luck."

four years later, they had to let me go (client pressure/transfer fees). well, I knew too much, and was about to spill the beans all over the studio floor.

while doing my time at the why not institute for down and out designers (WNIDOD) i was introduced to the fundamentals of my profession. how exciting: letter spacing. book-binding and stuff (is this it!). but more important was the introduction to soho's dens of iniquity and its downright fiendish, dastardly denizens. there was phil "candlesticks" baines. a prolific figure in heavy-handed door tactics: johnny "snowball" barnbrook. uncontrollable, rebellious and a revered villain: mike "the silver fox" nicholson. a fast talking wise guy. then there was nick "the barber" harrington, evil...even the mention of his name makes the hair on my toes curl. with this vault of wisdom at my fingertips, i felt uneasy. the studio atmosphere was pretty cool though. at times, well most of the time really. it reminded me of those hospital scenes from one flew over the cuckoo's nest.

from that little sweat-shop. tucked away in the pants of soho. came a movement. a blurred vision. alcoholics on a mission. at times the mood was of shambolic chaos. but we were drunk and weak and knew how to grasp this energy and use it to our disadvantage. we were...designers on mac!

i totally enjoyed my stay. i think they are the best. i would give them loads of work if i was a client with tons of cash. they're charming, witty, creative and aware.

chris priest

chris priest was with us for four years, he did things that you wouldn't expect anyone to do... with parts of his body you'd never expect....he did the opposite of what you should do with typography. he had a great eye for mark-making, you can't teach that.

andy

idea and of a mac-obsessed generation more interested in knitting with pixels, andy, david & co.'s personalities and obsessions – with old-school british comedians, table football, soap powder packaging and battered toys to name but a few – have given their work an unpredictable human touch. add that to mark-making skills, close client contact, grass-roots research and ideas which are subtle, relevant or occasionally mad and impetuous – flying a toy helicopter around model letters, for instance – and the end result is a working method combining content with process, the cerebral with the sensual. take just one example: the identity for post-production house blue set in red type alongside an appealing yet surreal photograph of a blue strawberry....

during this last decade, as our eyes have grown accustomed to reading between the lines, that fickle thing aesthetics – or is it fashion? – has begun to swing away from the overwrought towards a new bluntness. as this book

early on we were hell bent on proving that we could be stupid...and get away with it...and i guess we got it out of our system. we came from the saint martins tradition of "ideas" graphics, but we also had the idea of putting our personalities into our work and some tutors didn't understand that.

the weird thing is, we still cling to that "ideas" approach. i think that's why we've survived as long as we have because we can do both.... after our initial rebellious stage we've gone back to a simpler approach.

andy

the worse thing about working at why not associates was having to listen to andy going on about manchester united every monday morning....

graham jones

reveals, the why nots have ridden that wave without ever altering the essence of their design: constant change, pushing a solution to the edge of what is appropriate and surprising both clients and audiences. maybe such an "essence" could stand as a definition of workable innovation. poynor borrowed peter york's term "punk and pageant" to describe the very english combination of heritage and rebellion embraced by the why nots. versatility and contradiction...it keeps the

# experiment

rolling on.

1987–1988

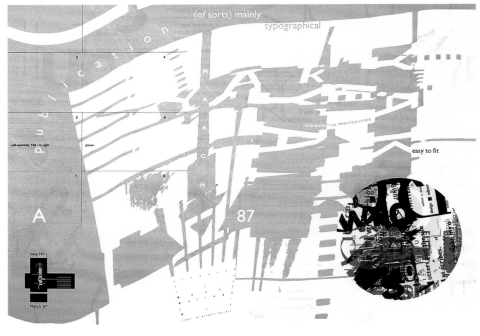

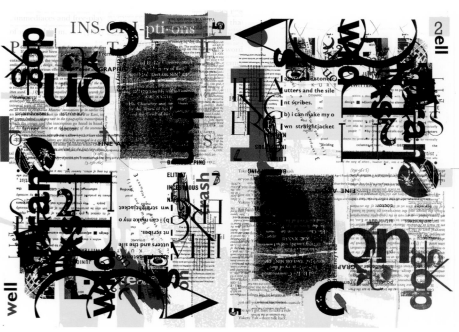

this page: **yak magazine.** royal college of art
poster. cover. overprint

opposite page: magazine pages (with phil baines)
letterpress and silkscreen

**yak soap box.** royal college of art

( 20    21 )

# INS-CRI-pti-ons

**P** Guillaume Apollinaire was the first person to use the French word 'calligrammes', (...). 'Calligram' means a combination of script, design, thought; it represents the shortest imply in the mysterious effectiveness of shapes and colours which can be taken for expressing a thought in material terms, and for forcing the eye to accept a global view of the written word. (...) If we were compelled at all costs to search for able adjustment if we are to enjoy a written text as an integral part of the picture. (...) In this respect Europe em as much in Hrabanus Maurus' invocations as in earlier Greek poems. Indeed—at any rate in the typographic transcription which the image and the inscription go hand in hand of his work which were set at the beginning of the seventeenth century—

**O** an alliance made all the easier by the fact that Oriental script is in itself pictorial while Oriental art is calligraphic.

pre-figuring, though involuntarily, Apollinaire's method of breaking up a word. (5.156–160)

*If our eyes have been conditioned by non-representational painting, the 'significance' of which resides s entational painting, the 'significance' of which resides significance of shapes and col ours and which does not ask us to understand or even t o recognise its content, we have to make an uncomfort iten word. (...)*

---

**2**

# KURT SCHWITTERS

the ability to produce the DYNAMIC within a design ● fascination with DETAILS in the process of design ■ adjustment of all the elements, so that one stands out, forming the DYNAMIC. ● in 1923 he wrote artist discovers some detail or other that need only be torn of its contrast to give rise to a work of art, i.e. a rhythm can also be perceived as a work of art by other artistically minded people **by cropping details out of** printers proof sheets he produced pictures (i—ZEICHNUNGEN) ● by vertically dividing columns of text, (i—GEDICHTE) the total concept he termed i ● "I am the i artist, Kurt Schwitters is the artist of the work des autres. I am the artist who turned the song of others, however bad, into a work of art."

---

**3**

well **Fran ks** **wild** **Year s** **on** **trash**

---

**4**

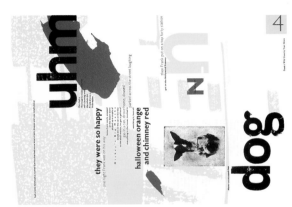

**uhm**

they were so happy one night Franz walt on his way

halloween orange and chimney red

**n**

**dog**

---

**5**

## When I grow up

| | |
|---|---|
| teacher | policeman | fireman |
| driver | shopkeeper | **GRAPHIC DESIGNER** |
| footballer | pilot | |
| nurse | kennel maid | |
| air hostess | astronaut | |
| farmer | doctor | |

**FINE ARTIST**

**COLD**
**IMPERSONAL**
**SOULLESS**
**MEDIOCRE**
**BACKSLAPPING**

The creation of the British graphics industry has now widened the divisions between commercial art and fine art. The traditional conflict between the two has been avoided, with the industry establishing itself as a separate entity, with its own language, pretensions and incestuous community. In creating this elitist community, awards are presented internally at an incredible rate: everyone trying to pat themselves on the back. This has led to a narrowness of thinking and therefore limited creativity.

---

**vi**

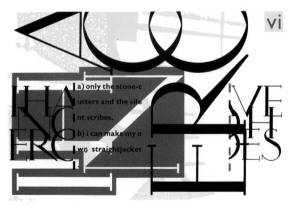

a) only the stone-c utters and the sile nt scribes.

b) i can make my o wn straightjacket

---

**7**

**ELITIST**
**INCESTUOUS**
**NARROW**

3 examples of the British lack of flair and imagination

design food football

The kind of thinking that must happen in the search for new and inventive problem solving is more likely to occur when the designer is in contact, and familiar with happenings in other fields, especially in painting and sculpture. The 'art' of the graphic designer is that in solving the client's problem he pushes his own ideas and personality. This does not seem to happen in most of the work being produced in Britain at present. The only fine art influences seem to be blatant pastiches of artists such as Mondrian and Matisse.

The kind of creative ability my Auntie Muriel thought was talent

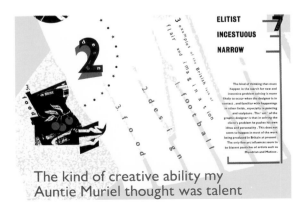

---

**8**

Take out the papers and the trash
or you don't get no spending cash
if you don't scrub that kitchen floor
you ain't gonna rock-n-roll no more
Yakety Yak – dont talk back.

Just finish cleaning up your room
lets see that dust fly with that broom
get all that garbage out of sight
or you dont go out friday night
Yakety Yak – dont talk back.

You just put on your coat-n-hat
and walk yourself to the laundramat
and when you finished doing that
bring in the dog and put out the cat
Yakety Yak – dont talk back.

Dont give me no dirty looks
your father's hip dont know about books
tell your hoodlum friends outside
you ain't got time to take a ride
Yakety Yak – dont talk back.

**dont talk back**

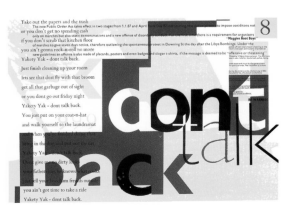

The new Public Order Act takes effect in two stages from 1.1.87 and April...

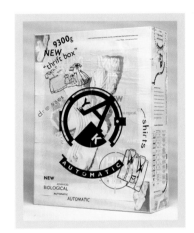

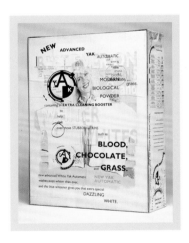

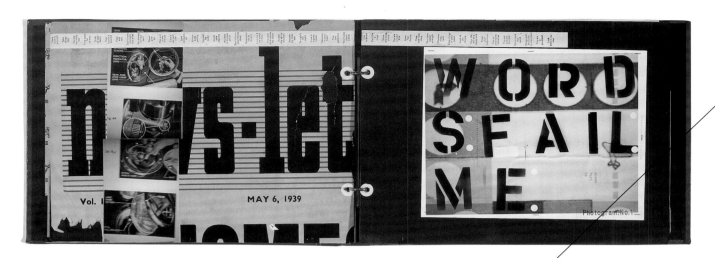

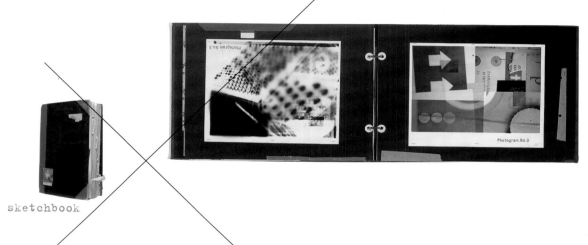

sketchbook

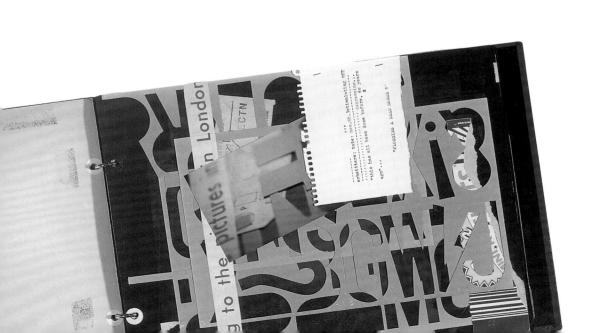

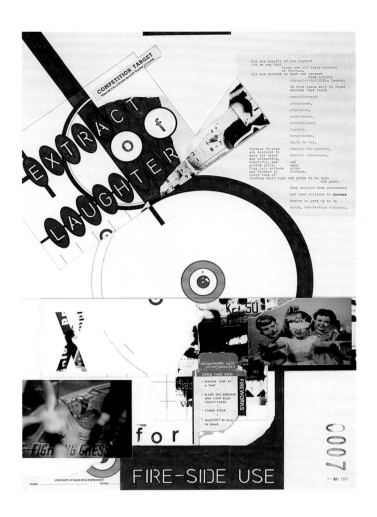

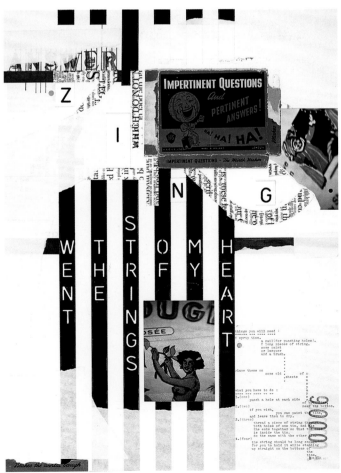

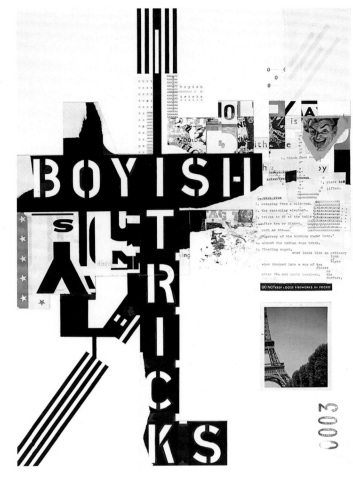

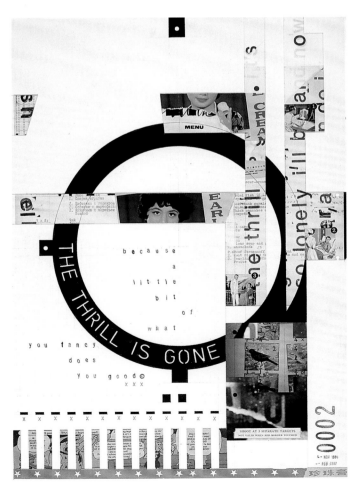

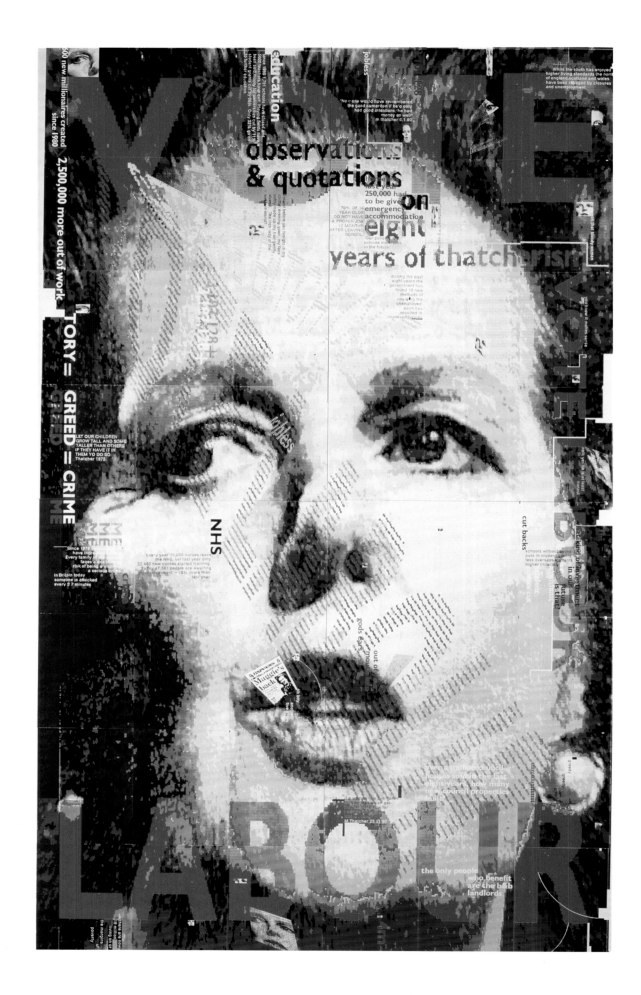

sandwiches, **chocolate pasta**, a boat ride, a
church, a mouth-wash. I've been dreaming my **whole**

greenest island of my imagination. Canal, next to the Pa-
**damned life** and ice cream in stacks. I've never

# Eight days a week in Venice

by David Ellis

**new**

I have never been in my
life so struck by any-
place as by Venice. It
is the wonder of the
world. Dreamy, beauti-
ful, inconsistent, im-
possible, wicked, sha-
dowy, double old place!

*i*

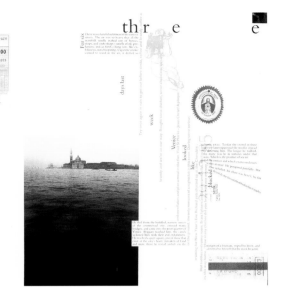

th r     e                    e

For six                days last

week

Venice

hooked

like

blacked

sink

---

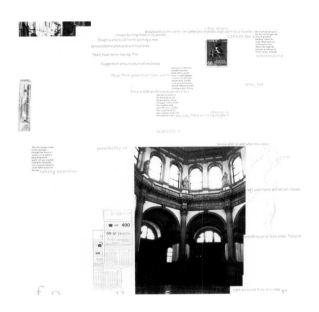

Breakfasted at the corner on coffee and

cheque burning holes in my pocket                    cannot be

Bought a phone call home sporting a new

beret and some postcards with blue skies

Really must sort out that bag. The                              wholesome

Guggenheim and a museum off the Strada

Nose, Mmm, good church, fancy a drink                  ave, for

A trip up the Brancheleoni downstairs (No.)

there is

scarcely a

possibility of

taking exercise.

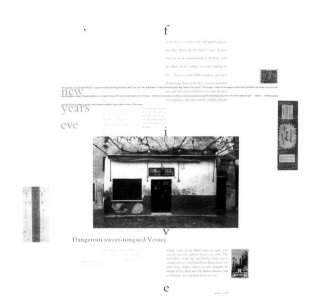

f

**new**

**years**

**eve**

*i*

*v*

Dangerous sweet-tongued Venice

*e*

---

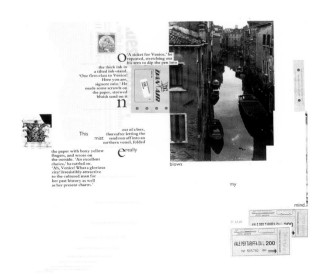

O 'A ticket for Venice,' he
repeated, stretching out
his arm to dip the pen into
the thick ink in
a tilted ink-stand.
'One first-class to Venice!
Here you are,
signore mio.' He
made some scrawls on
the paper, strewed
bluish sand on it
n

This        out of a box,
mist        thereafter letting the
sand run off into an
earthen vessel, folded
e really
the paper with bony yellow
fingers, and wrote on
the outside. 'An excellent
choice,' he rattled on.
'Ah, Venice! What a glorious
city! Irresistibly attractive
to the cultured man for
her past history as well
as her present charm.'

blows

my

mind.

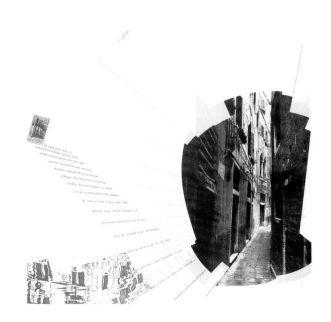

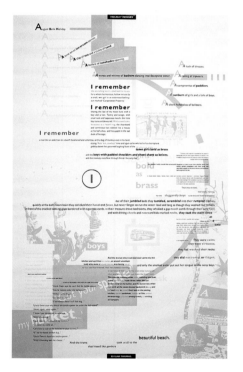

this page: **holiday memory**. words by dylan thomas
royal college of art. posters

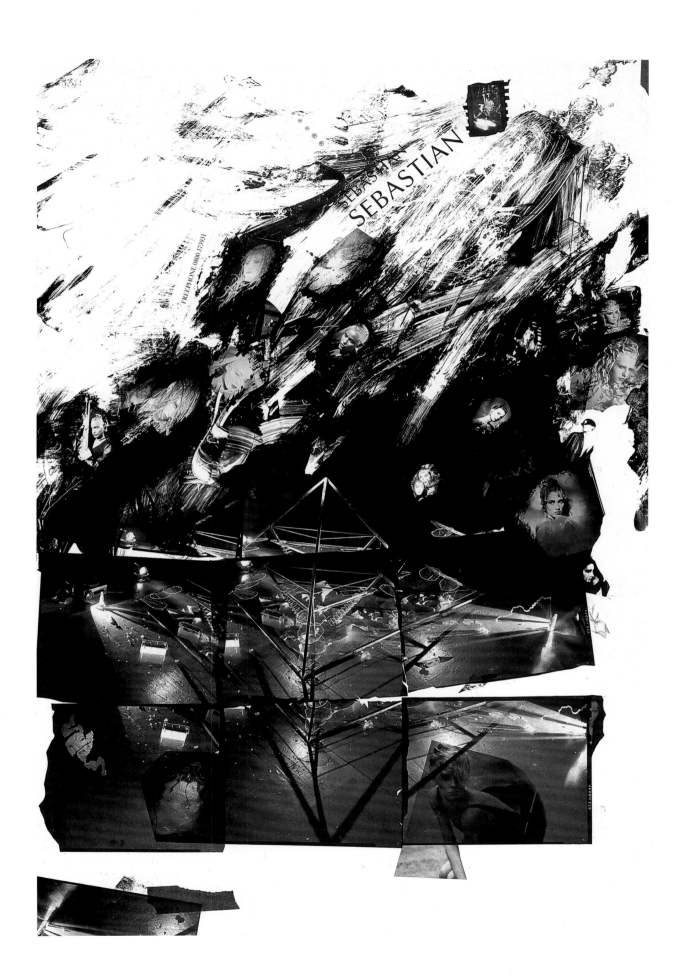

this page: **sebastian.** cosmetics company, USA
exhibition poster
photography: rocco redondo, robert lobetta

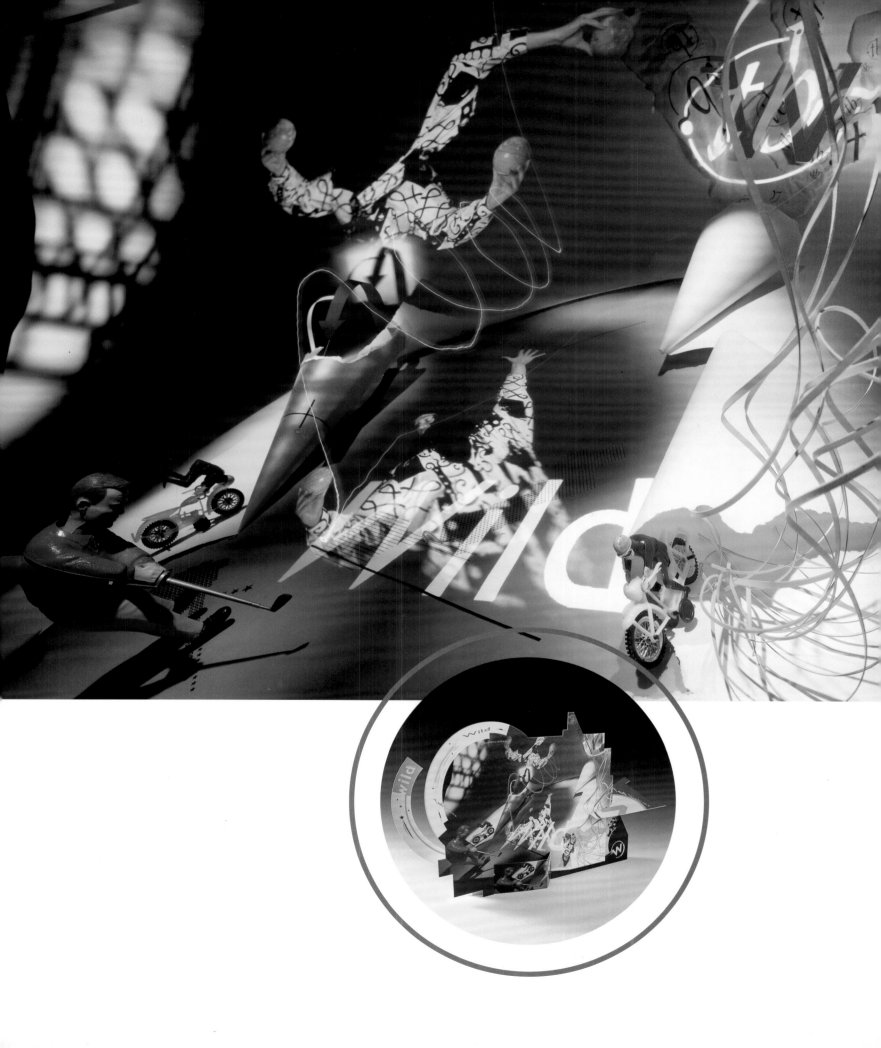

**ted baker.** men's wear
this spread: point of sale

following spread: advertisements

photography: rocco redondo

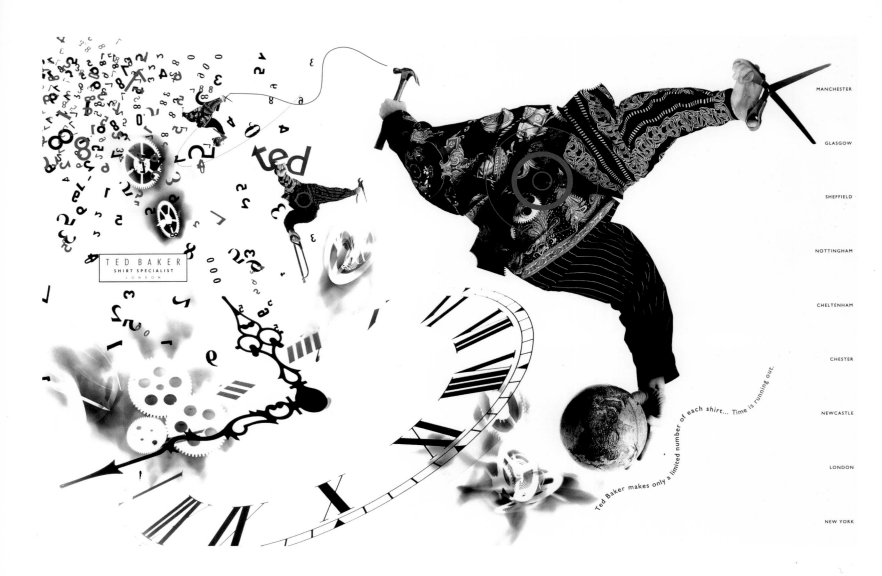

TED BAKER
SHIRT SPECIALIST
LONDON

Ted Baker makes only a limited number of each shirt... Time is running out.

MANCHESTER

GLASGOW

SHEFFIELD

NOTTINGHAM

CHELTENHAM

CHESTER

NEWCASTLE

LONDON

NEW YORK

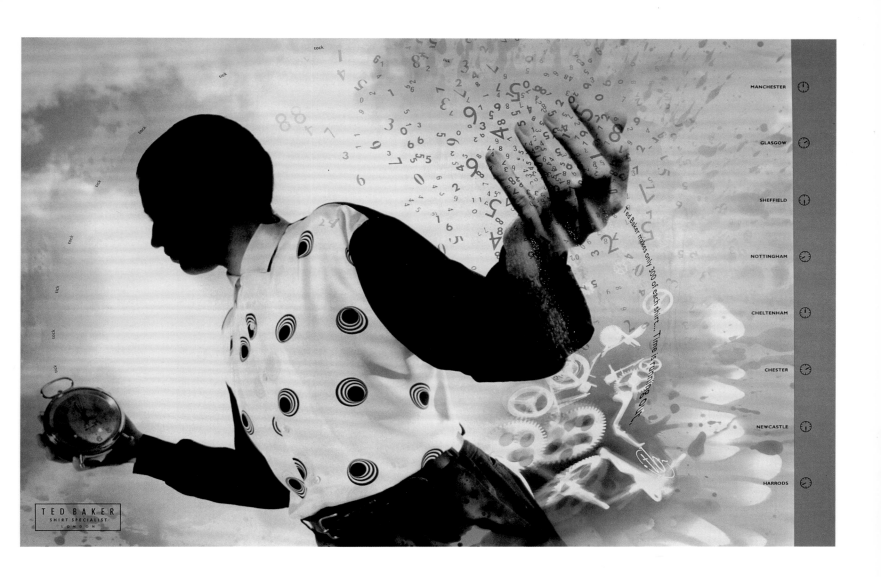

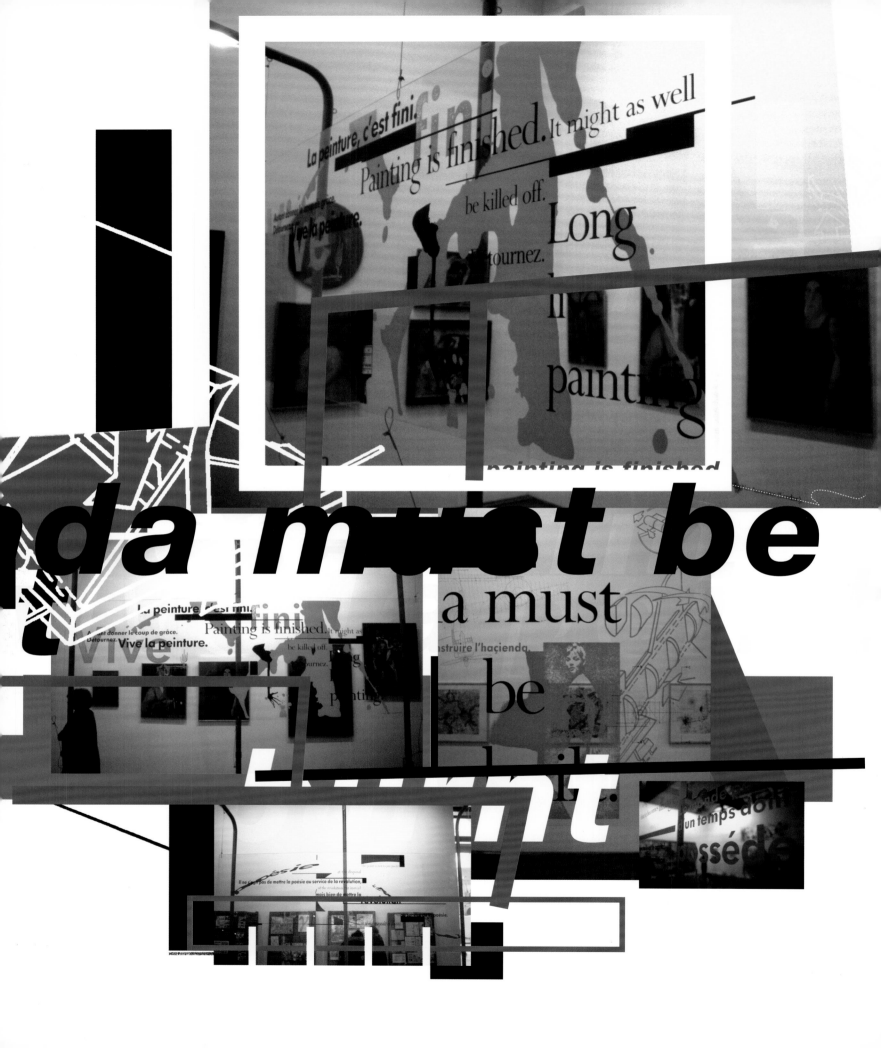

it might as well be killed off

# the hacien

II faut
The hacienda must
construire l'hacienda

**situationists.** pompidou centre. paris
exhibition graphics
exhibition design: branson coates architecture

( 32 ⇥    ⊢33 )

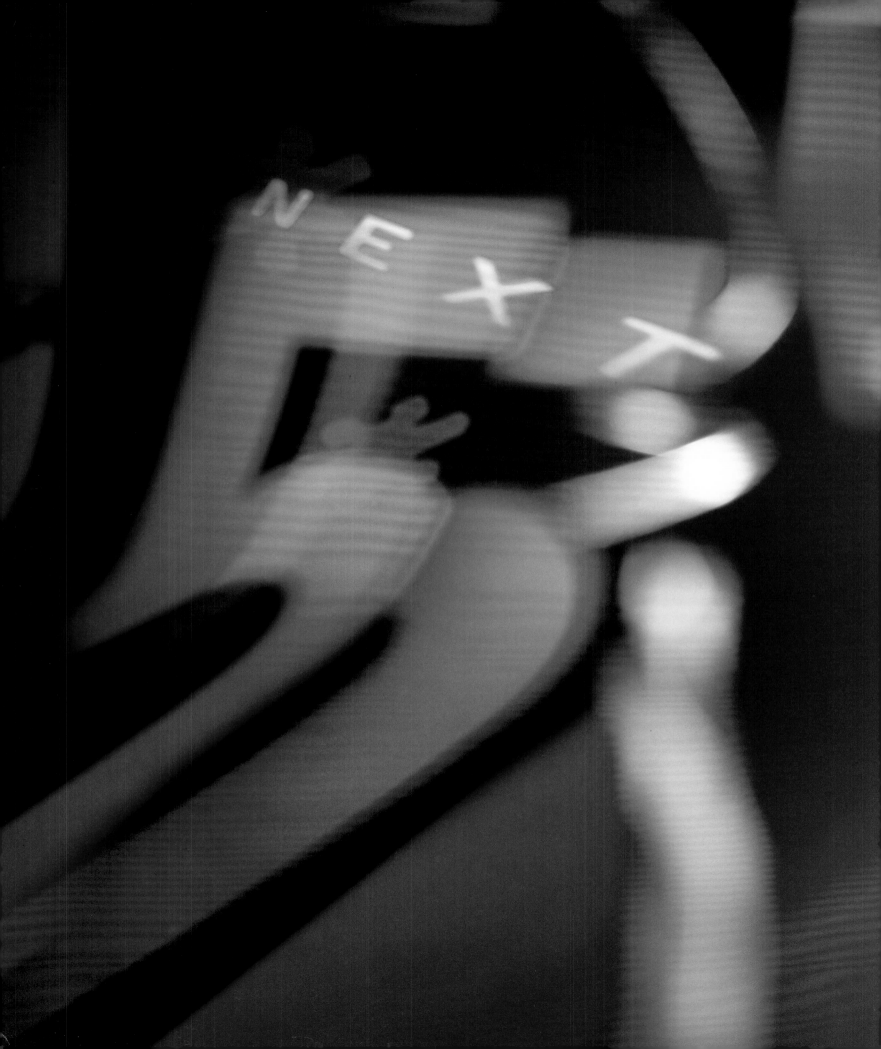

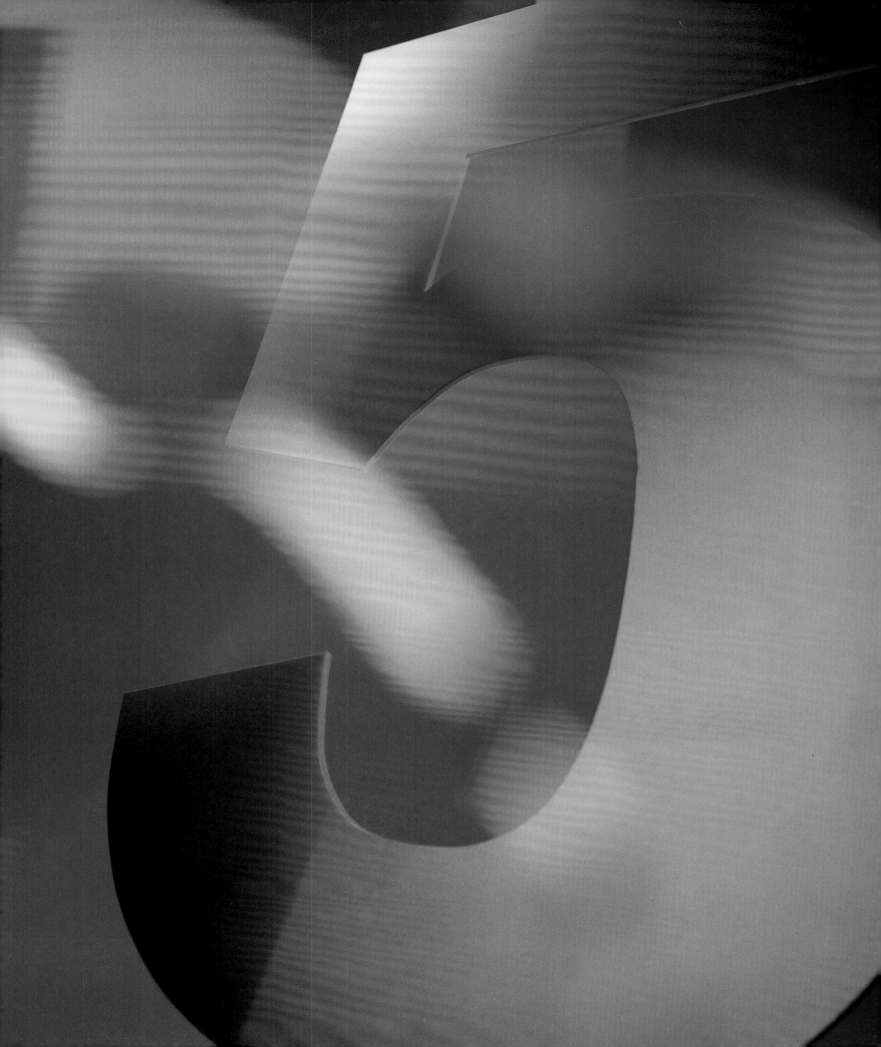

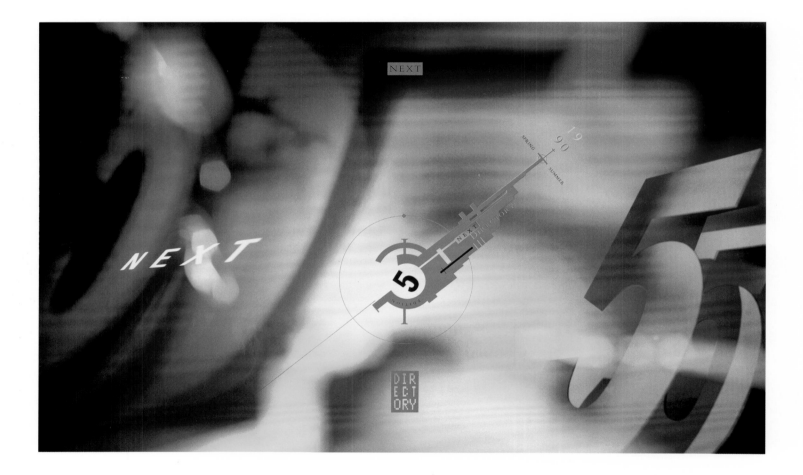

**next five.** mail order catalogue
photography: rocco redondo
previous spread: preview cover photograph

**next five.** endpaper. cover. back cover
introduction pages

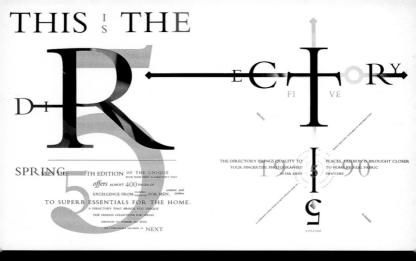
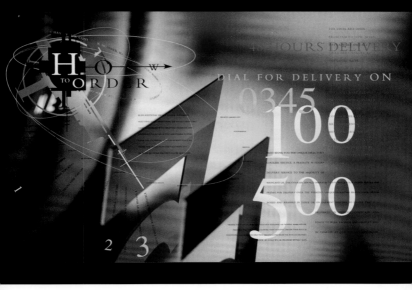
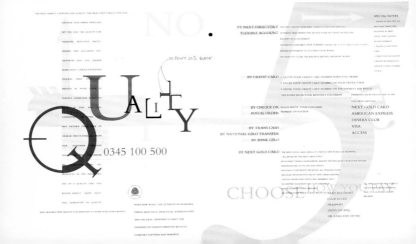

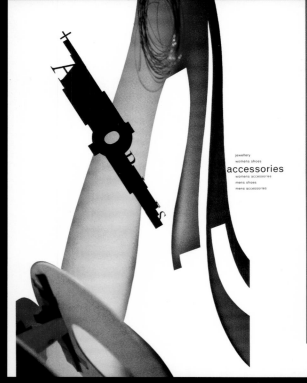

jewellery
womens shoes
**accessories**
womens accessories
mens shoes
mens accessories

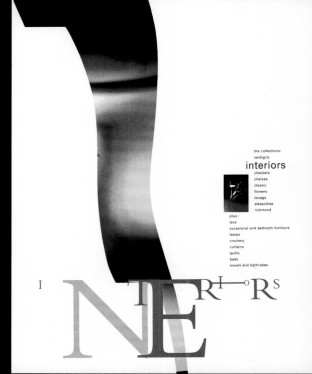

the collections:
verdigris
**interiors**
checkers
chelsea
classic
flowers
tocaga
alexandrea
richmond
plus :
lace
occasional and bedroom furniture
lamps
crockery
curtains
quilts
beds
towels and bathrobes

I N T E R I O R S

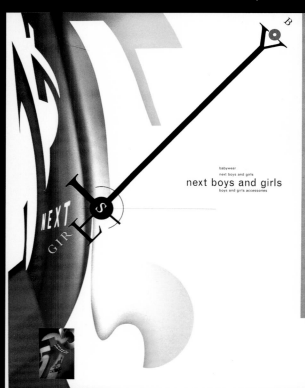

babywear
next boys and girls
**next boys and girls**
boys and girls accessories

NEXT
GIRLS

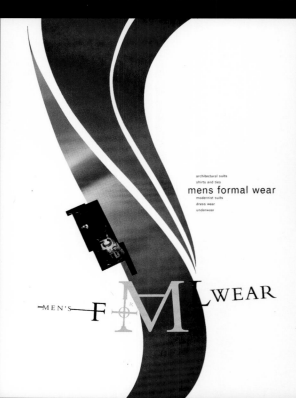

architectural suits
shirts and ties
**mens formal wear**
modernist suits
dress wear
underwear

MEN'S FORMAL WEAR

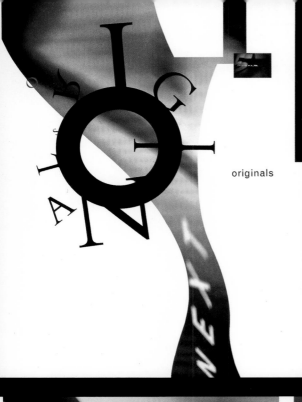

originals

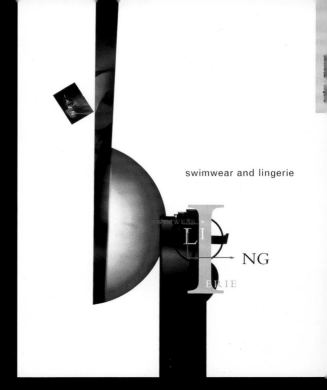

swimwear and lingerie

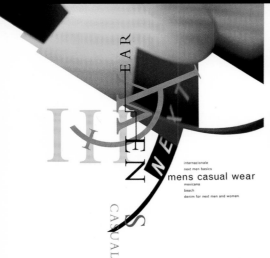

internazionale
next men basics
**mens casual wear**
maxicana
beach
denim for next men and women

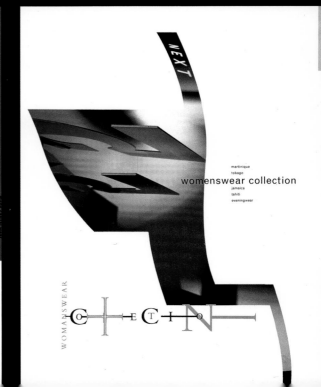

martinique
tobago
**womenswear collection**
jamaica
tahiti
eveningwear

the **city conference**

**A Symposium on Urban Design and (Post) Modernity**
**Saturday 1 – Sunday 2 October**

Speakers include Marshall Berman, Godfrey Bradman, Nigel Coates, Michael Graves, Richard Rogers, Richard Sennett, Elizabeth Wilson, Sharon Zukin.

**Sponsored by Flaxyard plc**

**University of Lancaster**

**Herman Miller Ltd**

**Greycoat Group plc**

the
# modern chair

**Twentieth Century British Chair Design**
**Thursday 4 August – Sunday 2 October**

## metropolis

**New British Architecture and the city**
**Thursday 4 August – Saturday 1 October**

Ron Arad
Nigel Coates/Branson Coates Architecture
Zaha Hadid
Future Systems
John Pawson and Claudio Silvestrin
Daniel Weil and Gerard Taylor

**ICA** Institute of Contemporary Arts
The Mall, London SW1
01 930 3647

These exhibitions have been sponsored by Chair Design Associates.
The sponsorship of this season by Chair Design Associates has been recognised by an award under the Government's Business Sponsorship Incentive Scheme which is administered by the Association for Business Sponsorship of the Arts.

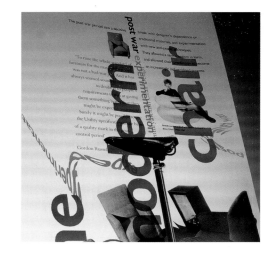

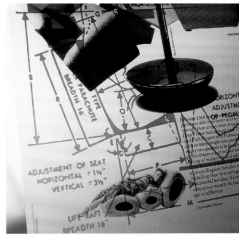

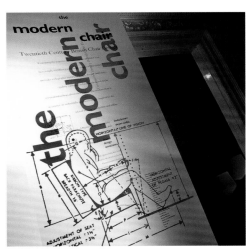

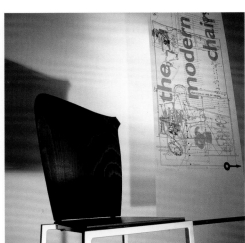

**metropolis and the modern chair**
institute of contemporary art
poster. exhibition graphics
photography: rocco redondo. jon barnes

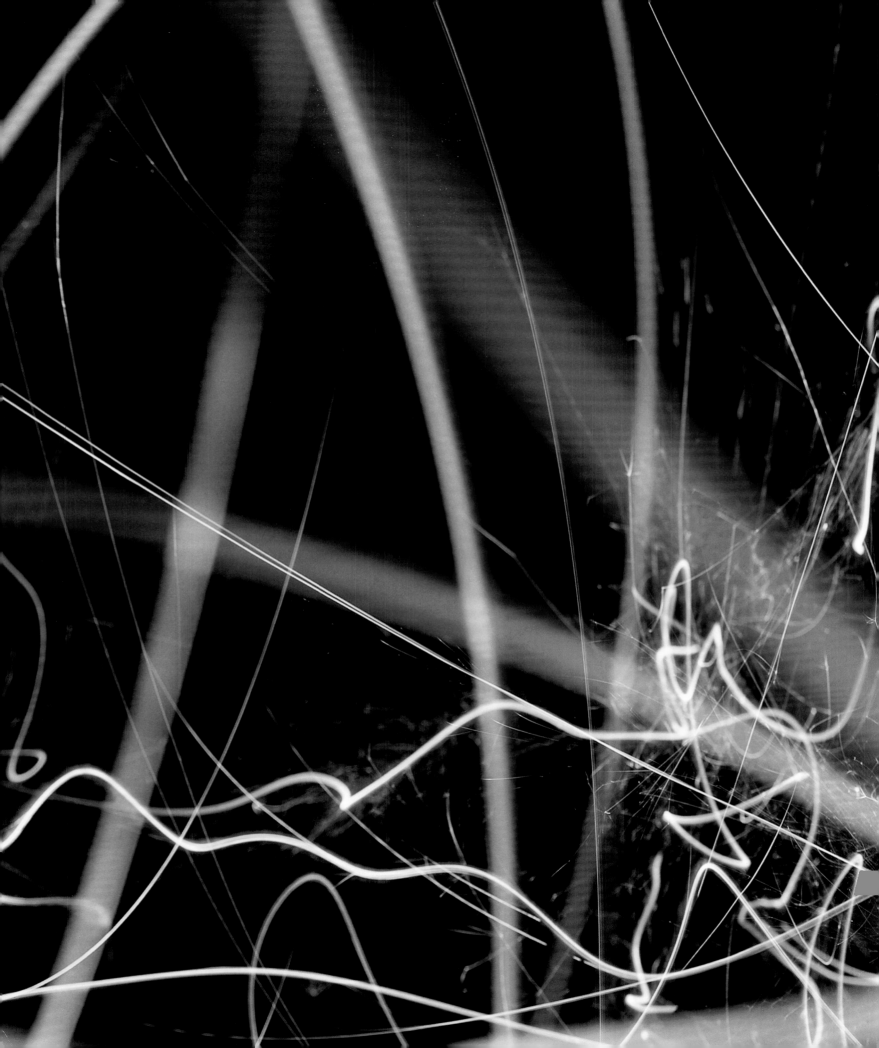

1989–1990

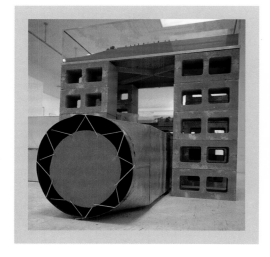

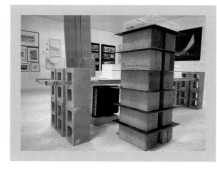

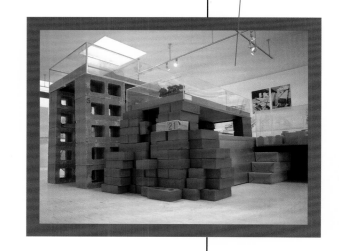

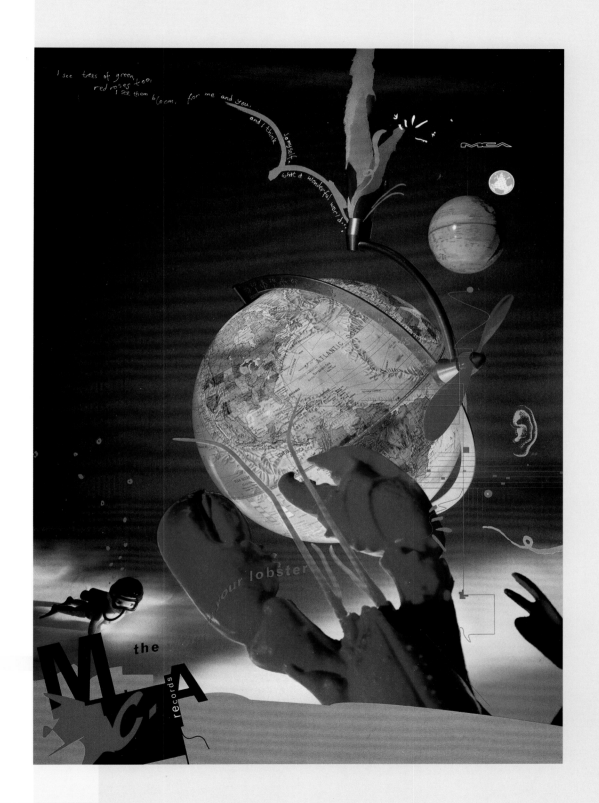

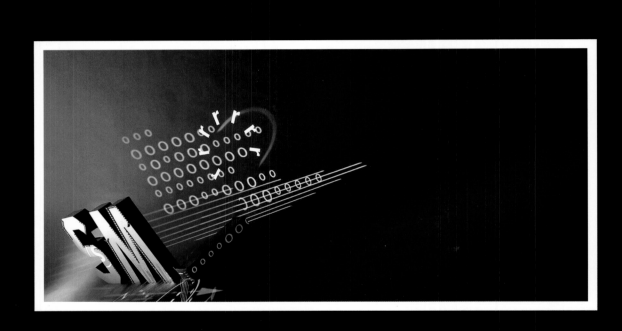

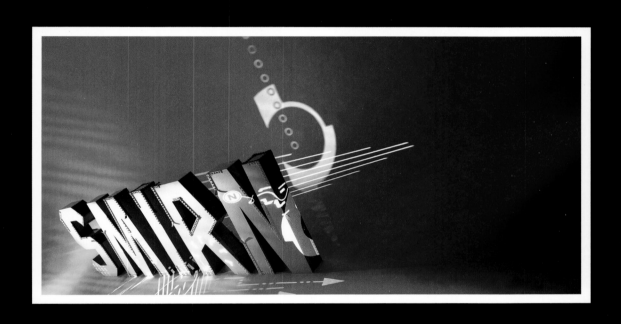

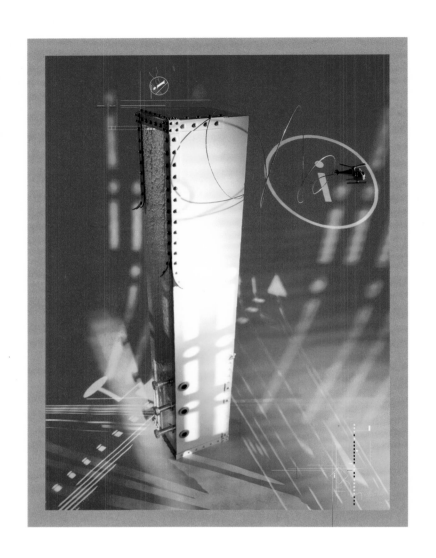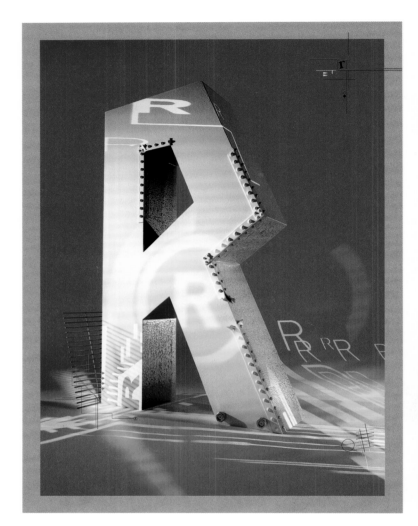

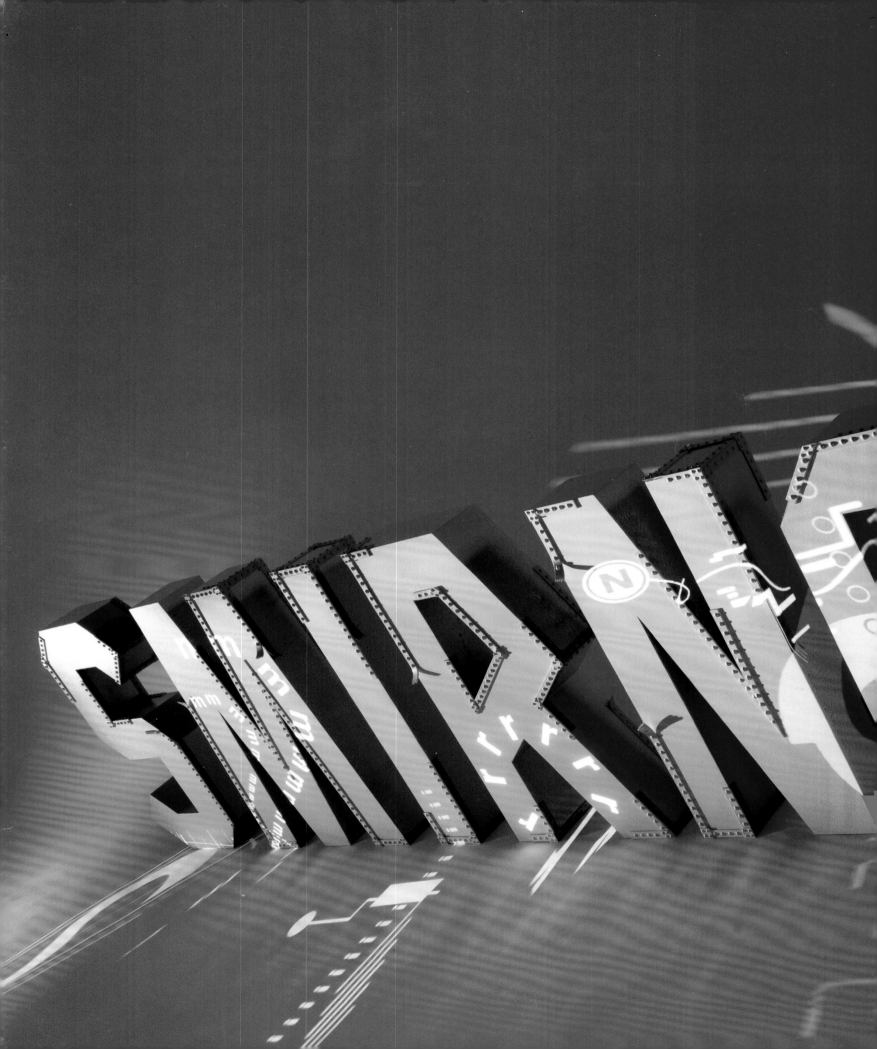

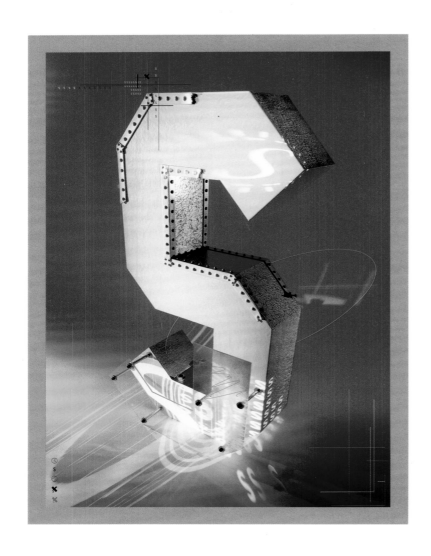

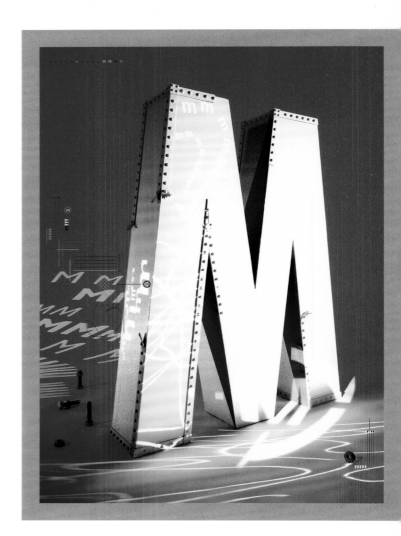

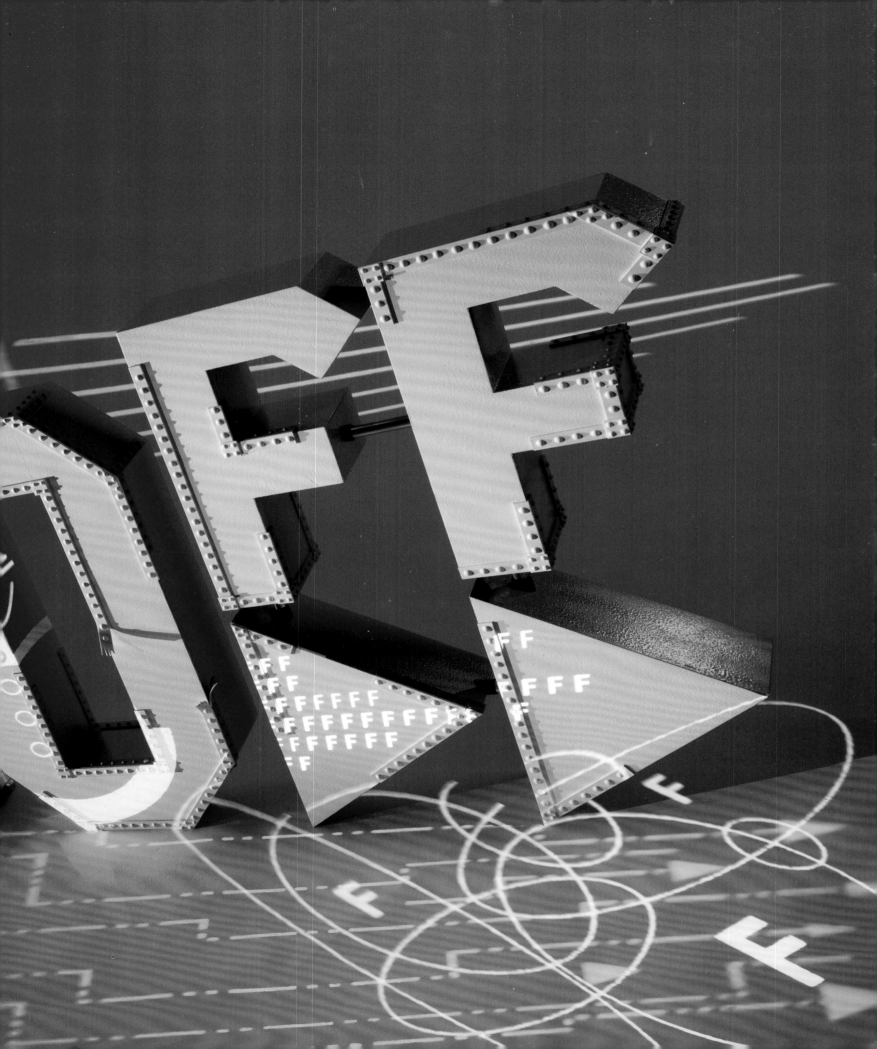

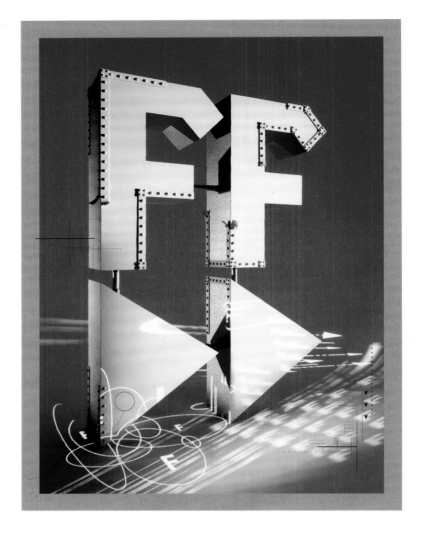

**smirnoff**
previous spreads: 48 sheet revolving billboards
this spread: set of posters displayed in the london underground
photography: rocco redondo

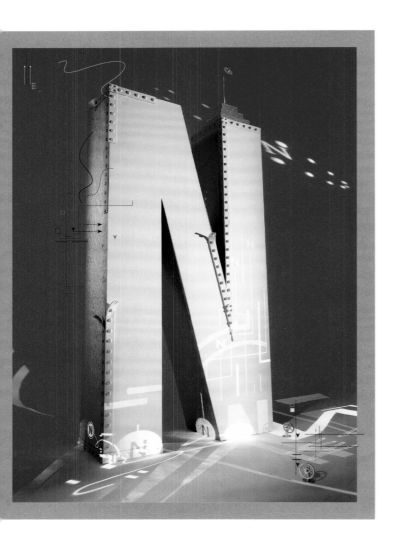
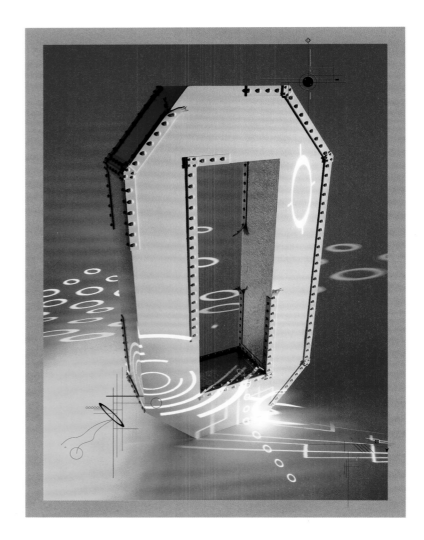

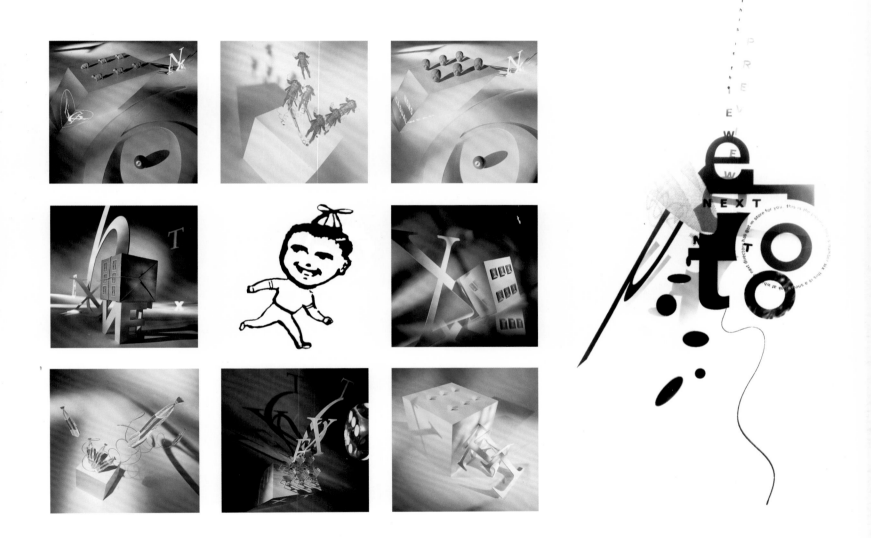

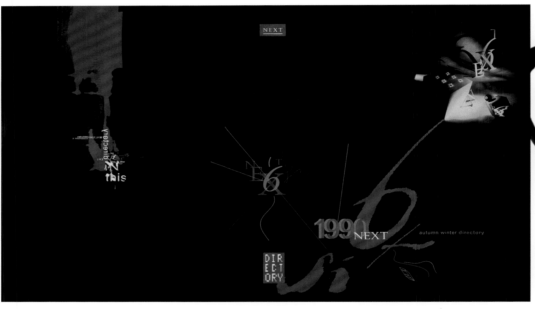

**next six.** mail order catalogue
illustration: ally wallace. photography: rocco redondo
previous spread: photographs. illustrations. photograms

catalogue cover and photograms
opposite page: section divider

←(50/51)   52|53   54/55)→

### Babywear

NEXT Babywear provides excellent **design,** colour and quality
in the most innovative babywear collection available for 0 to 24 months.
All accessorised with our **colourful** range of babies' footwear.

### Boys & Girls

Our NEXT Boys and Girls collection is the **best designed** childrenswear available.
Page after page of style and **quality** conscious clothes
that are practical, colourful and comfortable.
The range covers formalwear
and a wide selection of casualwear to suit every occasion.
For **style** conscious boys and girls
from 0 to 8 years,
our **choice** of looks is the best.

### Boys & Girls Accessories

A superb range of footwear and accessories,
**uniquely** designed for boys and girls
aged **0 to 8,**
reflecting the style
and design awareness of our clothing range.
Stylish **comfort and quality** are assured.

BOYS & girls

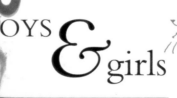

And six little Singing-boys,—these little souls
In nice clean faces, and their white choir stoles
(Revd. R H Barham 1788 1845)

## men's casualwear

Next bring you the best of casual style
for Autumn/Winter 1990

### Casual Tailoring

Subtle **interplay** between traditional cut and striking colour,
**weave** and pure design
forms the basis for our Casual Tailoring section.
**Essentially** versatile and industrial story.
a variety of options are available
to our style conscious customer.

### Basic Modern Style

All **essential** underwear pieces are considered here,
which have been carefully **designed** and made,
with a keen eye kept on traditional manufacturing techniques.
adding **detail** to a quality range of knitwear,
jerseywear and basic woven pieces.
Quality and style is an affordable price.
The essential **suede** jacket can be found in this section.

### Sports
A complete range of **dynamic** active sportswear.

### Mountain High
A rugged collection
of **sturdy**,
richly patterned and textured menswear,
featuring heavy knit winter knitwear,
brushed cotton shirts and denim.
**moleskin** and corduroy trousers.
Essentially a casual **outdoor** story.
The best **heavyweight** jackets are found here.

---

## eveningwear & Lingerie

### Eveningwear
A comprehensive collection of collections!
Autumn eveningwear ranges from seductive,
**glamorous** strapped satin through to elegant,
**sophisticated** velvets and crepes.
Our new, casual approach to formal dressing is found
in an elegant range of **relaxed** evening knitwear.
Special occasion dressing is not forgotten as our
exclusively designed story covers every eventuality.

### Lingerie
Next Lingerie becomes more sophisticated and elegant
with new attention to detail and texture.
Glamorous nightwear moves forward.
However, our jersey range is as lively as ever.

---

## interiors

Next Interior Autumn Winter 1990 the definitive reference
on interior decoration.
Plus, a selection of Home & Leisure goods
designed to complement the lifestyle of the new '90's.

The Interior Collections offer lounge, bedroom & bathroom designs & accessories in colours &
textures to suit a whole spectrum of taste. **Kensington, Italia, Checkers,
Verdigris, Chelsea, Classic,
Rosebury, Kashmir, Richmond,
Classic Stripe,
Tocata and Windermere.**

In addition, there is a full range of accessories specially selected for each collection
including lighting,
pictures & mirrors,
rugs,
occasional furniture,
bedding,
bedlinen,
towels & crockery.

Directory 6 hasn't forgotten the quality of **life**,
to make yours that much easier and that much fuller,
we present this exciting new collection for the home.

**Household Electricals**, including kitchen gadgetry,
floor cleaners, hi-fi, video recorders,
indeed everything needed to keep your home looking and sounding as you want it!

**Home Office Equipment**,
state of the art telecommunications and user friendly office-tec for homeworkers of all ages.

**Sports and Leisuretime**,
multi-gyms and exercise equipment designed to make the heart beat a little faster-longer!

---

## womenswear, *originals*

Next present Originals Autumn/Winter 1990
An exciting range of co-ordinated classics.

### Originals Formal
Formal **classics** from Next Originals have a new,
relaxed feeling, with **easier** shapes in softer proportions,
moving away from very structured clothing to a soft, feminine silhouette.
**Colour balance** is important
and makes a dramatic statement with softened brights,
combined with cool, toned neutrals.

### Originals Casual
Casualwear continues with its comfortable, easy shapes and styling.
A co-ordinated story makes these clothes ideal for the active, contemporary woman.
Colour balance is again important, mixing hot brights with neutral classics.

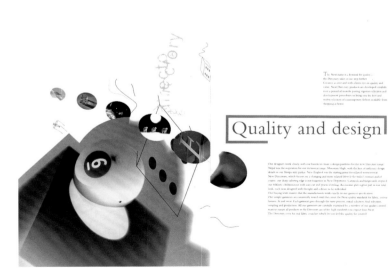

## Quality and design

The Next name is a byword for quality –
the Directory takes a one-step further.
Consistency over and with a keen eye on quality and
value, Next Directory products are developed carefully
over a period of months putting rigorous selection and
development procedures to bring into the best and
widest selection of contemporary fashion available from
shopping at home.

Our designers work closely with our buyers to create a design portfolio for the new Directory range. Digital was the inspiration for our menswear range. Museum, High, with the lines of authentic design details in our Sloops and Junior. Next, England was the starting point for relaxed menswear of New Directions, which focuses on a changing and more relaxed lifestyle the men's version and of course, our sharp tailoring edge is not forgotten in New Depository. Casuals and languorous inspired our folkloric, childrenswear with care and precise if striking. Accessories play a great part in our total look, each was designed with thought and a desire to be individual.

Our buying team ensures that the manufacturers work exactly to our garment specification. Our sample garments are consistently tested until they meet the Next quality standards for fabric, colour, feature, fit and wear. Each garment goes through the same process, initial selection, final schematic sampling and production. All our garments are carefully examined by a member of our quality control team to ensure all products in the Directory are of the high standards you expect from Next. The Directory, even has real fabric swatches which let you feel the quality for yourself.

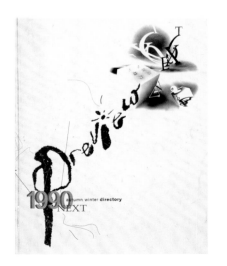

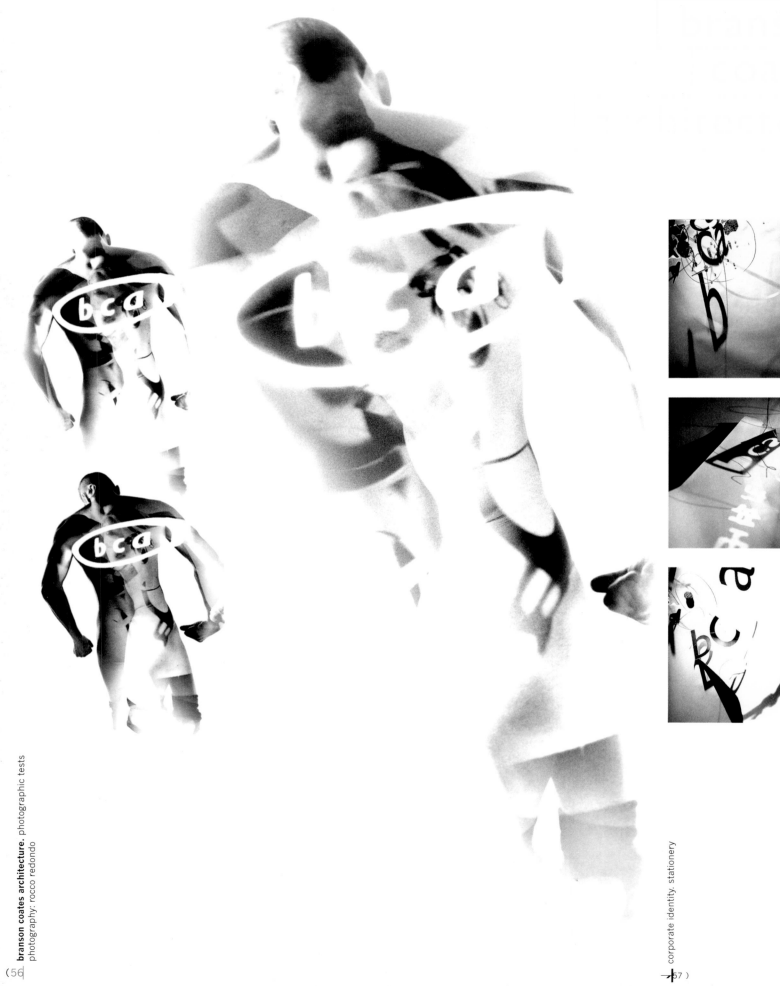

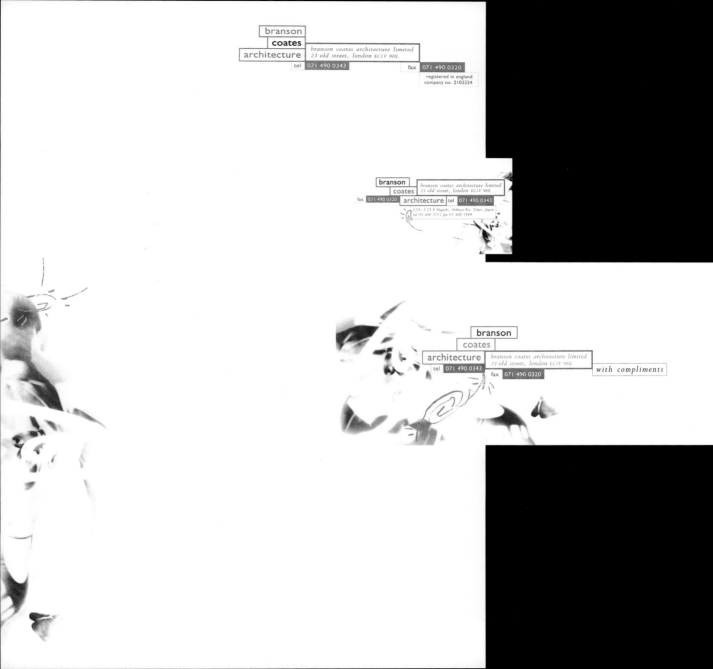

branson
coates
architecture
branson coates architecture limited
23 old street, london EC1V 9HL
tel 071 490 0343
fax 071 490 0320
registered in england
company no. 2103324

branson
coates
architecture
branson coates architecture limited
23 old street, london EC1V 9HL
fax 071 490 0320
tel 071 490 0343
CIA, 2-23-8 Higashi, Shibuya-Ku, Tokyo, Japan
tel 01 406 3715 fax 01 400 1889

branson
coates
architecture
branson coates architecture limited
23 old street, london EC1V 9HL
tel 071 490 0343
fax 071 490 0320
*with compliments*

next spread: **steelworks.** selected spreads
photography: julian germain. tommy harris
published by why not publishing

# steel works

Consett, from steel to tortilla chips

by Julian Germain

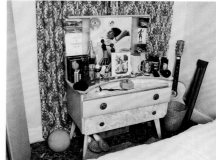

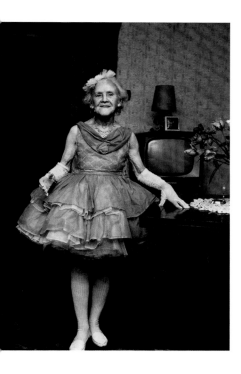

A fter all, how can a man be one of the lads when he can't afford any round let alone his round, when the fortnightly cheque has to be scrutinised by the wife before any money, if there's any to spare, can be allowed for a pint?

For many families the 80s – out 'perestroika' – were, to be years spent at home, years of watching the kids grow up, leave school and go on schemes, years of lost identity and purpose.

As everybody knows, housing is cheaper up here. Retired couples from the South are selling up and moving up. Downsizeis a new a term on a place in which to relax are. And when you have that lump sum or a good job, but you are paying mortgage interest rates verging on usury, then why not? After all, back we both, once the epitome of working class mentality, are becoming increasingly desirable. In an age where people are looking for the past, but without it uselessness, this is both apt and ironic.

I was happy in the lace of a drunken hour

I was looking for a girl
and then I found a job

**There's Work for those that Want It - Martin Herron**

**1**

I'm a little tired story that Mrs Thatcher, that paragon of industry, has played such a crucial role in making unemployment socially acceptable.

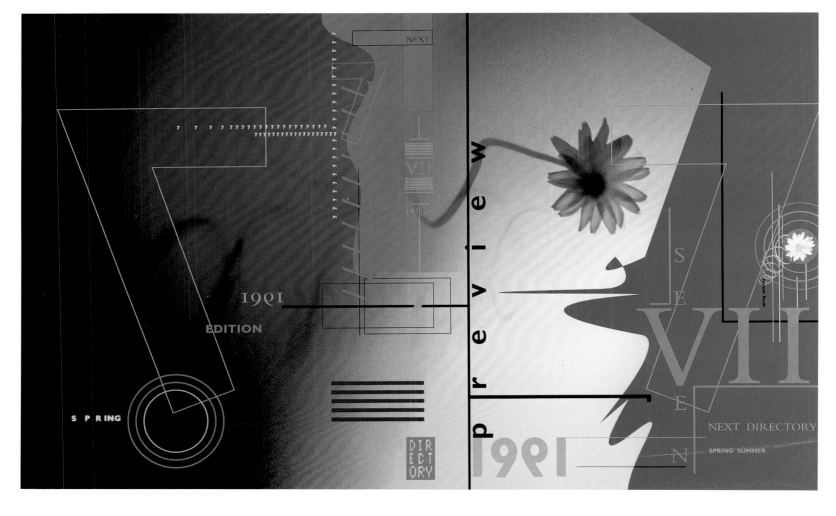

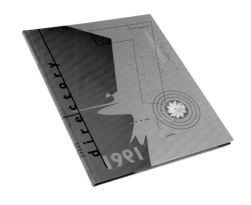

**next directory seven.** mail order catalogue
various covers. end papers. introduction pages
photography: rocco redondo

following spread: section dividers

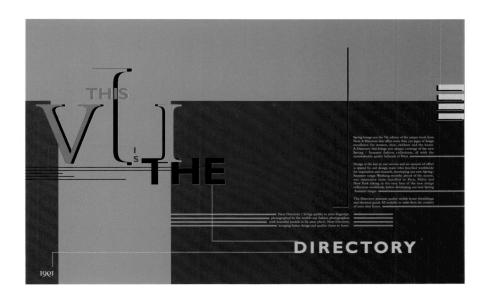

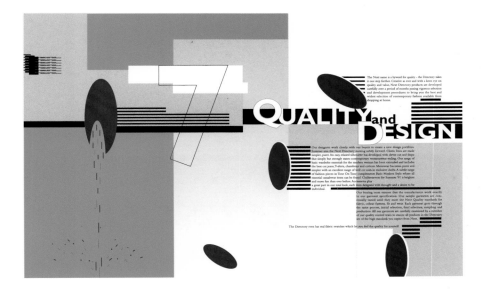

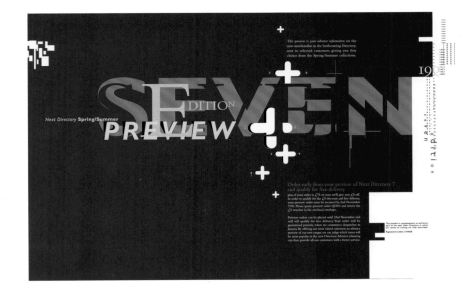

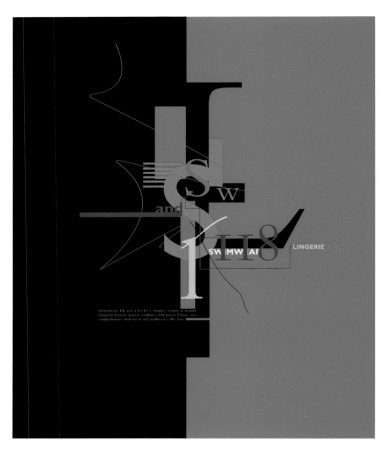

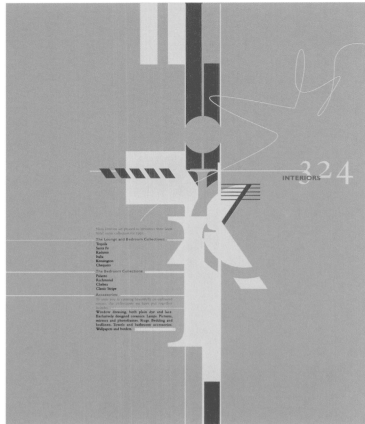

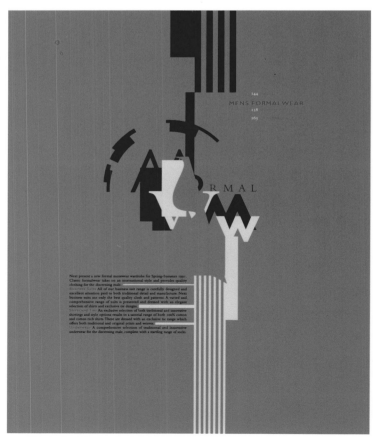

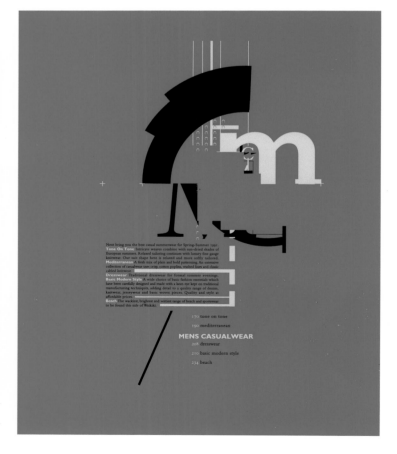

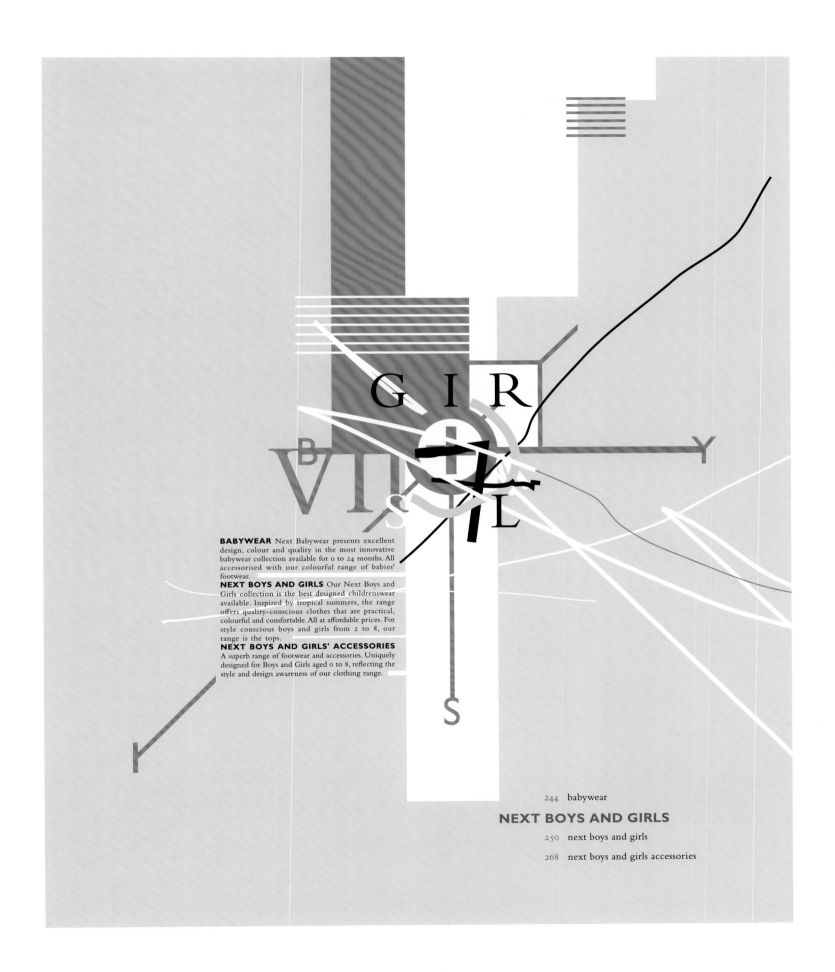

GIRL
BOYS
VISUAL

**BABYWEAR** Next Babywear presents excellent design, colour and quality in the most innovative babywear collection available for 0 to 24 months. All accessorised with our colourful range of babies' footwear.

**NEXT BOYS AND GIRLS** Our Next Boys and Girls collection is the best designed childrenswear available. Inspired by tropical summers, the range offers quality-conscious clothes that are practical, colourful and comfortable. All at affordable prices. For style conscious boys and girls from 2 to 8, our range is the tops.

**NEXT BOYS AND GIRLS' ACCESSORIES** A superb range of footwear and accessories. Uniquely designed for Boys and Girls aged 0 to 8, reflecting the style and design awareness of our clothing range.

loving

crying

laughing

working

being

seeing

thinking

touching

sleeping

walking

clothing

branding

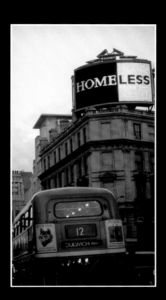

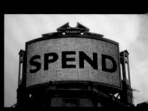

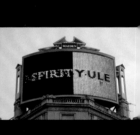

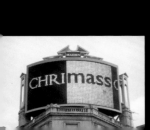

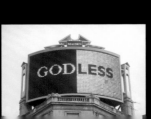

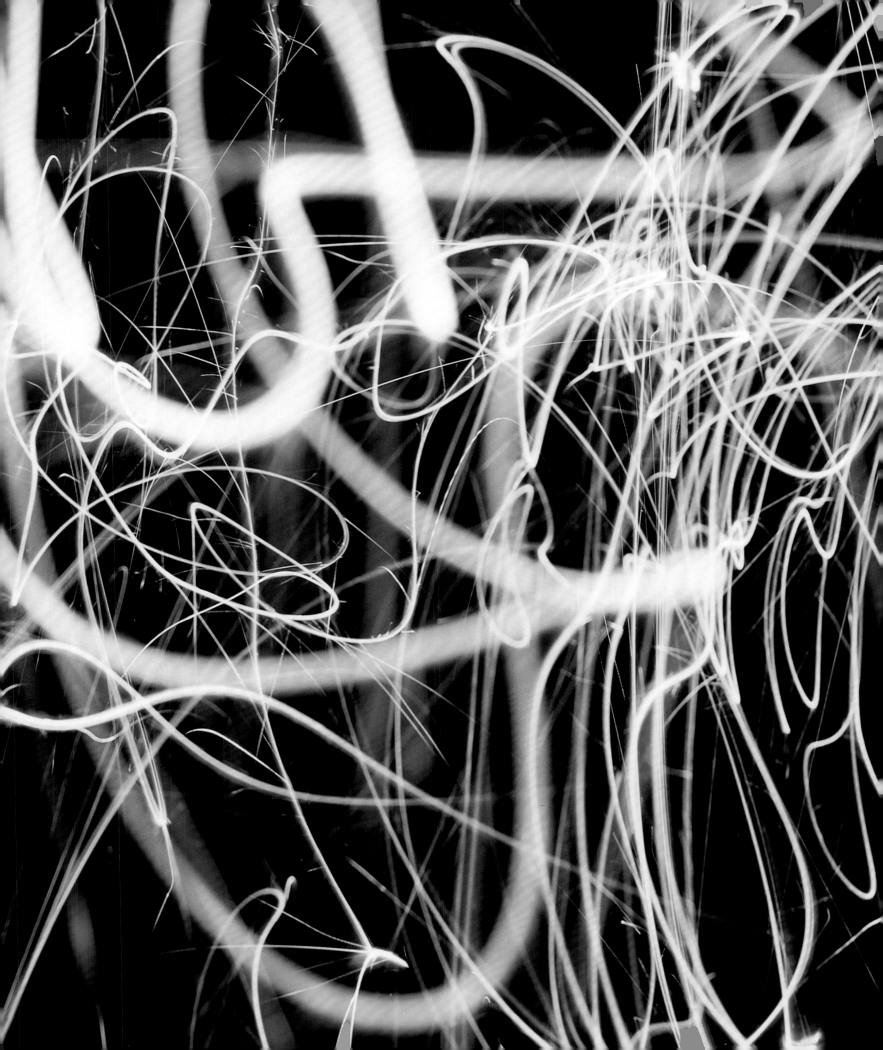

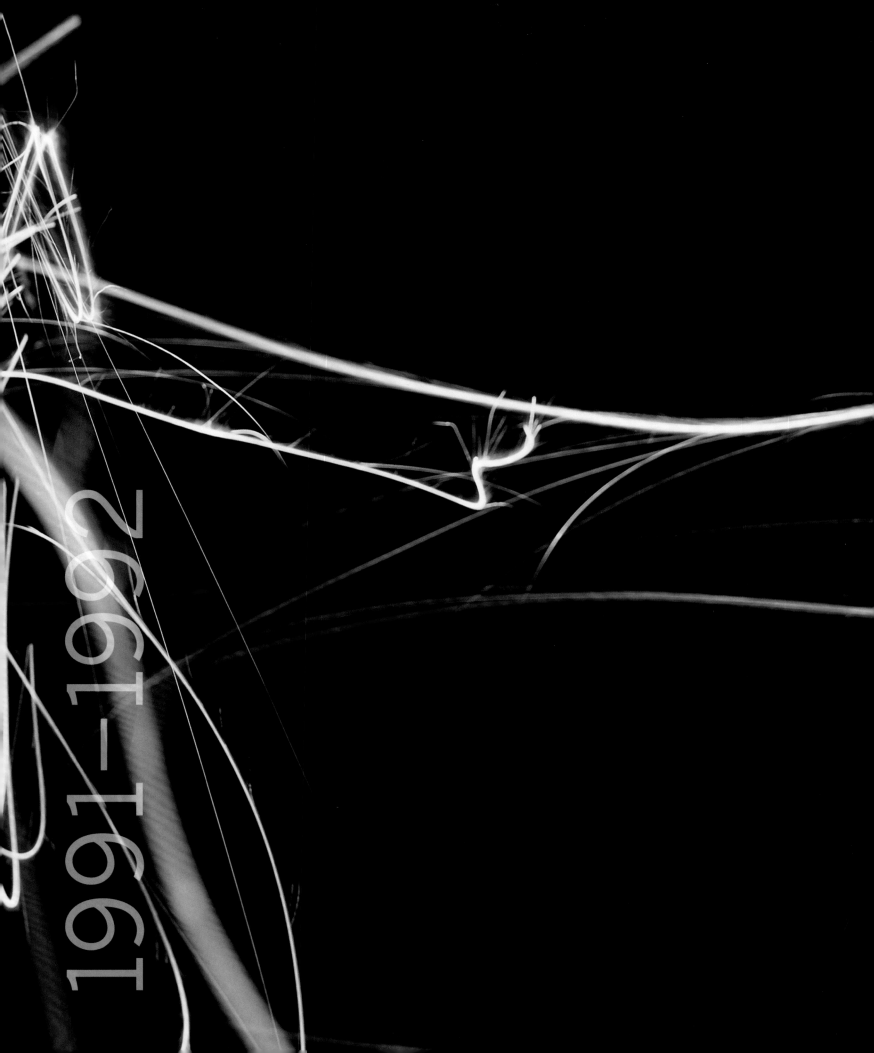

1991–1992

The Royal College of Art
**Computer Related Design**
Course Leader Gillian Crampton Smith

Developing the role of art and design disciplines in
the design of interaction - with electronic tools,
products and media.

Multi-disciplinary graduate programmes:
Taught masters course.
Master's degree by project.
PhD programme.

We seek women and men who delight in using their imagination in new and challenging ways and who
will develop this new field with rigour and flair. Students are mostly art and design graduates many from
graphic, industrial, or a/v design, or from video and animation. We also take graduates from related
disciplines such as human factors, media/communications and software, electronics or systems engineering.
Some students are sponsored by employers such as IBM, Racal, British Aerospace.

**The Taught Course**
The two-year course is project-based. Students work on interdisciplinary projects
aimed at developing their own discipline's contribution to interaction design, and
their understanding of the role of other disciplines. An open mind and willingness
to contribute to a team is essential.
The first year is quite structured and opens up a range of possibilities, issues and
avenues for exploration. Students decide on their personal direction within this
developing discipline and prepare proposals for their second-year projects, often
in collaboration with students in other departments or with outside institutions.
They can also contribute to research projects within the College.
The staff have backgrounds in graphic design, industrial design, engineering and
video, and there is a joint lecture course with Imperial College. There are many
visitors from institutions and companies in Britain and abroad.
These contacts allow us to arrange summer placements in Europe,
USA and Japan.

**Master's degree by project and the PhD programme**
Students taking these options have a particular project they wish to
undertake. The student and supervisor agree a programme of work
which may include elements of the taught course.

Royal College of Art london

computer related design

Tools for the mind

software tools
Interaction (Interact)
consumer products
interactive publications
information design
Interface

Design for the Electronic Age

**Interaction Issues and Projects**
Most people cannot programme their video recorder. How could you
make it easier and more intuitive?
What could an interactive magazine be like? How would it explain
the contents of video and print?
Ticket machines may be automatic but people don't seem to be able
to use them automatically. What's the problem?
What are the advantages and disadvantages of the use of metaphor in
interaction? What are the limitations of the desktop metaphor?
How come so many people can't find what they want or get the
wrong information. Can you make a computer information
system mistake-proof? What could it do that paper can't?
Is there a language of interaction? Or should we develop one?
Where do 3D modellers let turn the design process? How could they
better fit the way designers work?
Virtual reality - a blind alley?
Design an interactive homepage that will intrigue and entertain those
who have never used a computer.
What kinds of computer tools are needed to support fashion design?
We have developed good ways of communicating by phone: can we
learn from this to design computer tools for collaborative work?
What can we learn from the design of video games?
How will new technology affect the way we use our leisure?
What new products might we see in ten years' time?

The Royal College of Art is
Europe's only Graduate University
of Art and Design. It offers a rich
learning environment, with courses
in more than thirty disciplines
covering design for manufacture,
communication design, the fine
arts and crafts, and the history,
theory and management of design.
It draws students from more than
twenty countries.
The College is opposite Hyde Park
in the centre of London, a block
away from its collaborators in the
Royal School of Music, the Victoria
and Albert and Science Museums,
and Imperial College, Britain's
leading university institute of
science and technology.

Among the College's corporate sponsors are
Acorn
Aesthedes
Alias
Apple Computer
Canon UK
Coates Viyella
Crosfield Electronics
Gerber
Hewlett Packard
IBM
Letraset UK
Moggridge Associates/ID2
Monotype
Moving Picture Company
MultiMedia Corporation
Psion
Quantel
TDI
Thorn EMI

**TO APPLY**
Write, phone or fax for a prospectus
and application form to:
The Registry, Royal College of Art,
Kensington Gore, London SW7 2EU
phone +44 71 584 5020
fax +44 71 225 1487
Applications should arrive by the end
of January

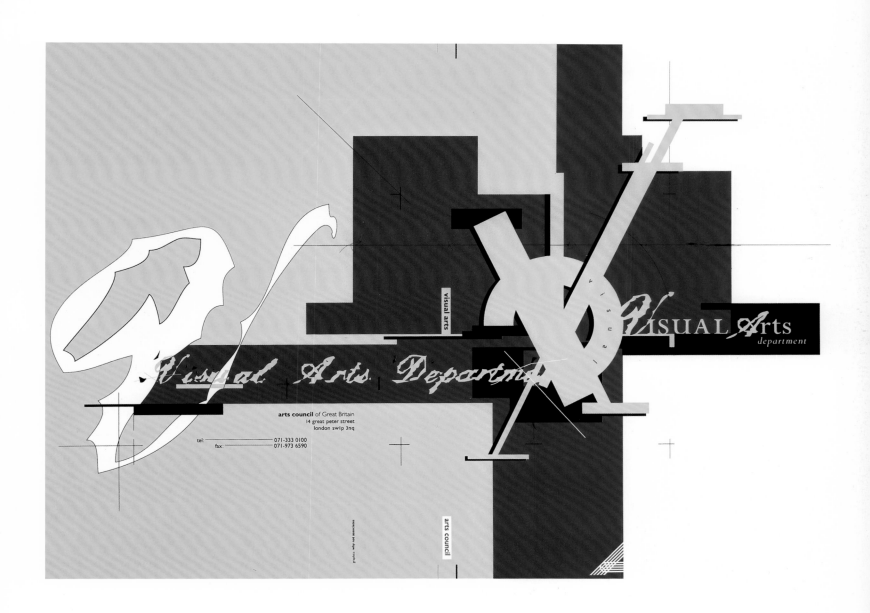

**arts council** of Great Britain
14 great peter street
london sw1p 3nq

tel: —————————— 071-333 0100
fax: —————————— 071-973 6590

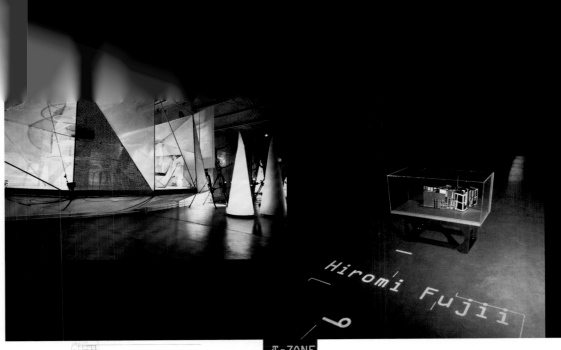

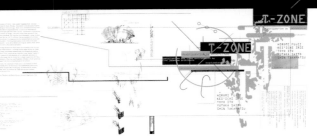

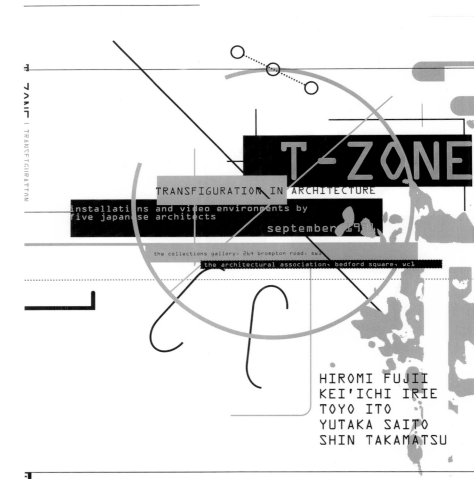

**t-zone - transfiguration in architecture**
exhibition graphics. brochure

perspex invitation. front. back
architects: hiromi fujii. kei'ichi irie. toyo ito. yutaka saito. shin takamatsu
exhibition design: andrew mckinley baylis

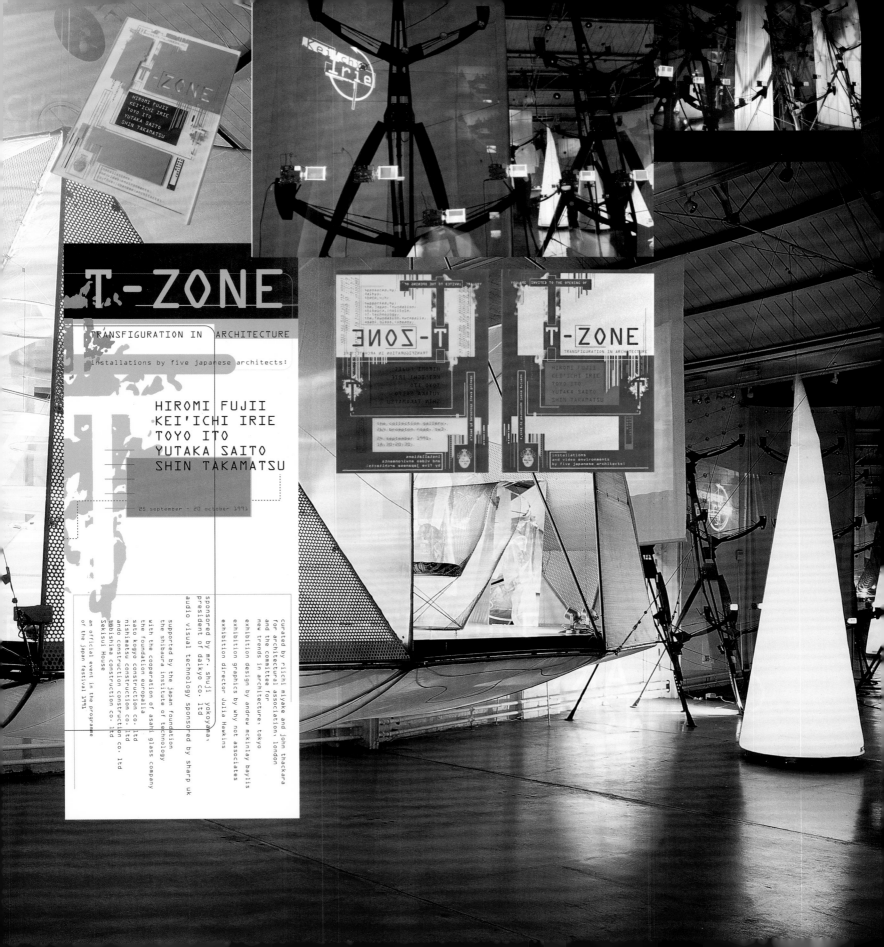

# T-ZONE

TRANSFIGURATION IN ARCHITECTURE

installations by five japanese architects:

HIROMI FUJII
KEI'ICHI IRIE
TOYO ITO
YUTAKA SAITO
SHIN TAKAMATSU

25 september - 20 october 1991

curated by riichi miyake and john thackara
for architectural association, london
and the committee for
new trends in architecture, tokyo

exhibition design by andrew mckinlay baylis
exhibition graphics by why not associates
exhibition director julia hawkins

sponsored by mr. shuji yokoyama,
president of daikyo co. ltd
audio visual technology sponsored by sharp uk

supported by the japan foundation
the shibaura institute of technology
with the cooperation of asahi glass company
the foundation europalia
sato kogyo construction co. ltd
nishimatsu construction co. ltd
ando construction construction co. ltd
tobishima construction co. ltd
Sekisui House

an official event in the programme
of the japan festival 1991

the next wave

typography

isbn no. 0 904 866 904

no

w

# —typography NOW

## the next wave

rick poynor
edward booth-clibborn
and why not associates

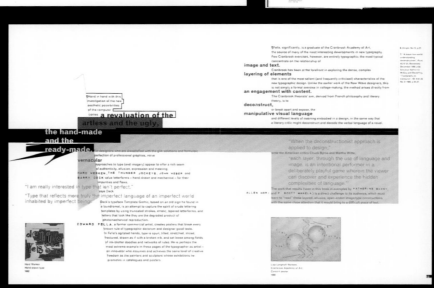

**typography now.** book
photography: rocco redondo. pirco wolfframm. alistair lever. simon scott
published by: booth-clibborn editions
previous spread: back cover. cover

introduction pages. english. japanese

selected section dividers

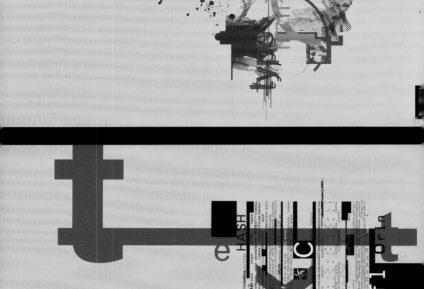

type florin

HASH
e
EM
 exclamation
HAS
parenthesis

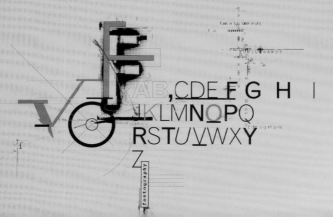

A B , C D E F G H I
J K L M N O P Q
R S T U V W X Y
Z

fontography

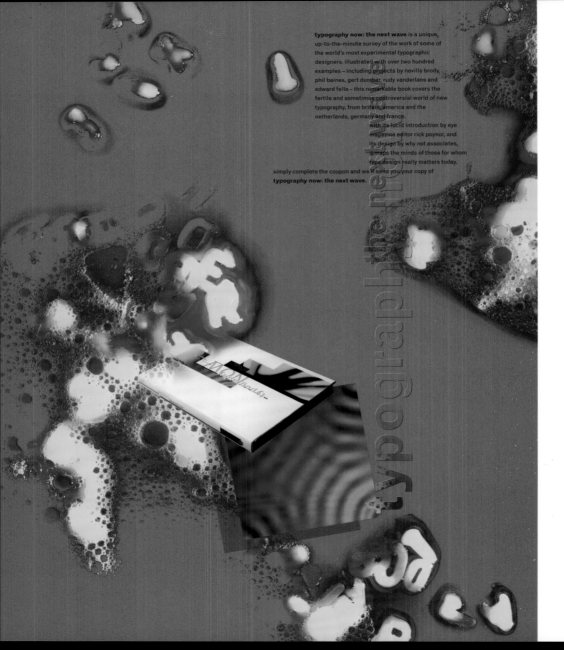

**typography now: the next wave** is a unique,
up-to-the-minute survey of the work of some of
the world's most experimental typographic
designers. illustrated with over two hundred
examples – including projects by neville brody,
phil baines, gert dumbar, rudy vanderlans and
edward fella – this remarkable book covers the
fertile and sometimes controversial world of new
typography, from britain, america and the
netherlands, germany and france.

with its lucid introduction by eye
magazine editor rick poynor, and
its design by why not associates,
it maps the minds of those for whom
type design really matters today.

simply complete the coupon and we'll send you your copy of
**typography now: the next wave.**

ABCDEFGH
abcdefgh
IJKLMNOPQ
ijklmnopq
RSTUVWXYZ
rstuvwxyz
1234567890

ABC DE F GH
abc def gh
IJKLM NOPQ
ijklm nopq
RSTUVWXYZ
rstuvwxyz
1234567890

# ABC

ABCDEFGHIJKLMNOPQRSTUVWXYZ

ABCDE

FGHIJKLMN

OPQRSTUVWXYZ

**midland bank typeface**
designed for press and television advertising
(bastardized perpetua, thank you mr gill)

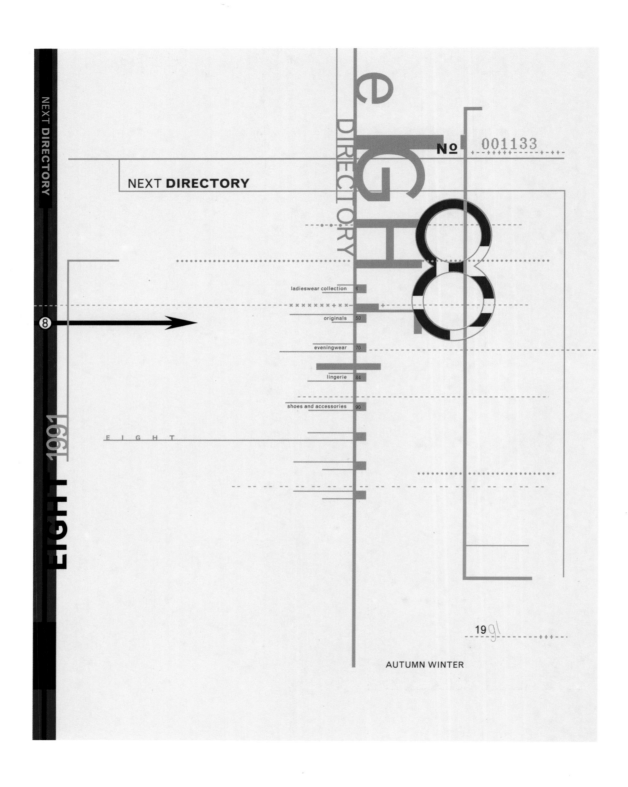

NEXT **DIRECTORY**

№ 001133

EIGHT

ladieswear collection 6

originals 50

eveningwear 70

lingerie 84

shoes and accessories 90

EIGHT

19 91

AUTUMN WINTER

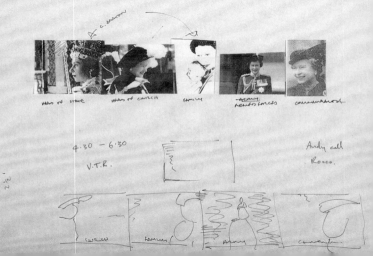

HEADS OF STATE     HEADS OF CHURCH     FAMILY     ARMY/ARMED FORCES     COMMONWEALTH

4.30 – 6.30
V.T.R.

Andy call
Rocco.

CHURCH     FAMILY     ARMY     CORONATION

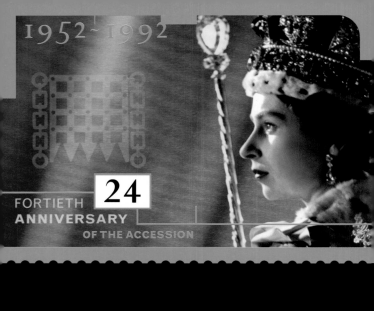

1952~1992

FORTIETH **ANNIVERSARY** OF THE ACCESSION

24

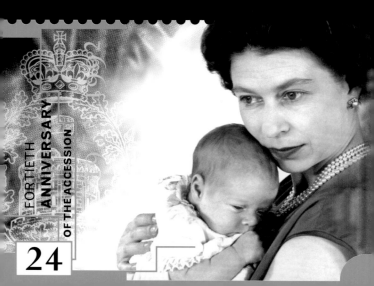

FORTIETH **ANNIVERSARY** OF THE ACCESSION

24

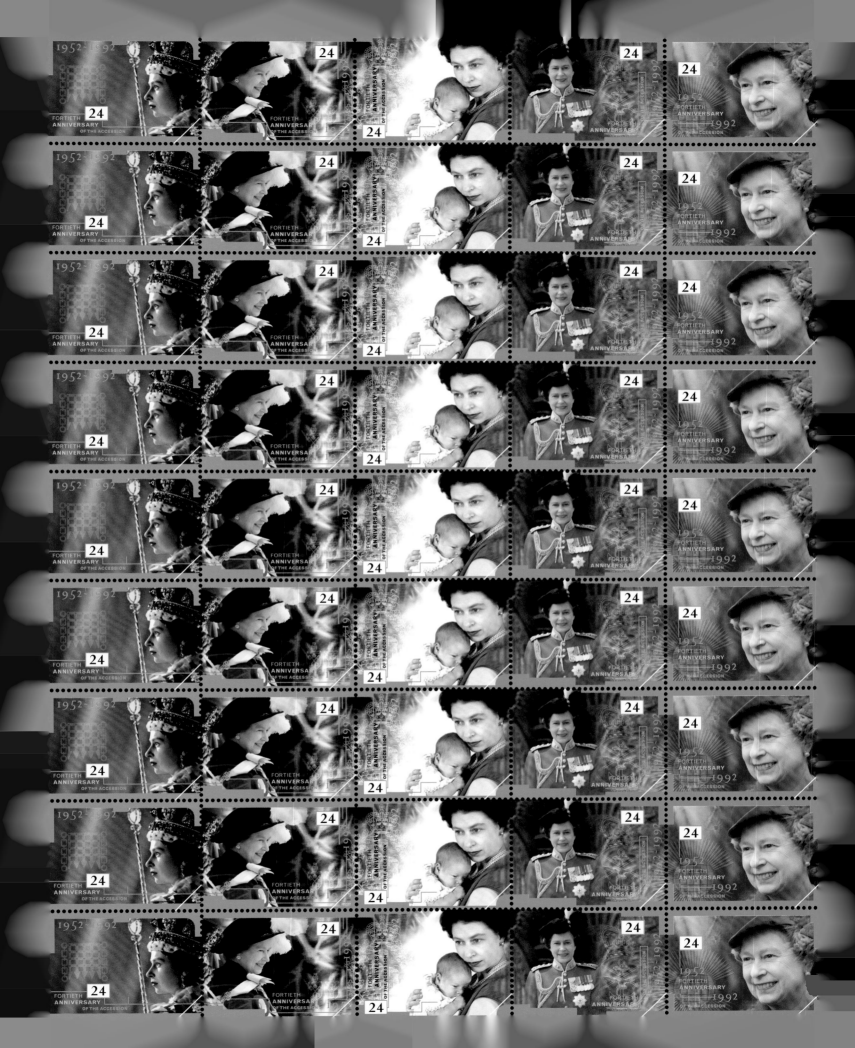

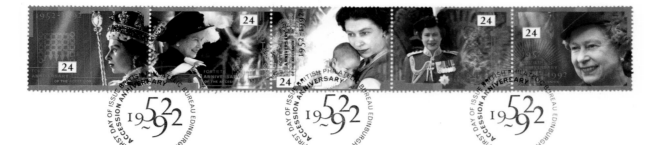

HAPPY & GLORIOUS

*royal mail first day cover*

1952 ~ 1992

THE FORTIETH
**ANNIVERSARY OF THE ACCESSION**

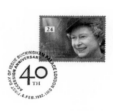

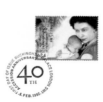

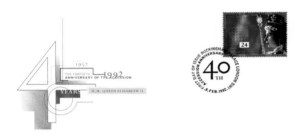

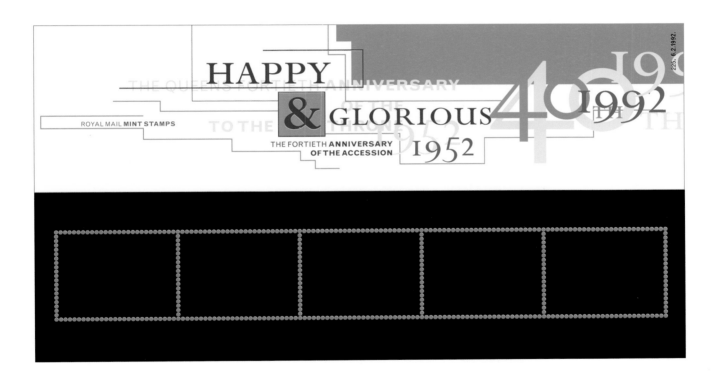

HAPPY **&** GLORIOUS 1952

ROYAL MAIL **MINT STAMPS**

THE FORTIETH **ANNIVERSARY**
**OF THE ACCESSION**

225. 6.2.1992.

initial presentation to the royal mail

**commemorative stamps for the fortieth anniversary of the accession**

first day covers. presentation pack

reproduced by permission of the royal mail
photography: cecil beaton. anwar hussein. tim graham

the inventi

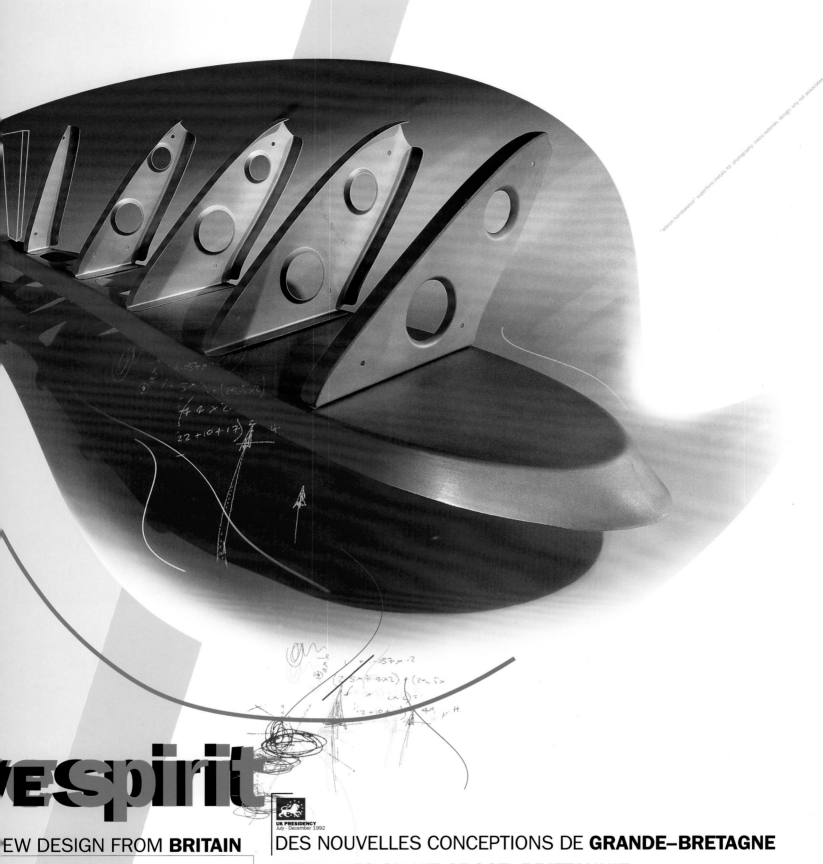

espirit

EW DESIGN FROM **BRITAIN** | DES NOUVELLES CONCEPTIONS DE **GRANDE—BRETAGNE**

NIEUW DESIGN UIT **GROOT—BRITTANNIE**

**AUTOWORLD** BRUSSELS

PARC DU CINQUANTENAIRE 11 - JUBELPARK 11,

1040 BRUXELLES - BRUSSEL.

**13.10.92. - 06.11.92.** 10.00am - 5.00pm.

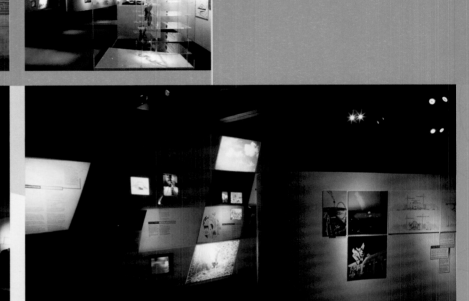

the inventive spirit. new british design
exhibition graphics. belgium
exhibition architects: apicella associates

opposite page: brochure. cover. selected spreads. flyer

photography: the crystal palace museum.
quadrant/flight international.
british motor industry heritage trust/rover group.
richard bryant/arcaid. chris gascoigne/arcaid.
roger lean·vercoe

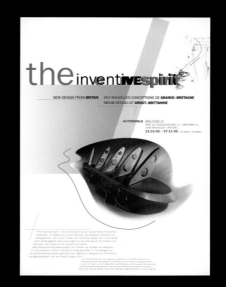

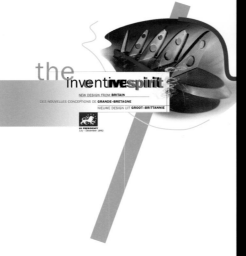

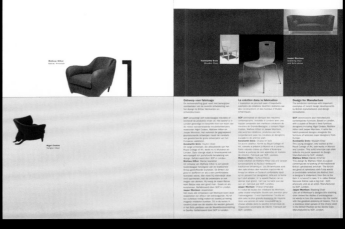

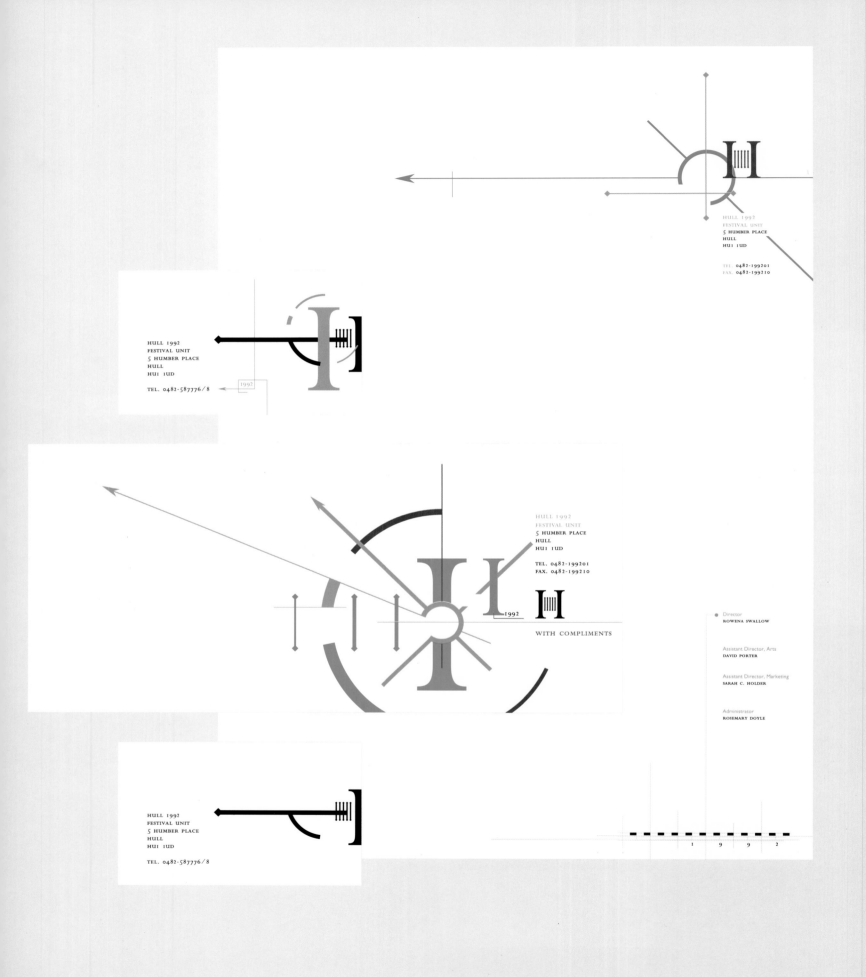

HULL 1992
FESTIVAL UNIT
5 HUMBER PLACE
HULL
HU1 1UD

TEL. 0482-199201
FAX. 0482-199210

HULL 1992
FESTIVAL UNIT
5 HUMBER PLACE
HULL
HU1 1UD

TEL. 0482-587776/8

1992

HULL 1992
FESTIVAL UNIT
5 HUMBER PLACE
HULL
HU1 1UD

TEL. 0482-199201
FAX. 0482-199210

1992

WITH COMPLIMENTS

Director
ROWENA SWALLOW

Assistant Director, Arts
DAVID PORTER

Assistant Director, Marketing
SARAH C. HOLDER

Administrator
ROSEMARY DOYLE

1 9 9 2

HULL 1992
FESTIVAL UNIT
5 HUMBER PLACE
HULL
HU1 1UD

TEL. 0482-587776/8

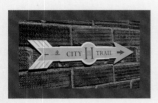

CITY H TRAIL

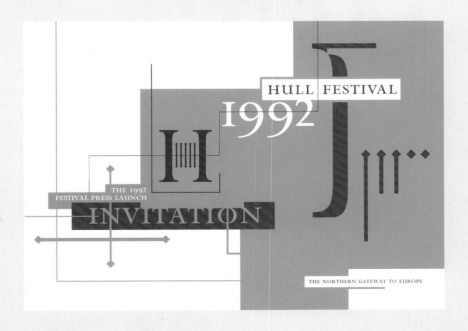

HULL FESTIVAL
1992
H
THE 1992
FESTIVAL PRESS LAUNCH
INVITATION
THE NORTHERN GATEWAY TO EUROPE

this spread: **hull 1992 arts festival.** corporate identity.

stationery. christmas card. city trail signage

photography: rocco redondo

following two spreads: festival posters

photography: nick georghiou. jeremy hall.

neil holmes. mike palframan

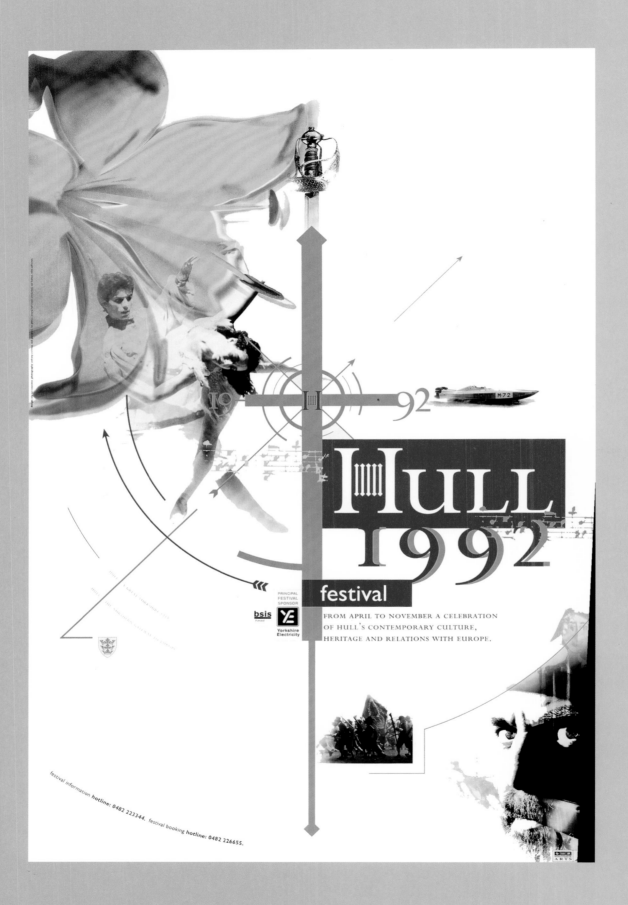

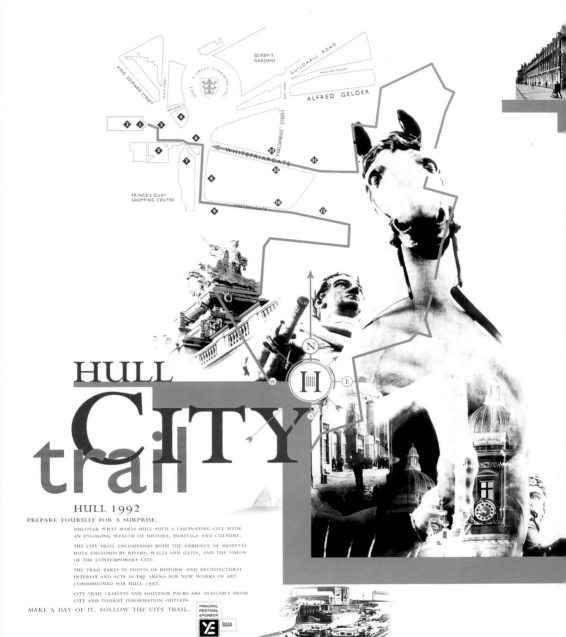

QUEEN'S GARDENS

GUILDHALL ROAD

HANOVER SQUARE

ALFRED GELDER

KING EDWARD STREET

A GREAT YORKSHIRE CITY

HULL

PARLIAMENT STREET

WHITEFRIARGATE

PRINCE'S QUAY
SHOPPING CENTRE

POSTERNGATE

N
W ⊞ E
S

# HULL
# CITY
# trail

## HULL 1992

PREPARE YOURSELF FOR A SURPRISE.

DISCOVER WHAT MAKES HULL SUCH A FASCINATING CITY WITH
AN ENGAGING WEALTH OF HISTORY, HERITAGE AND CULTURE.

THE CITY TRAIL ENCOMPASSES BOTH THE AMBIENCE OF MEDIEVAL
HULL ENCLOSED BY RIVERS, WALLS AND GATES, AND THE VISION
OF THE CONTEMPORARY CITY.

THE TRAIL TAKES IN POINTS OF HISTORIC AND ARCHITECTURAL
INTEREST AND ACTS AS THE ARENA FOR NEW WORKS OF ART
COMMISSIONED FOR HULL 1992.

CITY TRAIL LEAFLETS AND SOUVENIR PACKS ARE AVAILABLE FROM
CITY AND TOURIST INFORMATION OUTLETS.

MAKE A DAY OF IT. FOLLOW THE CITY TRAIL.

PRINCIPAL
FESTIVAL
SPONSOR

YE    bsis

Yorkshire
Electricity

Project Management of Trail by
HUMBERSIDE ARTS

C    ARTS

Additional support from:
Smith and Nephew, Seven Seas, Mercury Communications,
Price Waterhouse, Joshua Tetley and Co. amongst others

photography: mike palframan. design: why not associates

HULL IS JUSTLY PROUD OF ITS HISTORIC REFUSAL
TO ALLOW CHARLES I TO ENTER THE WALLS,
IN APRIL 1642. A SIGNIFICANT TURNING POINT
IN ROYAL POPULARITY, IT JUSTIFIES THE CLAIM:

HULL – BIRTHPLACE OF
THE CIVIL WAR 1642 – 1992

# CIVIL WAR

## HULL 1992 FESTIVAL

HULL – A GREAT YORKSHIRE CITY

## events

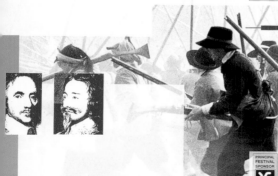

| | | |
|---|---|---|
| april 11 - may 31 | **Arms and Armour Exhibition** | town docks museum |
| april 15 | **Cromwell Film** | Ferens Art Gallery |
| april 23 | **Witchfinder General Film** | hull film theatre |
| april 17 - 23 | **Hull Flower and Church Arts Festival** | holy trinity church |
| april 23 | **Civic Service with Lord Tonypandy** | holy trinity church |
| april 25 | **Beverley Gate Refusal Re-enactment** | beverley gate |
| april 25 | **The Governors Reception Party** | the maltings |
| april - december | **Hull in the 17th Century** | wilberforce house |
| june 15 - 19 | **Hull 1642: Living History Events** | schools |
| june 16 - 27 | **Hull City Play** | city hall |
| june 20 - 21 | **Re-enactment of Civil War Battle** | city site |
| july 11 - 12 | **Wilberforce House: July 1642** | wilberforce house |

PRINCIPAL
FESTIVAL
SPONSOR

**YE** bsis

Yorkshire
Electricity

organised in association with
the English Civil War Society

ARTS

photographer: jeremy hall (royal armouries), neil holmes
design: why not associates

**most events are free**
for further details telephone
Hull Festival hotline on 0482 223344

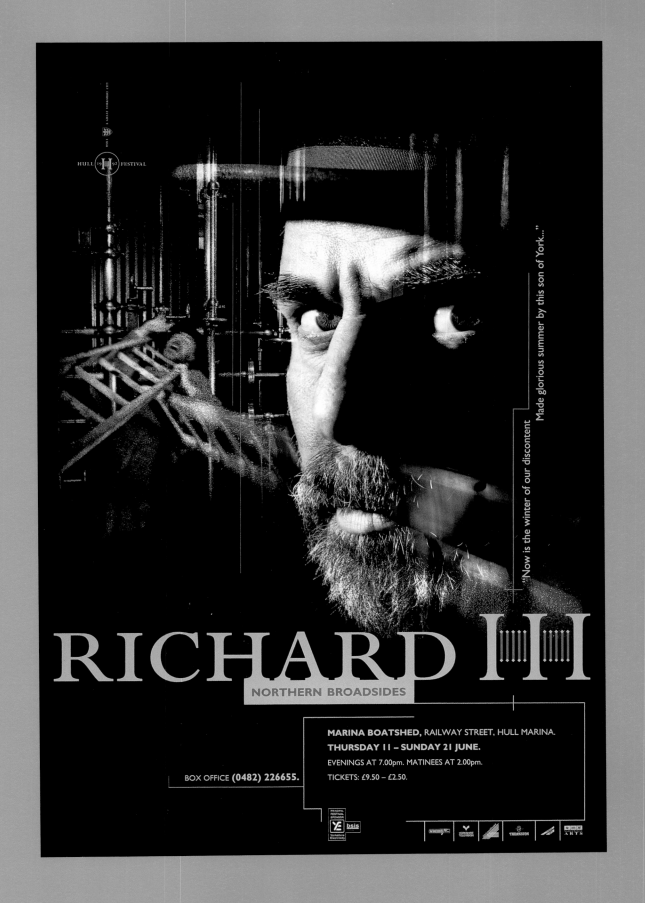

**tobacco free**

**tobacco free**

**tobacco free**
film direction and
graphics for a series
of 'no smoking'
commercials. usa

 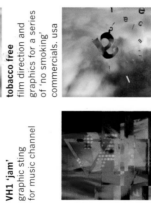  

**VH1 'jam'**
graphic sting
for music channel

  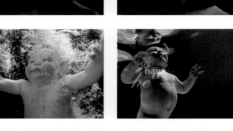 

**wordperfect**
microsoft
animated type
for commercial. usa

**jesus jones**
graphic elements
for music promo

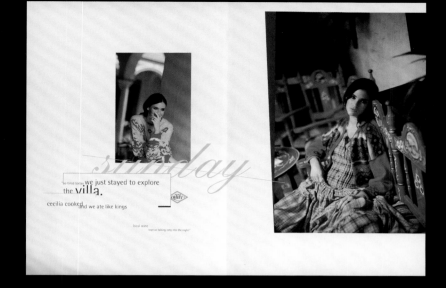

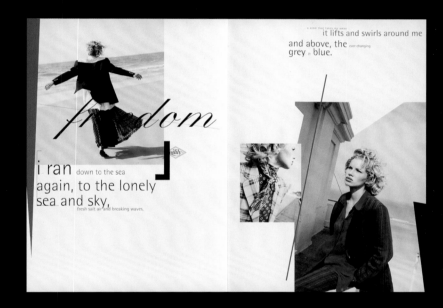

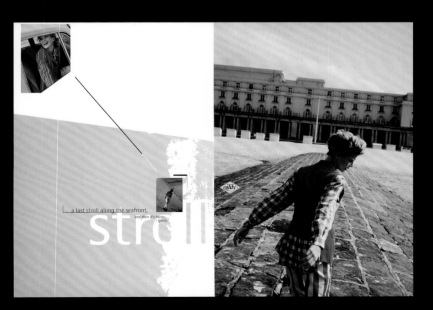

**oilily.** women's wear catalogue. holland
photography: bart van leeuwen. jan welters

**Julian Germain**
 Born 25th September 1962.
 On this day Ipswich Town
 achieved their biggest ever win –
 10-0 vs Floriana (Malta).
 European Cup Preliminary Round.

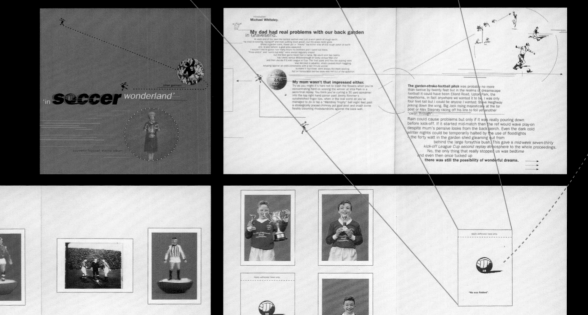

**soccer wonderland.** exhibition 'sticker' catalogue
photography: julian germain

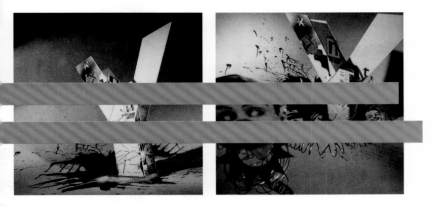

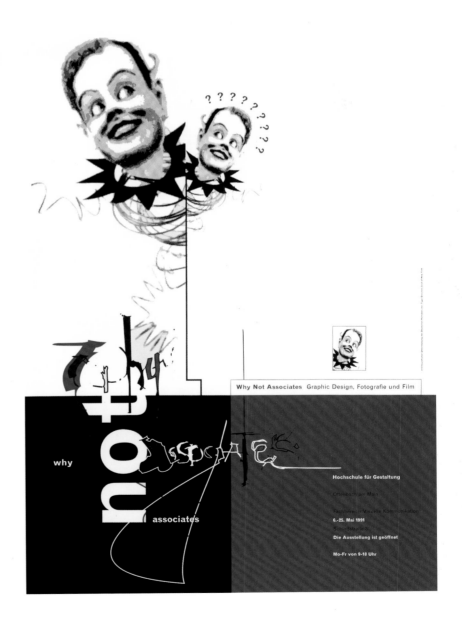

**why not associates exhibition.** offenbach, germany
unused photography. invite. poster
* **bergen international poster festival.** norway

(+) 101 ⟩

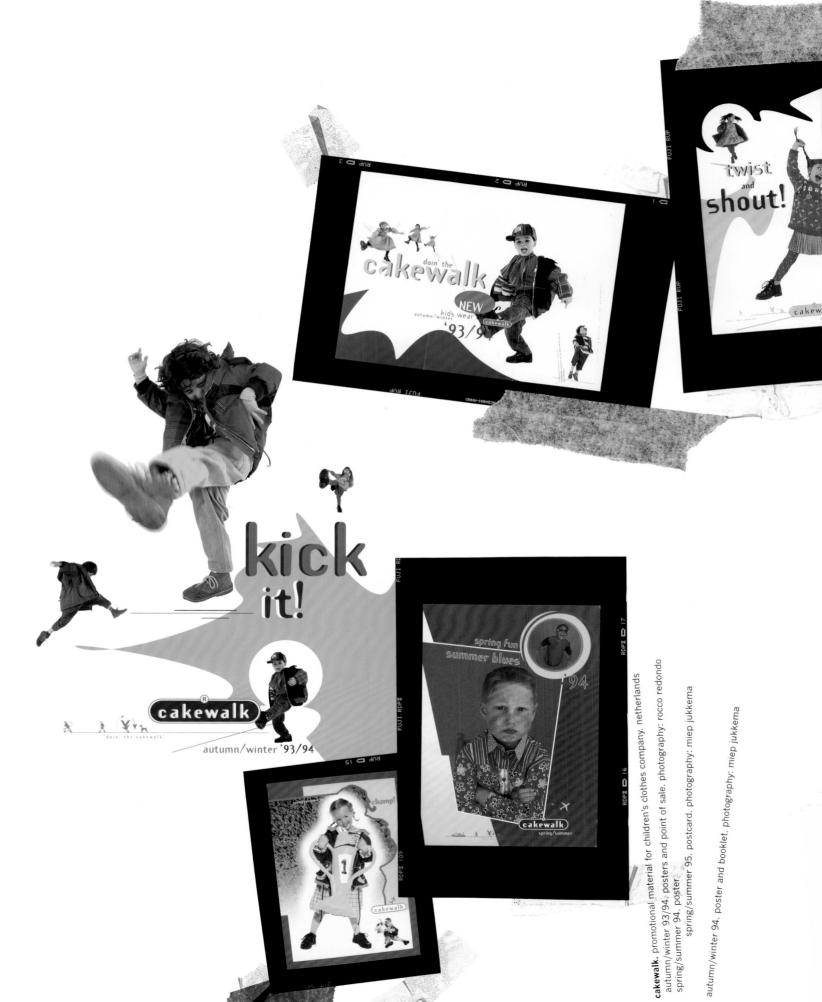

**cakewalk.** promotional material for children's clothes company. netherlands
autumn/winter 93/94. posters and point of sale. photography: rocco redondo
spring/summer 94. poster
spring/summer 95. postcard. photography: miep jukkema

autumn/winter 94. poster and booklet. photography: miep jukkema

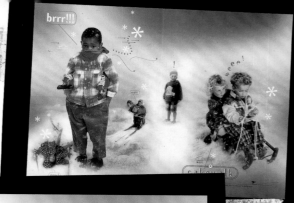

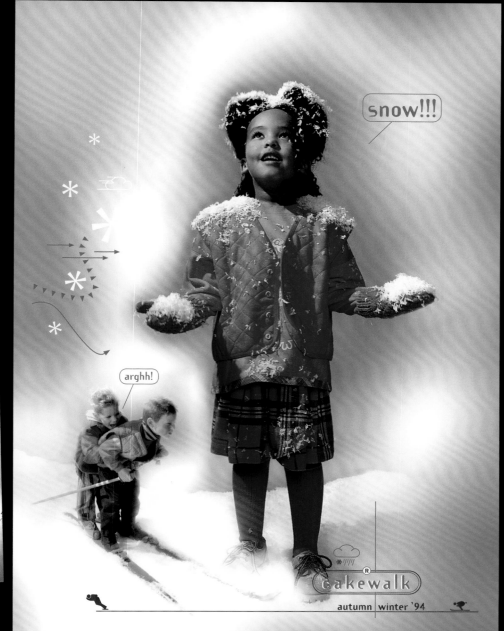

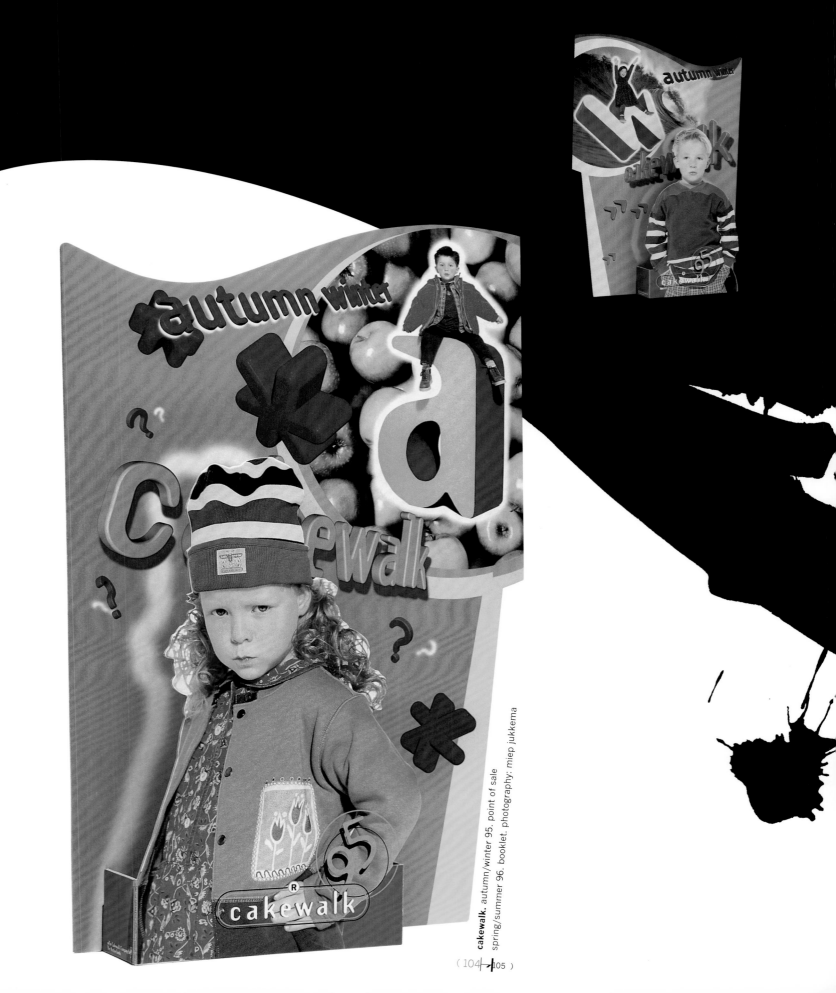

**cakewalk.** autumn/winter 95. point of sale
spring/summer 96. booklet. photography: miep jukkema

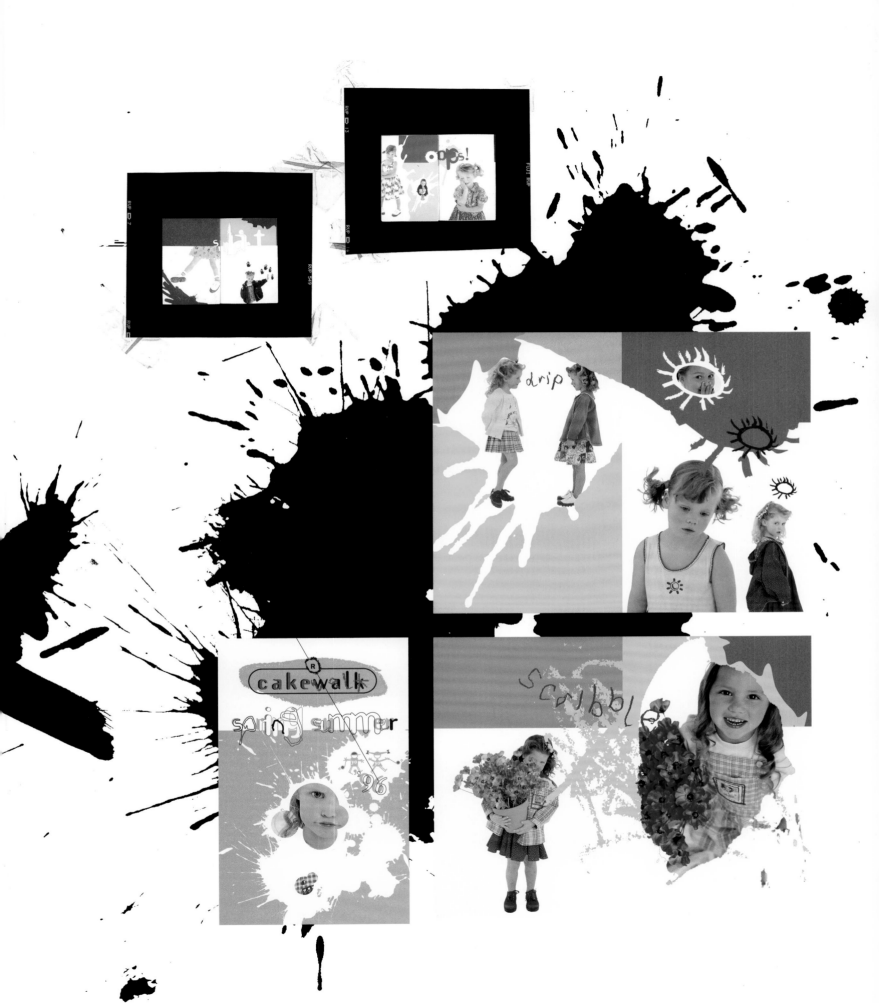

1993–1994

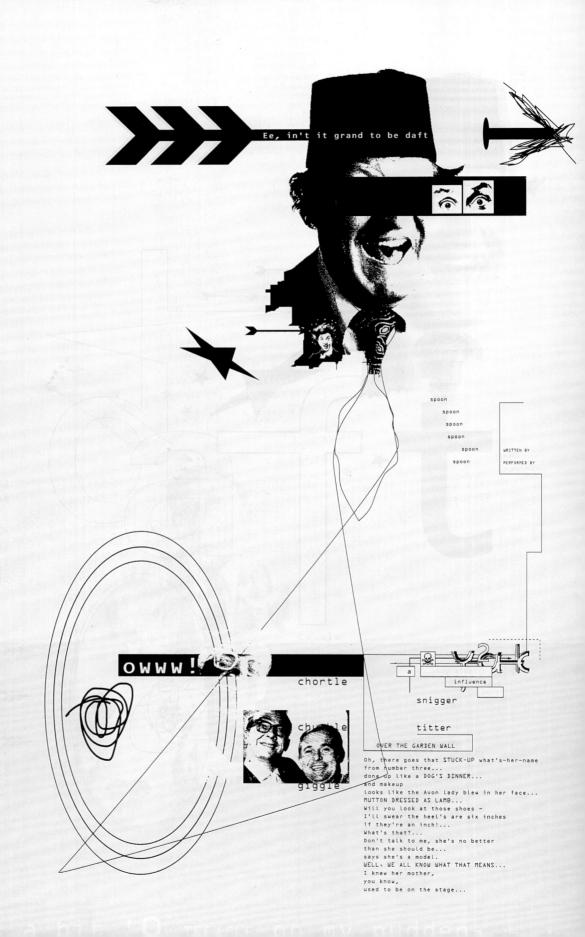

Ee, in't it grand to be daft

spoon
spoon
spoon
spoon
spoon
spoon

WRITTEN BY

PERFORMED BY

owww!

chortle

snigger

titter

a

influence

OVER THE GARDEN WALL

Oh, there goes that STUCK-UP what's-her-name
from number three...
done up like a DOG'S DINNER...
and makeup
Looks like the Avon lady blew in her face...
MUTTON DRESSED AS LAMB...
Will you look at those shoes –
I'll swear the heel's are six inches
if they're an inch!...
What's that?...
Don't talk to me, she's no better
than she should be...
says she's a model.
WELL, WE ALL KNOW WHAT THAT MEANS...
I knew her mother,
you know,
used to be on the stage...

chuckle

giggle

controlled alcohol use, a few liveners while working out ideas, creatively stimulated by a blurred logic, a dropout, relaxation of previously held beliefs, permission to explore. "In vino veritas"; creative endeavour as a truth which comes as much from the heart as the head, dull the head a little and let the heart learn to trust instinct. Of course, just a quiet, a good drop of red, drink may be unfunctionable, but who gives a fig about fashion. you'll never get me back onto flares.

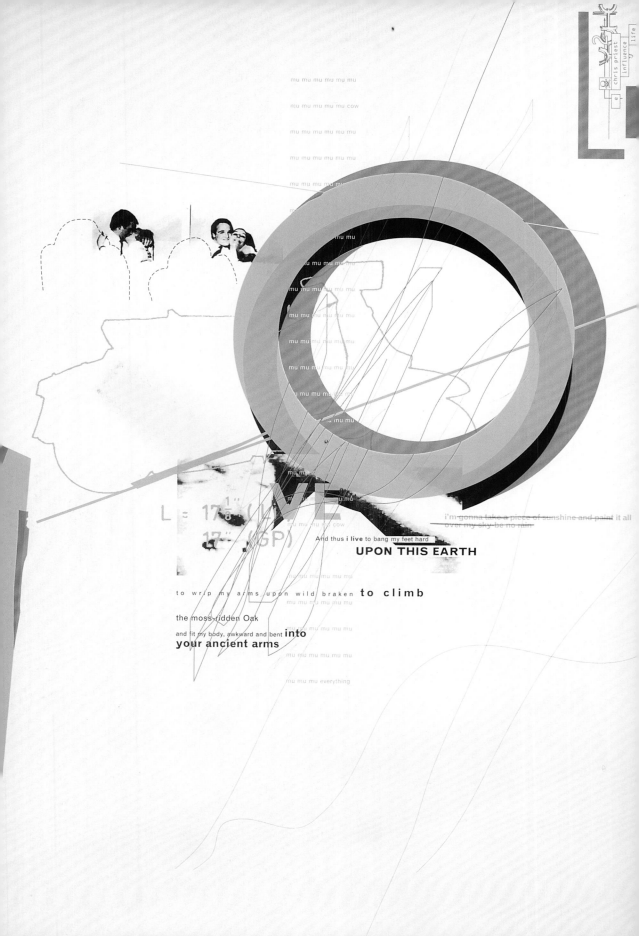

mu mu mu mu mu mu

mu mu mu mu mu mu cow

mu mu mu mu mu mu

mu mu mu mu mu mu

mu mu mu mu

mu mu mu mu mu mu

mu mu mu mu mu

mu mu mu mu mu mu

mu mu mu mu mu

mu mu mu mu mu mu

mu mu mu mu

mu mu mu mu mu mu

mu mu mu mu mu mu

mu mu mu mu mu mu mu cow

i'm gonna take a piece of sunshine and paint it all over my sky be no rain

L = 17 1/8" (LP)

17" (SP)

And thus **i live** to bang my feet hard

**UPON THIS EARTH**

mu mu mu mu mu

to wrip my arms upon wild braken **to climb**

the moss-ridden Oak

and fit my body, awkward and bent **into**
**your ancient arms**

mu mu mu mu mu mu

mu mu mu mu mu mu everything

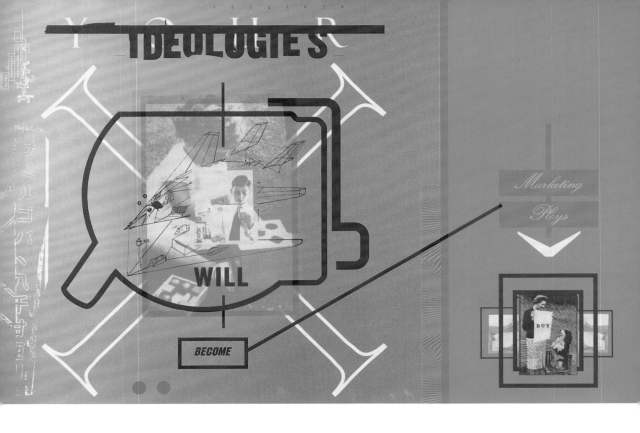

YOUR
# IDEOLOGIES

WILL

BECOME

Marketing
Ploys

BUY

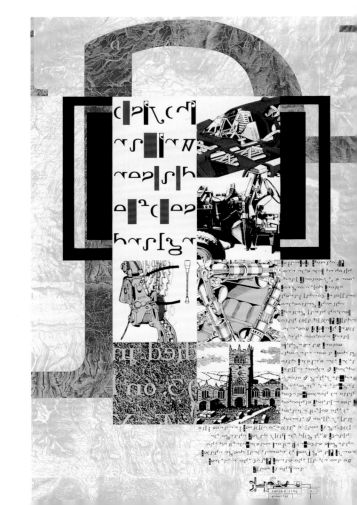

### your business needs

When you consider your property
– whether as an investor or an occupier – you are looking at
a valuable asset. You know that assets need to be managed
strategically to maximise their benefits to your business.
Whatever your challenge – **investment,**
**reorganisation,**
**new working practices,**
**growth**
**or external pressures**
you can either: remodel – refurbish or restack your current property
or relocate – through new build or fit out
The way forward is to be clear about the business
need and develop solutions that are driven by your
strategy, not dictated by implementation issues.
At Mace, our vision, is to be your first choice strategic
adviser on these property related business challenges.

### working with you

We are an independent,
professional management consultancy,
working in **partnership** with clients and the industry.
As we are **independent,** we commit ourselves
to your long-term interests, without compromise.
If we are to help you find a solution to your business need,
we understand that the total project cycle may involve
more than design and construction implementation.
As a result we will work with you to:
clarify your business needs
develop the brief
manage any resulting design and construction
process through to handover and beyond

in short, help you achieve your business goals

### services tailored to meet your needs

No two projects are ever the same.
The Mace approach has been designed
to offer you **total flexibility,**
as our services can be taken up individually,
in a tailored combination
or as a single comprehensive cycle of activity.
However you choose to engage Mace, we are confident
that you will find that your needs are always put first.
The following illustration shows the complete project cycle
from inception to handover and beyond, identifying the
relationship between the clients business processes
and our service stages.

**mace.** management and construction engineering
corporate identity. brochure. cover. selected spreads. logo
photography: phototone

( 112 - 113 )

## what you can expect

**Trust, honesty and integrity**
are the cornerstones of our partnership approach.
We create a challenging but non-confrontational
project environment where risks and opportunities
are identified and managed to your benefit.
We are also a campaigning organisation –
consistently advancing the standards
for professional management practice
in the industry and imaginatively
delivering against them.
We develop lasting relationships with our clients
based on our commitment to a total quality service
and work with you to identify emerging business needs
which will affect your future property requirements.

## dedicated to your project

At Mace, we bring together the complementary skills
of strategic advisers and practical implementers in one
creative environment.
This powerful combination – made
up of people from the full range of
**property, design, construction &
allied professional backgrounds** – not only speak the professional
language of their training
but also the common language of
co-operation and teamwork.
The structure of our company has been
developed to promote strong relationships
with our clients and underlines the Mace
team's commitment to achieving your
business goals. Each client has their
own dedicated team, which results in:

a fully accountable project leader

ease of communication and team
building at every stage

an array of skills targeted to
achieving the project's success.

m|a|c|e

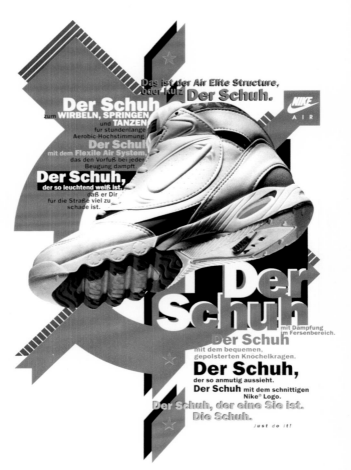

OPER NACH DEM FILM VON
JEAN COCTEAU

PHILIP GLASS
ORPHÉE

Freiluftveranstaltung im Innenhof des Renaissance-Schlosses Weikersheim/Württemberg:
31.7., 2.8., 4.8., 6.8., 8.8.
Sonderveranstaltung ohne Vorverkauf: 7.8.

Beginn: Jeweils 21 Uhr

Musikalische Leitung: Dennis Russell Davies
Regie: Brigitta Trommler
Bühnenbild: Thomas Pekny
Kostüme: Barbara Löschenkohl
Orchester des Konservatoriums Vilnius (Litauen)
Solisten und Instrumentalisten des 38. Internationalen Sommer Kurses Schoß Weikersheim

telefonische und schriftliche Kartenbestellungen: Jeunesses Musicales Deutschland e.V.,
Marktplatz 12, W-6992 Weikersheim. Telefon: 07934/xxxx. Telefax: 07934.8526

Für die großzügige danken wir: Daimler Benz AG, Mercedes-Benz AG (Niederlassung
Würzburg), Lippert Wilkens Partner, Düsseldorf

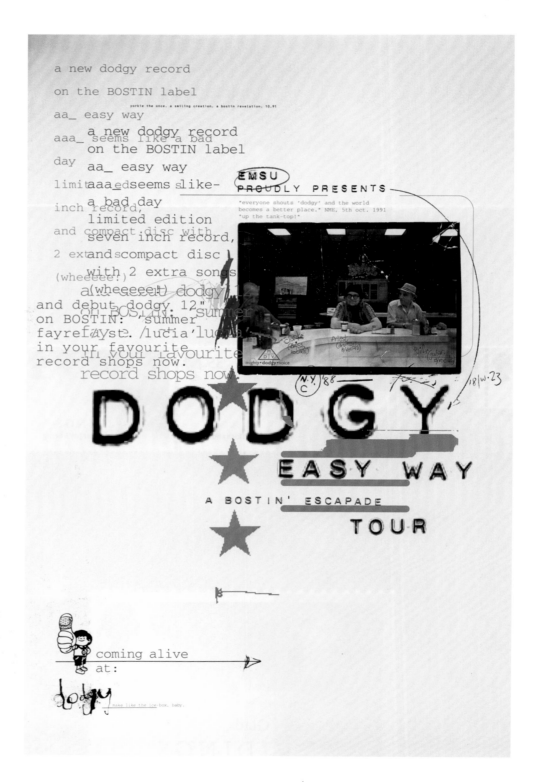

**dodgy.** poster. easy way tour
photography: julian germain
poster. water under the bridge

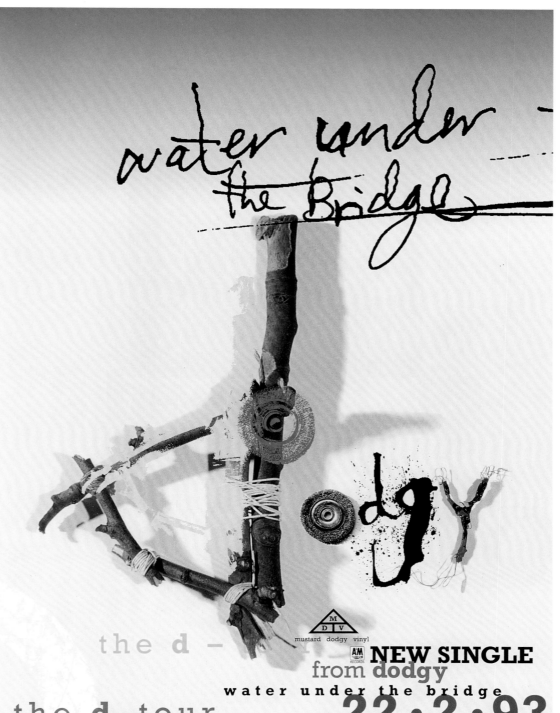

*water under the Bridge*

the d-tour

mustard dodgy vinyl

**NEW SINGLE** from **dodgy**
water under the bridge

the **d**-tour
dodgy play their instruments
and sing LIVE! @:

**22·2·93**

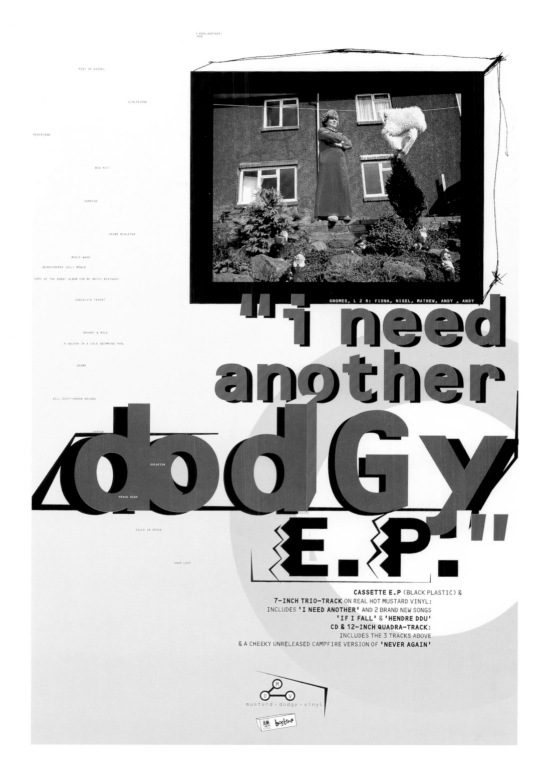

"i need
another
dodGy
E.P."

CASSETTE E.P (BLACK PLASTIC) &
7-INCH TRIO-TRACK ON REAL HOT MUSTARD VINYL:
INCLUDES 'I NEED ANOTHER' AND 2 BRAND NEW SONGS
'IF I FALL' & 'HENDRE DDU'
CD & 12-INCH QUADRA-TRACK:
INCLUDES THE 3 TRACKS ABOVE
& A CHEEKY UNRELEASED CAMPFIRE VERSION OF 'NEVER AGAIN'

mustard · dodgy · vinyl

**dodgy.** poster. i need another dodgy ep

i need another dodgy ep (reverse). the dodgy album (front).
lovebirds (reverse). water under the bridge (reverse)

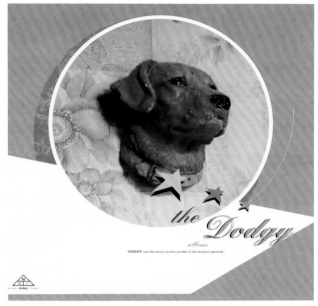

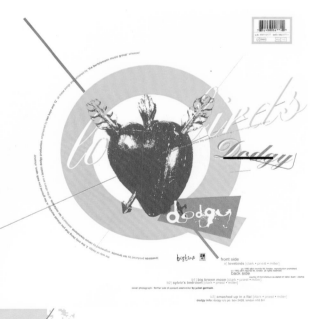

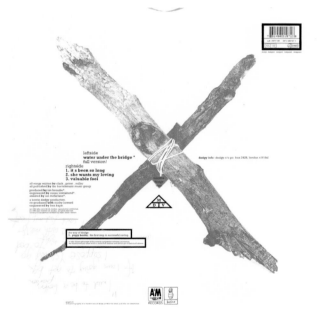

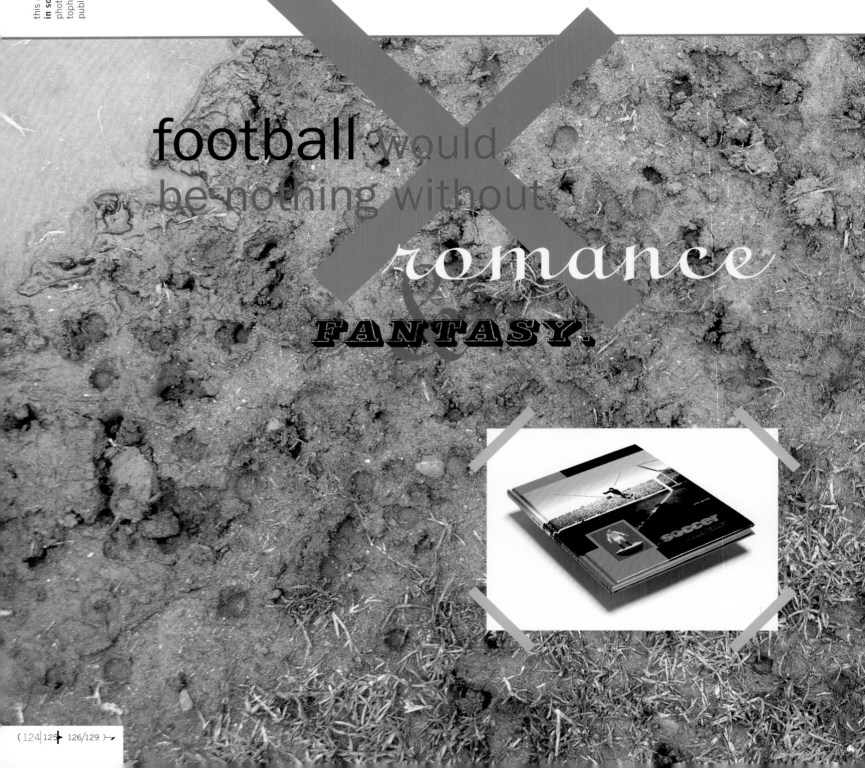

this and following two spreads:
in soccer wonderland. book by julian germain
photography: julian germain. jornal da tarde.
topham picture source. sports and general
published by booth-clibborn editions

football would be nothing without romance & FANTASY.

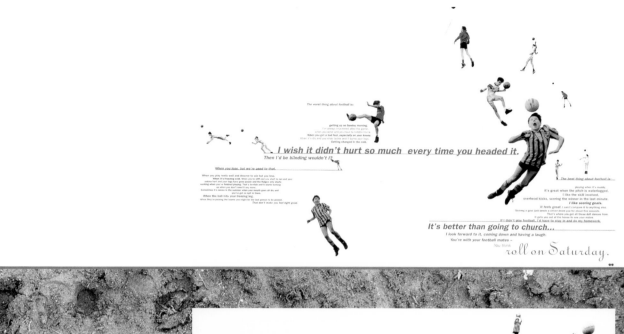
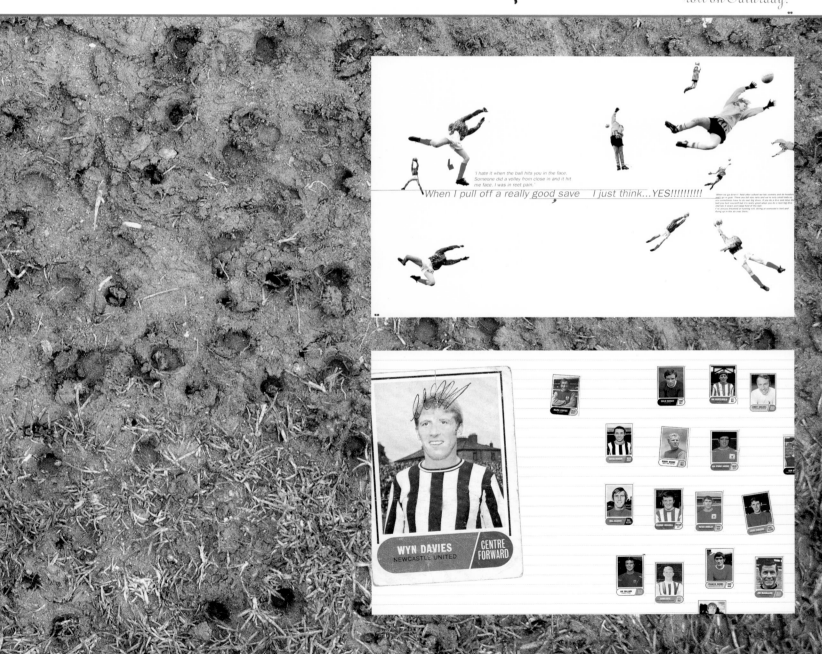

Subbuteo was invented
in 1947 by Peter Adolph
from Tunbridge Wells.

The game is played competitively in over 50
countries, including Nigeria and Paraguay.

Pelé

5th Round FA Cup

27th February 1932

Huddersfield Town 0

Arsenal 1

Record Attendance

67,037

The word Subbuteo is derived from the Latin name for the Hobby Falcon - *Falco Subbuteo Subbuteo* subbuteo SUBBUTEO

## soccer *wonderland*

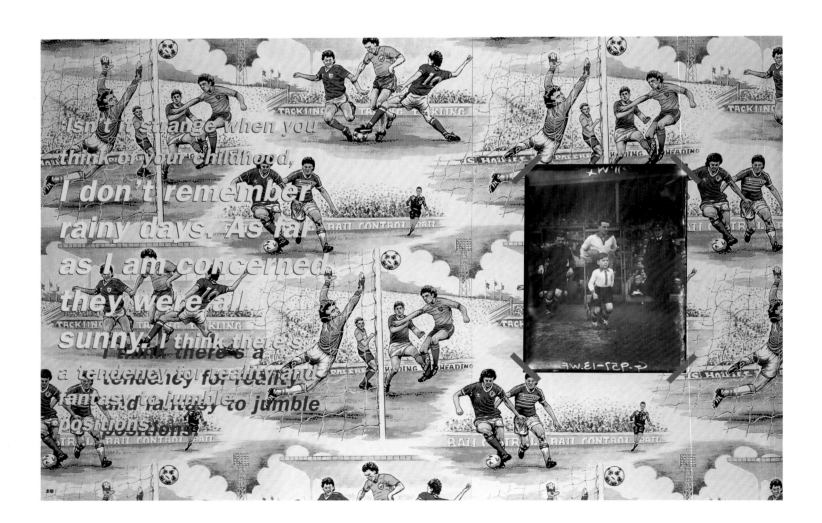

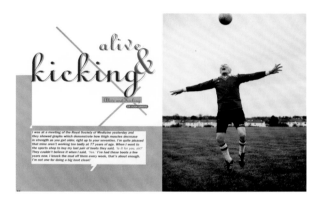

alive &
## kicking

*Alive and kicking*

I was at a meeting of the Royal Society of Medicine yesterday and they showed graphs which demonstrate how thigh muscles decrease in strength as you get older, right up to your seventies. I'm quite pleased that mine aren't working too badly at 77 years of age. When I went to the sports shop to buy my last pair of boots they said, 'Is it for you, sir?' They couldn't believe it when I said, 'Yes.' I've had these boots a few years now. I knock the mud off them every week, that's about enough. I'm not one for doing a big boot clean!

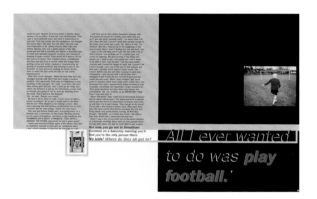

**All I ever wanted to do was play football.'**

# 11
## GEORGIE

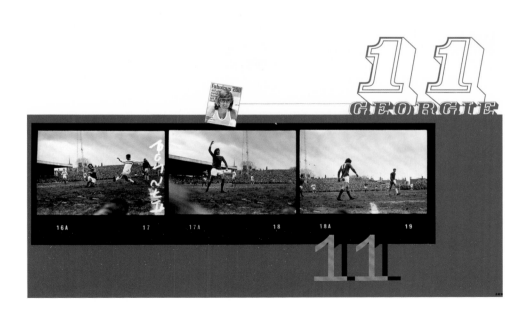

16A   17   17A   18   18A   19

11

## After the Last Sky

A unique collaborative
project that combines
recorded movement in
projection with a
specially commissioned
sound environment

| | |
|---|---|
| choreography | Rosemary Butcher |
| video | David Jackson |
| sound | Simon Fisher Turner |
| dancers | Jonathan Burrows |
| | Gill Clark |
| | Deborah Jones |
| | Russell Maliphant |
| | Finn Walker |

1)

# Aft

Put all the images in language
in a place of safety
and make use of them,
for they are in the desert,
and it's in the desert that
we must go and look for them.

*Jean Genet, Prisoner of Love*

# st

# Sk

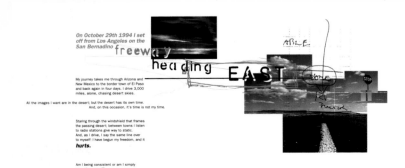

On October 29th 1994 I set
off from Los Angeles on the
San Bernadino **freeway**
**heading EAST**

My journey takes me through Arizona and
New Mexico to the border town of El Paso
and back again in four days. I drive 3,000
miles, alone, chasing desert skies.

All the images I want are in the desert; but the desert has its own time.
And, on this occasion, it's time is not my time.

Staring through the windshield that frames
the passing desert; between towns I listen
to radio stations give way to static.
And, as I drive, I say the same line over
to myself: I have begun my freedom, and it
**hurts.**

Am I being consistent or am I simply
repeating myself?

**after the last sky.** rosemary butcher
invitational booklet for contemporary dance installation
photography: david jackson

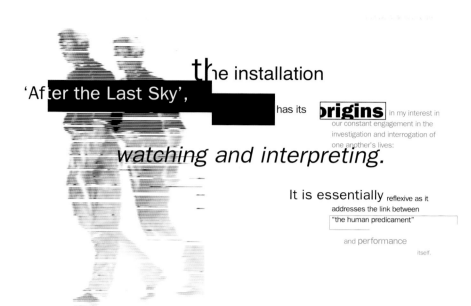

The installation 'After the Last Sky', has its **origins** in my interest in our constant engagement in the investigation and interrogation of one another's lives:

*watching and interpreting.*

It is essentially reflexive as it addresses the link between "the human predicament" and performance itself.

ter

th

text by David Jackson

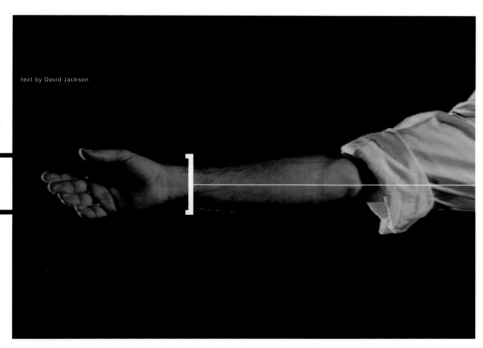

In New York City a friend gives me a snapshot of herself standing next to the Hudson River; on the reverse she wrote:

*spring '93? my freedom picture in battery park. ironically taken by tommy james who was soon to grant me my freedom. in the background is the statue of liberty. fitting isn't it?*

I take this photograph with me to the desert.

In Los Angeles someone calls me (not for lunch) and demands to know why I am back again. For the skies, I say, like the one we saw together. I know that sky is still there, waiting for me.

ky

Late one night in Tularosa, New Mexico, a waitress in a diner sits down with me for coffee and tells me the story of her life. She says it took her two weeks to marry and twenty years to divorce.

Afterwards, she left behind two grown daughters in Wisconsin for the desert thousands of miles away.
At first, she said, she wrote to them often. But as her new life became more and more familiar, she found she had less and less to say. At that time she bought a Sony camcorder and started to record the skies above where she lived. She said that these days, rather than write a letter, she would send the videotapes to her daughters.

That night, I think about what the daughters must make of their mother's tapes: hand-held images of desert dusk skies on a tv in Wisconsin.

after the last sky

VTR plc

**John Banks**
Managing Director

Video Tape Recording
64 Dean Street
London W1V 5HG
tel 071 437 0026
fax 071 439 9427

VTR

**Anthony Frend**
Managing Director

Video Tape Recording
64 Dean Street
London W1V 5HG
tel 071 437 0026
fax 071 439 9427

**vtr.** television post production facility
corporate identity. packaging. stationery. brochure pages

In 1985,

1985

**VTR** was established as a new kind of **VIDEO FACILITIES HOUSE**
– one where TECHNICAL EXCELLENCE would go hand in hand
with friendly, professional client care.

idea

concept

spark

WE WERE A SMALL COMPANY THEN, BUT OUR AMBITIONS WERE BIG:
we invested in the best equipment and recruited the most talented operators in town. Word spread within the industry,
and soon we had built up a broad and loyal client base. And we haven't stopped growing ever since.

growth

**We** are now one of London's TOP
post-production houses, employing more than 80 staff.

We also have two sister companies whose resources complement our own:

**THE MACHINE ROOM**  TAPE-TO-TAPE CONVERSION AND DUPLICATION
**BLUE**  BROADCAST POST-PRODUCTION

Although we've expanded, the **VTR** philosophy remains the same:
we believe that technical wizardry is only part of the picture –
**teamwork is what makes us succeed.**

AXIAL

MATADOR  D.C.P.

**SGI EXTREMES**  URSA GOLD

ALIAS

**HENRY**

**PARALLAX ADVANCE**

IMAGE 3D

With a broad range of the best equipment there is – including Henrys, Ursa Gold
telecines, Axial edit suites, Parallax Advance, Alias and Softimage 3D–we can find
the solution for even the most demanding project, whether it's multi-layering,
morphing or any other special effect. But although we're at the forefront of
technological innovation, we put the emphasis firmly on user-friendliness:
**we want to dazzle you with the results,
not blind you with science.**

equipment

**We** want every job to be as

worry-free

AS POSSIBLE, FROM **concept** meeting
right through to completion.

THAT'S WHERE THE

**VTR PRODUCTION TEAM**

production

COMES IN: they are there to provide clients with
PROFESSIONAL ADVICE and friendly support from start
to finish, and to keep a close eye on bookings and costs.

WE ALSO HAVE A TRAINED ENGINEERING DEPARTMENT ON HAND AT
ALL TIMES TO ENSURE THE smooth RUNNING OF OUR EQUIPMENT.

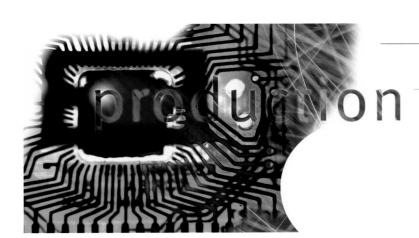

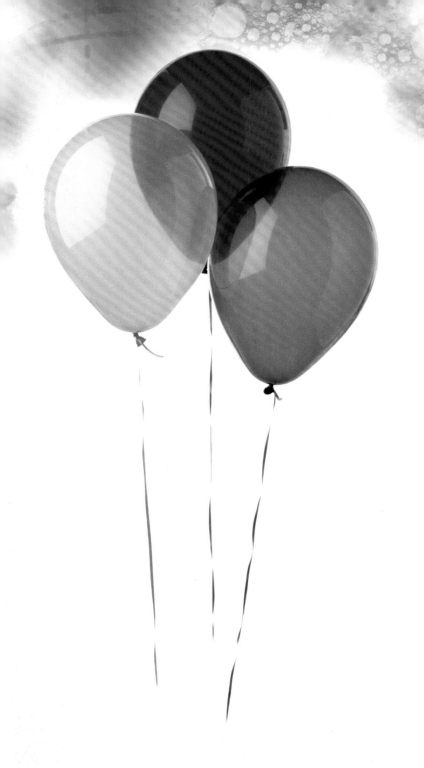

blue

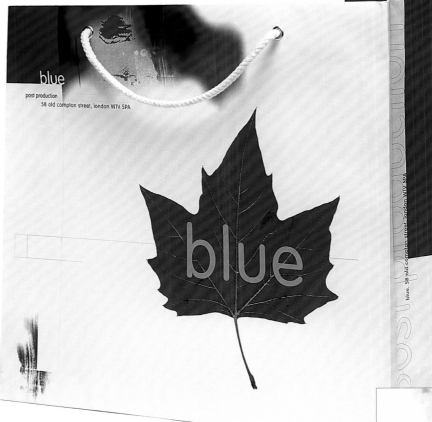

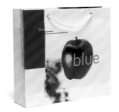

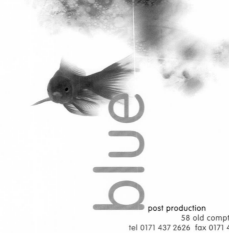

this and previous spread: **blue.** television post production edit facility
corporate identity. advertising. packaging. stationery
photography: rocco redondo. photodisc. ace photo agency

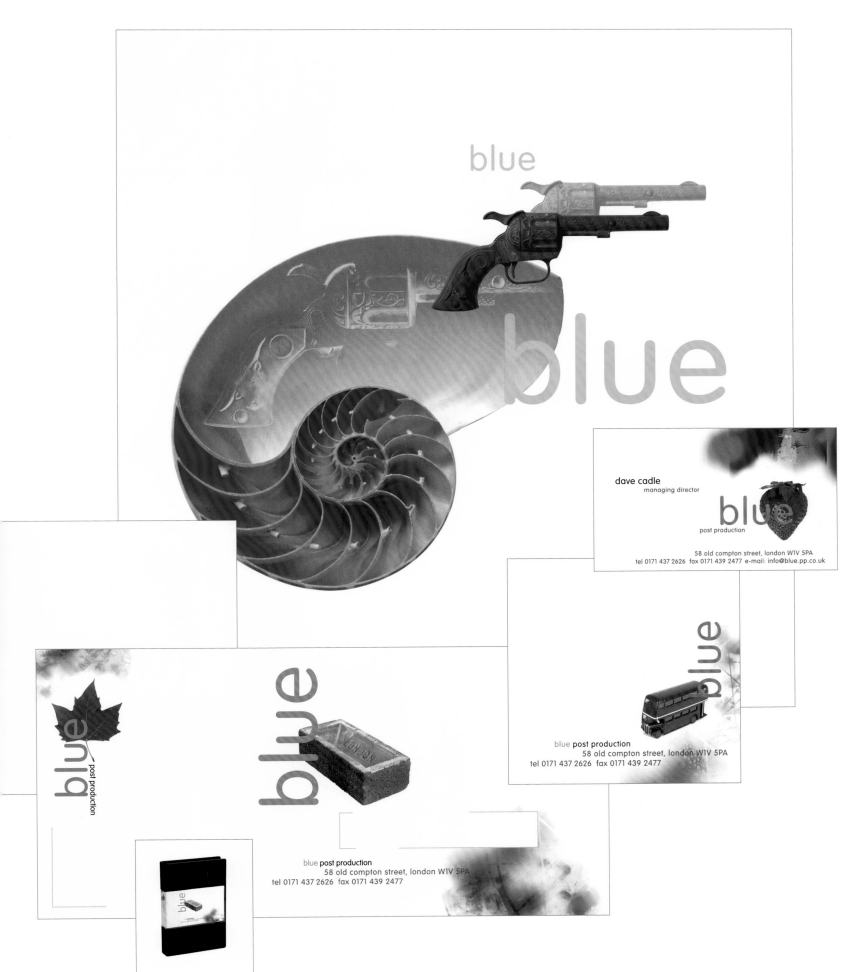

blue

blue

dave cadle
managing director

blue
post production

58 old compton street, london W1V 5PA
tel 0171 437 2626  fax 0171 439 2477  e-mail: info@blue.pp.co.uk

blue

blue post production
58 old compton street, london W1V 5PA
tel 0171 437 2626  fax 0171 439 2477

blue
post production

blue

blue post production
58 old compton street, london W1V 5PA
tel 0171 437 2626  fax 0171 439 2477

1995–1996

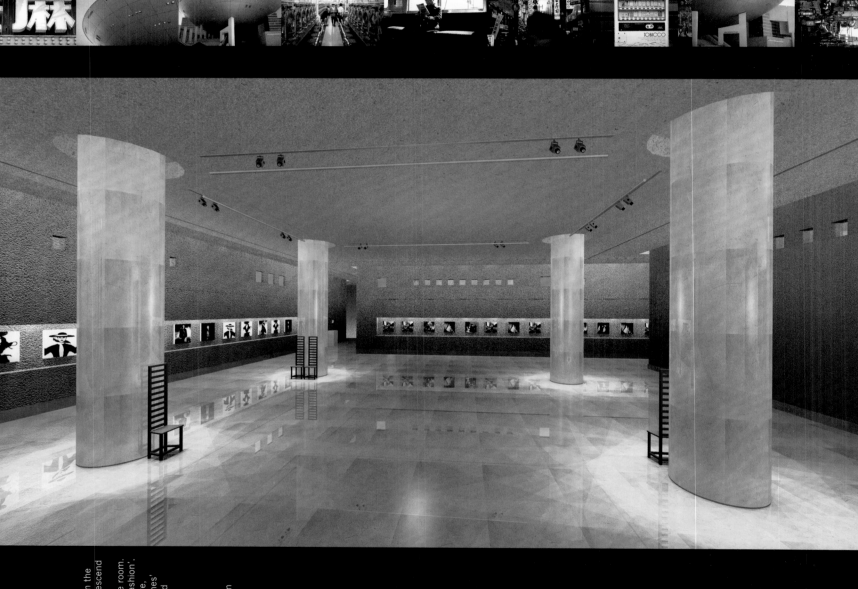

**synapse.** kobe fashion museum, japan
audiovisual installation that takes place hourly in the
museum's central square. lights dim, screens descend
and 24 hidden projectors, cast 1500 individual
compositions onto the four walls and floor of the room.
the ten minute display explores the theme of 'fashion'.
layered imagery depicting nature, shelter, culture,
communication, technology and materials, 'clothes'
the human figure, illustrating what produces and
affects our notion of fashion.

previous two spreads: initial presentations

installation area before 'synapse' commences

opposite and following three spreads: installation
and storyboard illustrating the six categories

audiovisual programming: simple
music: the orb
photography: rocco redondo. photodisc.
richard wolf. hulton deutch

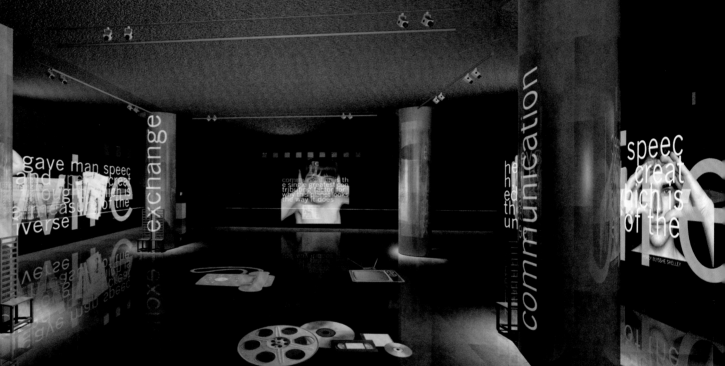

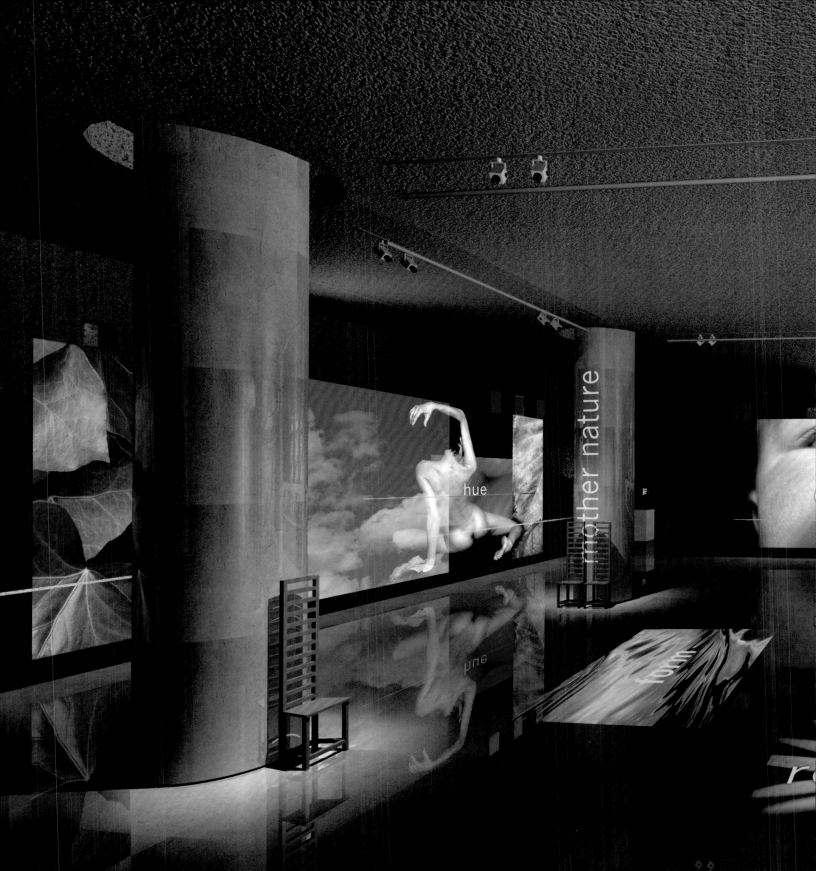

mother nature

generate

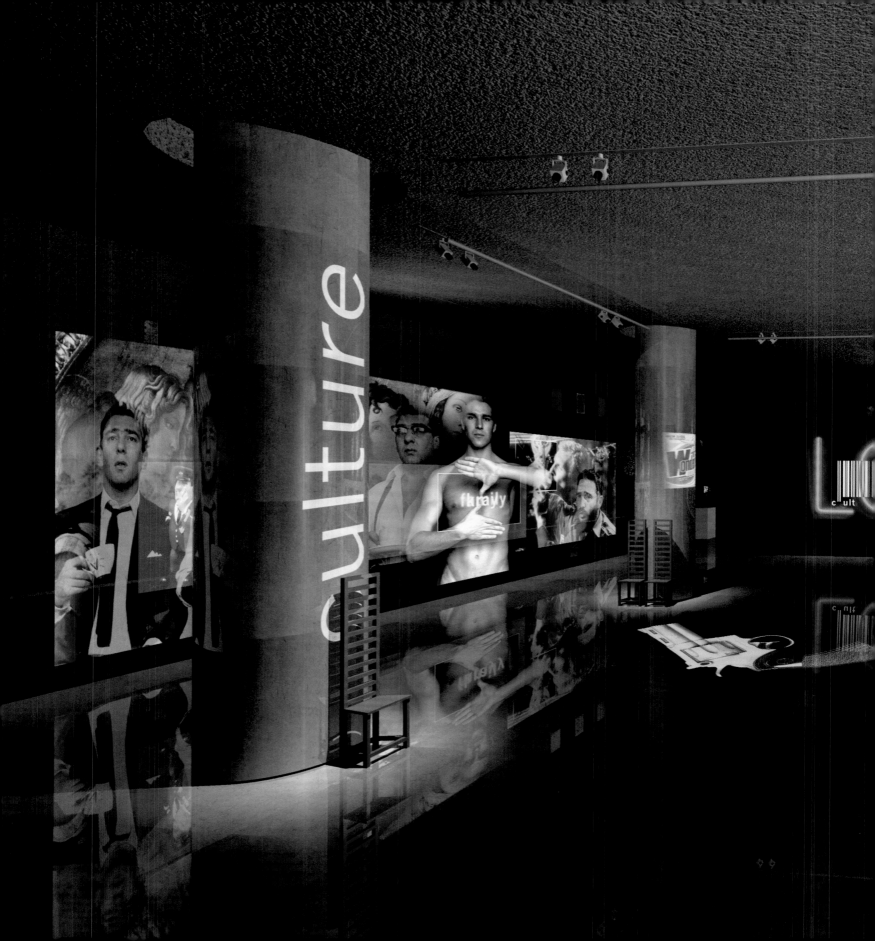

culture

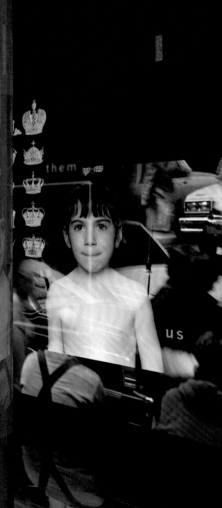

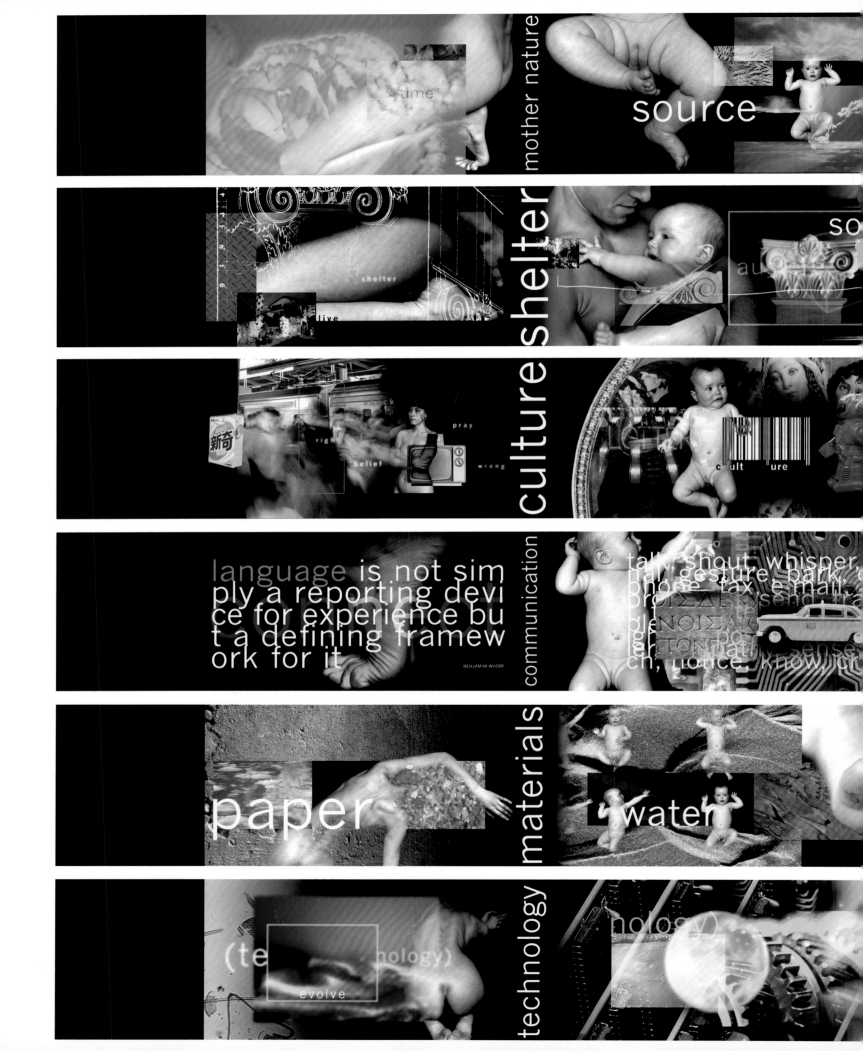

source

mother nature

shelter

au...

culture

pray

belief    wrong

c...ult    ure

language is not sim ply a reporting devi ce for experience bu t a defining framew ork for it

BENJAMIN WHORF

communication

tally shout whisper gesture bark phone fax e-mail send notice know

materials

paper    water

technology

nology)

(te...nology)

evolve

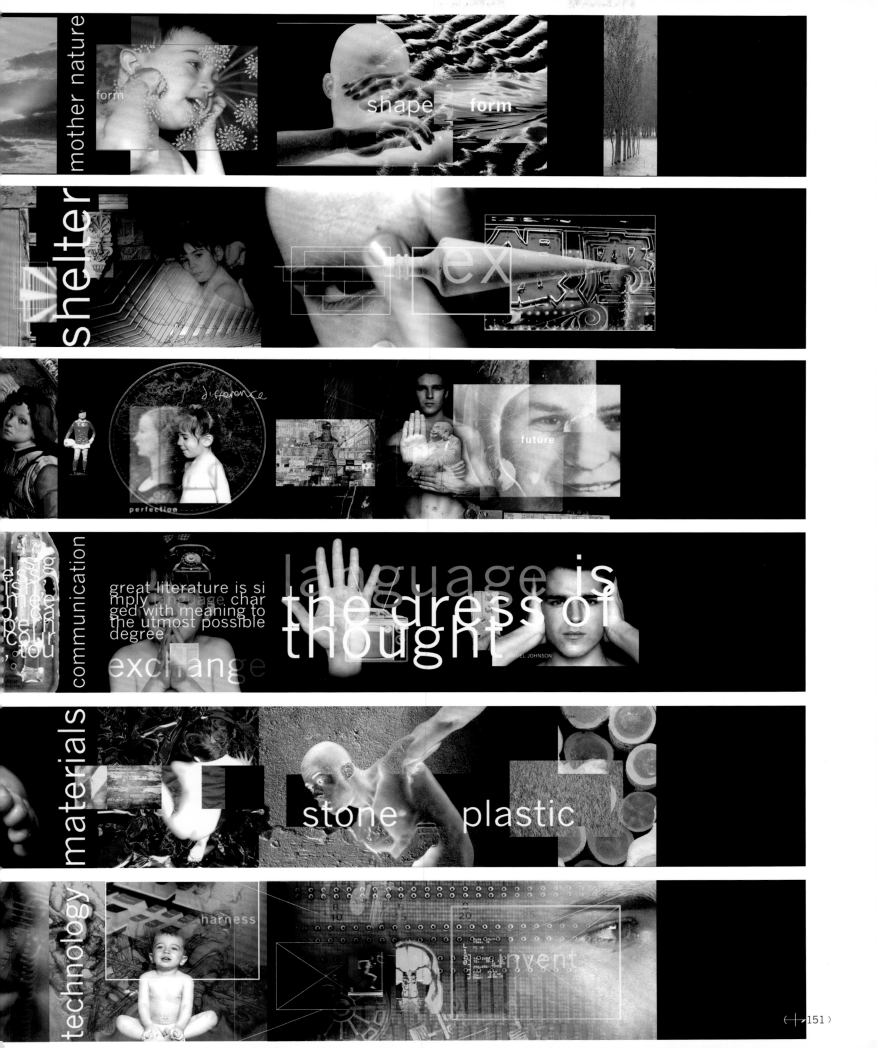

mother nature

form

shape — form

shelter

ex

difference

perfection

future

communication

great literature is simply language charged with meaning to the utmost possible degree

language is the dress of thought

SAMUEL JOHNSON

exchange

materials

stone     plastic

technology

harness

invent

"offside!"

**european football championship 96**
royal mail commemorative book of stamps. first day cover
photography: rocco redondo. popperfoto. coloursport. hulton deutsch. EFE Madrid
comics © fleetway editions ltd

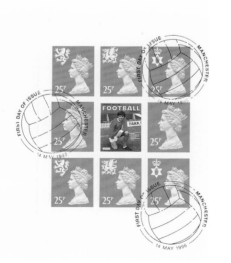

The USSR's famous goalkeeper Lev Yashin was the competition's first key player, keeping a clean sheet in the semi, beaten only by his captain Igor Netto's deflection in the final. The talented Yugoslavs, who won the Olympic title later in the year, were worn down by the more physical Soviets, epitomised by the hefty centre-forward and match-winner Viktor Ponedelnik.

*Arthur Ellis*

## France <sup>19</sup>60

**champions: Soviet Union**

- In 1960, Milan Galic scored in ten consecutive internationals, including this final, equalling a world record that still stands.
- Yugoslavia, 4-2 down in their semi-final against the hosts France, scored three goals in three minutes to win 5-4.
- The very first match in the competition was played in Dublin, the Republic of Ireland beating Czechoslovakia 2-0 before losing 2-4 on aggregate.

*Lev Yashin*

| European Nations' Cup Final |
| --- |
| 10 July 1960 Parc des Princes, Paris |
| Attendance: 18,000 |
| Referee: Arthur Ellis (England) |
| USSR 2 Yugoslavia 1 |
| Metreveli 49 Galic 41 |
| Ponedelnik 113 (after extra time) |

**Best of the British:** None entered. But an Englishman refereed the final.

The biggest crowd in the competition's history, who sat through a grim encounter between the hosts and the very defensive holders, were eventually rewarded with a goal good enough to win any match: Marcelino Martinez' brilliant diving header past Yashin. Spain, though, were unconvincing champions, needing extra-time to win their semi-final; losing 6-2 at home to Scotland the previous year.

## Spain <sup>19</sup>64

**champions: Spain**

| European Nations' Cup Final |
| --- |
| 21 June 1964 Estadio Bernabéu, Madrid |
| Attendance: 120,000 |
| Referee: Arthur Holland (England) |
| Spain 2 USSR 1 |
| Pereda 6 Khusainov 8 |
| Marcelino 84 |

- Arthur Holland also refereed the 1964 FA Cup Final.
- Between the qualifying matches against Holland in 1964 and Malta in 1995, Luxembourg didn't win a single away match!
- Deigning to enter this time, England went out in the first round, 5-2 to France in Alf Ramsey's first match as manager.

**Best of the British:** NORTHERN IRELAND, who lost by only a single goal to the eventual champions after drawing 1-1 in Bilbao.

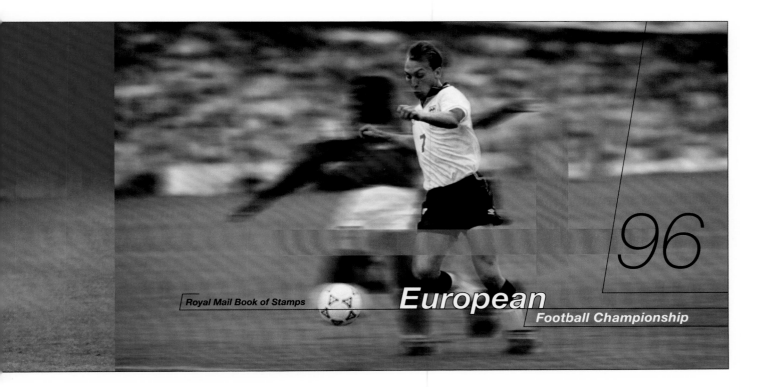

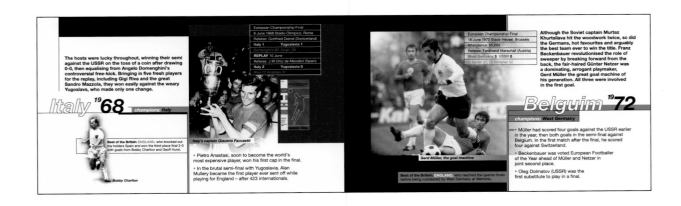

Royal Mail Book of Stamps

## European
### Football Championship

/96

The hosts were lucky throughout, winning their semi against the USSR on the toss of a coin after drawing 0-0, then equalising from Angelo Domenghini's controversial free-kick. Bringing in five fresh players for the replay, including Gigi Riva and the great Sandro Mazzola, they won easily against the weary Yugoslavs, who made only one change.

## Italy <sup>19</sup>68

**champions: Italy**

| European Championship Final |
| --- |
| 8 June 1968 Stadio Olimpico, Rome |
| Referee: Gottfried Dienst (Switzerland) |
| Italy 1 Yugoslavia 1 |
| Domenghini 80 Dzajic 39 |
| **REPLAY** 10 June |
| Referee: J M Ortiz de Mendibil (Spain) |
| Italy 2 Yugoslavia 0 |
| Riva 12 Anastasi 31 |

*Italy's captain Giacinto Facchetti*

**Best of the British:** ENGLAND, who knocked out the holders Spain and won the third-place match 2-0 with goals from Bobby Charlton and Geoff Hurst.

*Bobby Charlton*

- Pietro Anastasi, soon to become the world's most expensive player, won his first cap in the final.
- In the brutal semi-final with Yugoslavia, Alan Mullery became the first player ever sent off while playing for England – after 423 internationals.

Although the Soviet captain Murtaz Khurtsilava hit the woodwork twice, so did the Germans, hot favourites and arguably the best team ever to win the title. Franz Beckenbauer revolutionised the role of sweeper by breaking forward from the back, the fair-haired Günter Netzer was a dominating, arrogant playmaker, Gerd Müller the great goal machine of his generation. All three were involved in the first goal.

## Belguim <sup>19</sup>72

**champions: West Germany**

| European Championship Final |
| --- |
| 18 June 1972 Stade Heysel, Brussels |
| Attendance: 65,000 |
| Referee: Ferdinand Marschall (Austria) |
| West Germany 3 USSR 0 |
| Müller 27, 58 Wimmer 52 |

*Gerd Müller, the goal machine*

**Best of the British:** ENGLAND, who reached the quarter-finals before being outclassed by West Germany at Wembley.

- Müller had scored four goals against the USSR earlier in the year, then both goals in the semi-final against Belgium. In the first match after the final, he scored four against Switzerland.
- Beckenbauer was voted European Footballer of the Year ahead of Müller and Netzer in joint second place.
- Oleg Dolmatov (USSR) was the first substitute to play in a final.

SOHO 601

SOHO 601  71 DEAN STREET  LONDON  W1V 5HB
TEL +44 171 439 2730  FAX +44 171 734 3331  WEB www.sohogroup.com

[ HENRY ELLIS  MANAGING DIRECTOR ]

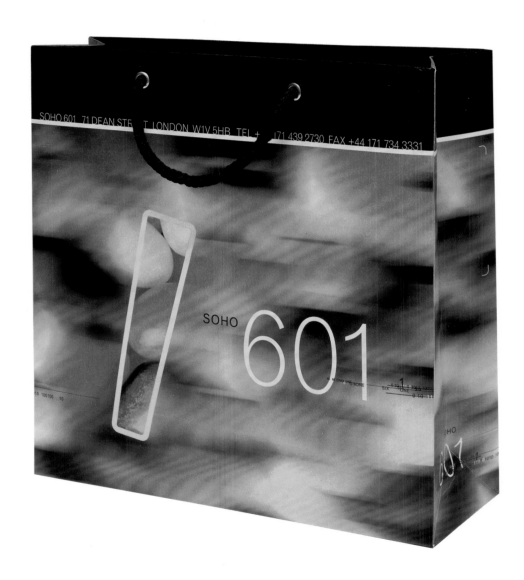

**soho 601.** television post production facility
photography: photodisc
previous spread: business card

corporate identity. carrier bag
ratecard covers

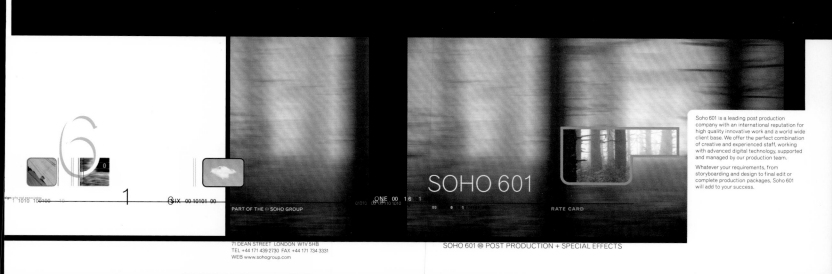

# SOHO 601

Soho 601 is a leading post production company with an international reputation for high quality innovative work and a world wide client base. We offer the perfect combination of creative and experienced staff, working with advanced digital technology, supported and managed by our production team.

Whatever your requirements, from storyboarding and design to final edit or complete production packages, Soho 601 will add to your success.

RATE CARD

PART OF THE ⊕ SOHO GROUP

71 DEAN STREET LONDON W1V 5HB
TEL +44 171 439 2730 FAX +44 171 734 3331
WEB www.sohogroup.com

SOHO 601 ⊕ POST PRODUCTION + SPECIAL EFFECTS

# SOHO 601

Soho 601 is a leading post production company with an international reputation for high quality innovative work and a world wide client base. We offer the perfect combination of creative and experienced staff, working with advanced digital technology, supported and managed by our production team.

Whatever your requirements, from storyboarding and design to final edit or complete production packages, Soho 601 will add to your success.

RATE CARD

PART OF THE ⊕ SOHO GROUP

71 DEAN STREET LONDON W1V 5HB
TEL +44 171 439 2730 FAX +44 171 734 3331
WEB www.sohogroup.com

SOHO 601 POST PRODUCTION + SPECIAL EFFECTS FACILITY

SOHO
601

SHOWREEL

SOHO 6 0 1

SHOWREEL
UMATIC

SOHO 601  71 DEAN STREET  LONDON  W1V 5HB  TEL +44 171 439 2730  FAX +44 171 734 3331

SOHO
601

SOHO 6 0 1

BETA SP

SOHO 601  71 DEAN STREET  LONDON  W1V 5HB  TEL +44 171 439 2730  FAX +44 171 734 3331

SOHO 601  71 DEAN STREET  LONDON  W1V 5HB
TEL +44 171 439 2730  FAX +44 171 734 3331

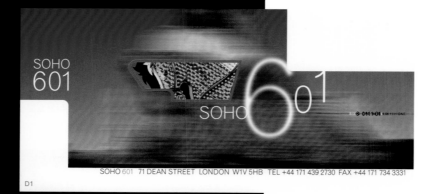

SOHO
601

SOHO 6 01

D1

SOHO 601  71 DEAN STREET  LONDON  W1V 5HB  TEL +44 171 439 2730  FAX +44 171 734 3331

various labels
carrier bag

SOHO 601

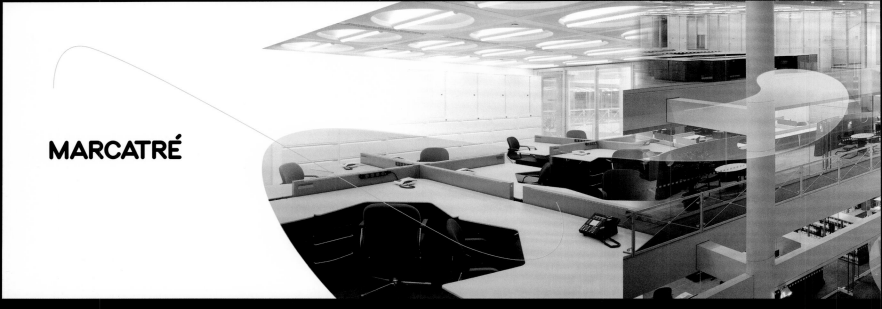

# MARCATRÉ

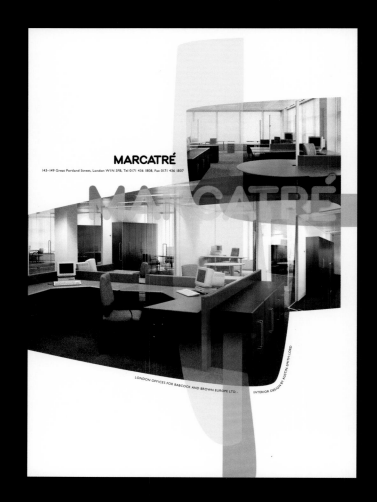

**marcatré.** office furniture
brochure. magazine adverts
photography: chris gascoigne. nicholas kane

( 160 → 161 )

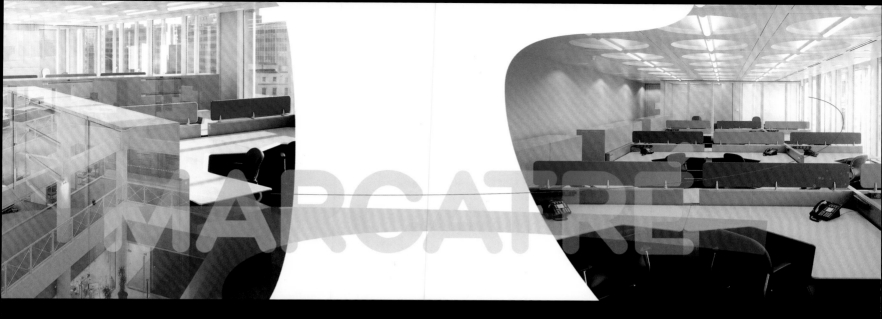

LONDON OFFICES FOR THE DMB&B COMMUNICATIONS GROUP    INTERIOR DESIGN BY MARSHALL CUMMINGS HARSH LTD

# MARCATRÉ

143–149 Great Portland Street, London W1N 5FB,
Tel 0171 436 1808, Fax 0171 436 1807

**Type** the medium and the message

# UPPER and lower case

The International Journal of Graphic Design and Digital Media
Published by International Typeface Corporation

Volume 23, Number 1, Summer 1996

For a free issue of U&lc please write to U&lc,
866 2nd Ave, New York, NY 10017, USA
or fax to U&lc at 212 752 4752.

**upper and lower case.** magazine design. usa
photography: rocco redondo. photodisc. david potter. christine cody.
elga wimmer gallery new york. matthew marks gallery new york.
cristinerose gallery new york. sperone westwater new york

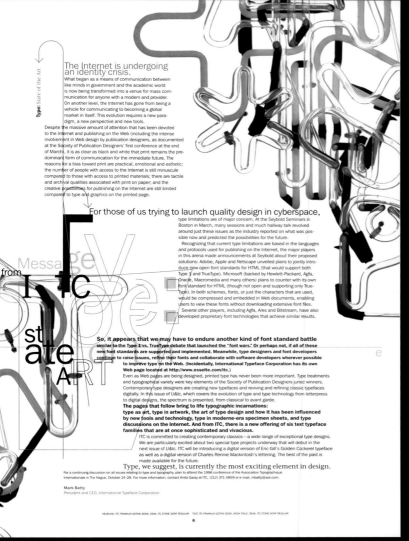

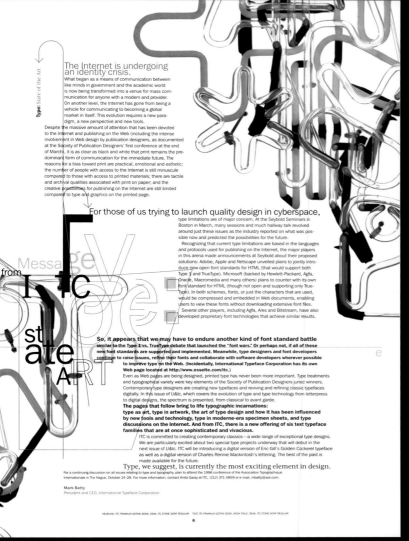

**Type: State of the Art**

## The Internet is undergoing an identity crisis.

What began as a means of communication between like minds in government and the academic world is now being transformed into a venue for mass communication for anyone with a modem and provider. On another level, the Internet has gone from being a vehicle for communicating to becoming a global market in itself. This evolution requires a new paradigm, a new perspective and new tools.

Despite the massive amount of attention that has been devoted to the Internet and publishing on the Web (including the intense involvement in Web design by publication designers, as documented at the Society of Publication Designers' first conference in the end of March), it is as clear as black and white that print remains the predominant form of communication for the immediate future. The reasons for a bias toward print are practical, emotional and esthetic: the number of people with access to the Internet is still minuscule compared to those with access to printed materials; there are tactile and archival qualities associated with print on paper; and the creative possibilities for publishing on the Internet are still limited compared to type and graphics on the printed page.

### For those of us trying to launch quality design in cyberspace,

type limitations are of major concern. At the Seybold Seminars in Boston in March, many sessions and much hallway talk revolved around just these issues as the industry reported on what was possible now and predicted the possibilities for the future.

Recognizing that current type limitations are based in the languages and protocols used for publishing on the Internet, the major players in this arena made announcements at Seybold about their proposed solutions: Adobe, Apple and Netscape unveiled plans to jointly introduce new open font standards for HTML (that would support both Type 1 and TrueType). Microsoft (backed by Hewlett-Packard, Agfa, Oracle, Macromedia and many others) plans to counter with its own font standard for HTML (though not open and supporting only True-Type). In both schemes, fonts, or just the characters that are used, would be compressed and embedded in Web documents, enabling users to view these fonts without downloading extensive font files.

Several other players, including Agfa, Ares and Bitstream, have also developed proprietary font technologies that achieve similar results.

**So, it appears that we may have to endure another kind of font standard battle similar to the Type 1 vs. TrueType debate that launched the "font wars." Or perhaps not, if all of these new font standards are supported and implemented. Meanwhile, type designers and font developers continue to raise issues, refine their fonts and collaborate with software developers wherever possible to improve type on the Web. (Incidentally, International Typeface Corporation has its own Web page located at http://www.esselte.com/itc.)**

Even as Web pages are being designed, printed type has never been more important. Type treatments and typographical variety were key elements of the Society of Publication Designers juried winners. Contemporary type designers are creating new typefaces and reviving and refining classic typefaces digitally. In this issue of *U&lc*, which covers the evolution of type and type technology from letterpress to digital designs, the spectrum is presented, from classical to avant garde.

**The pages that follow bring to life typographic incarnations: type as art, type in artwork, the art of type design and how it has been influenced by new tools and technology, type in moderne-era specimen sheets, and type discussions on the Internet. And from ITC, there is a new offering of six text typeface families that are at once sophisticated and vivacious.**

ITC is committed to creating contemporary classics—a wide range of exceptional type designs. We are particularly excited about two special type projects underway that will debut in the next issue of *U&lc*. ITC will be introducing a digital version of Eric Gill's Golden Cockerel typeface as well as a digital version of Charles Rennie Mackintosh's lettering. The best of the past is made available for the future.

### Type, we suggest, is currently the most exciting element in design.

For a continuing discussion on all issues relating to type and typography, plan to attend the 1996 conference of the Association Typographique Internationale in The Hague, October 24-28. For more information, contact Anita Garay at ITC, (212) 371-0699 or e-mail, mbatty@aol.com.

**Mark Batty**
President and CEO, International Typeface Corporation

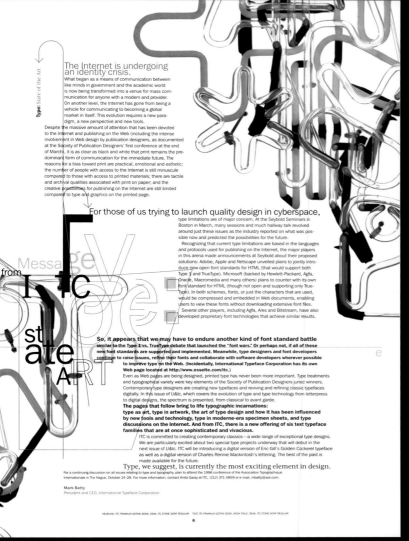
Type state of the art

Message from ITC

HEADLINE: ITC FRANKLIN GOTHIC BOOK, DEMI, ITC STONE SERIF REGULAR   TEXT: ITC FRANKLIN GOTHIC BOOK, BOOK ITALIC, DEMI, ITC STONE SERIF REGULAR

6

---

## A Century of Type

### A Little Revolution Now and Then

By Sebastian Carter

---

## French Resistance

by Peter Hall

Students at the Atelier National de Création Typographique in Paris are infiltrating this revered institution with experimental projects that challenge legibility and conservatism.

# FIVE NEW EXHIBITS FROM ITC

Presenting a collection
of text typefaces worthy
of framing

Charlotte, Charlotte Sans, Elysium, Gilgamesh and Figural are text
families that are refined, readable and highly versatile. Designers and
typographers can achieve a wide variety of typographic color simply
by varying the weights within each typeface family.

All of these text families include a book style, italic, medium, bold
and small capitals. Additionally, each type family is enhanced with an
extensive collection of alternate characters such as oldstyle numerals,
symbols, ligatures, diphthongs, special characters and upper- and
lowercase accented characters.

Also included is the Character Chooser, a utility that enables
Macintosh type users to view and select special characters such as lig-
atures, swashes, symbols and alternate characters. These typefaces
are now available through ITC in both PostScript Type 1 and TrueType
formats for the Macintosh and PC.

British type designers Michael Gills and Colin Brignall are the
creative team behind this collection. Originally developed by Letraset,
these five text families are now being marketed and distributed by
ITC and are making their debut in the ITC Library in this issue of *U&lc*.

Michael Gills developed an interest in calligraphy and lettering
while working as an apprentice engineer in the 1980s. He subsequently
studied printing and design at Suffolk College in England. Gills began
working at Letraset as a trainee type designer in 1988 and over the next
seven years, he designed a range of display faces. Among his early works were
Aachen Bold, Revue, Harlow, Premier Shaded and Superstar, and
later when he entered the demanding arena of designing typefaces
for both text and display, he created the equally successful Italia,
Romic, Corinthian and Edwardian families.

In 1995, Gills joined the Folio Society, a London book publisher
specialising in fine printing, where he works as a typographer and
graphic designer creating publicity, support materials and the occa-
sional book jacket.

Colin Brignall's career began in photography. He trained as a press
photographer in London's Fleet Street before moving on to com-
mercial and fashion photography. In 1964, he joined Letraset as
a photographic technician in the company's type design studio.
Before long, a keen interest in letterforms surfaced and despite
his lack of formal typographic training, he showed promise in the
design and artwork of display faces. Among his early works were
Aachen Bold, Revue, Harlow, Premier Shaded and Superstar, and
later when he entered the demanding arena of designing typefaces
for both text and display, he created the equally successful Italia,
Romic, Corinthian and Edwardian families.

In 1984, he was appointed type director responsible for the
sourcing, art direction and selection of new Letraset typeface
releases. He was also responsible for many award-winning lettering
and logotype designs.

Currently working as ITC's new font scout, Brignall is charged
with discovering new type design talent and cultivating an ongoing
source of new typefaces from established designers. Brignall's
refined contemporary aesthetics combined with his strong historical
perspective come through in his direction of the Figural type family.

## Charlotte Sans™

The Charlotte Sans family of typefaces was
designed specifically to coordinate with Charlotte
roman typefaces in style, weight and color.
**Michael Gills created Charlotte
Sans onscreen, and has achieved
a perfect balance between the
humanistic qualities of Gill Sans
and the evenness of color in the
Frutiger series.** HIGHLY VERSATILE
ON ITS OWN, AND COMPATIBLE WITH ITS ROMAN
COUNTERPART, THE CHARLOTTE SANS FAMILY
OFFERS A SPECTRUM OF CHOICES FOR *creative
typographic expression.*

portrait

Charlotte Sans Sans Caps
ABCDEFGHIJKLMNOPQRSTUVWXYZ
&fifl@*#%$¢£¥ÇØÆŒ(["!?~`.,:;)[†‡§«»]

Charlotte Sans Medium
ABCDEFGHIJKLMNOPQRSTUVWXYZ abcdefghijklmnopqrstuvwxyz
&fifl@*#%$¢£¥ÇØÆŒß(["!?~`.,:;)[†‡§«»] 0123456789

Charlotte Sans Bold
**ABCDEFGHIJKLMNOPQRSTUVWXYZ abcdefghijklmnopqrstuvwxyz
&fifl@*#%$¢£¥ÇØÆŒß(["!?~`.,:;)[†‡§«»] 0123456789**

Charlotte Sans Book
ABCDEFGHIJKLMNOPQRSTUVWXYZ abcdefghijklmnopqrstuvwxyz
&fifl@*#%$¢£¥ÇØÆŒß(["!?~`.,:;)[†‡§«»] 0123456789

Charlotte Sans Book Italic
*ABCDEFGHIJKLMNOPQRSTUVWXYZ abcdefghijklmnopqrstuvwxyz
&fifl@*#%$¢£¥ÇØÆŒß(["!?~`.,:;)[†‡§«»] 0123456789*

44

## GILGAMESH™

FUNCTIONALITY WITH STYLE IS THE KEYNOTE OF GILGAMESH,
*the latest typeface family from the hand of Michael Gills.*
Based largely on Gills' calligraphic experiments,
Gilgamesh offers designers slightly narrower than normal
letterforms for economy of space, a top-left, bottom-
right serif formation on the lowercase for close letterspacing
in larger point sizes and a crisp, angular italic that will give
emphasis to typographic designs.

The face was named after a poem from Middle
Eastern mythology, **"The Epic of Gilgamesh."**

a**B**stract

book | ab

Gilgamesh Book
ABCDEFGHIJKLMNOPQRSTUVWXYZ
1234567890&fifl@*#%$¢£¥ÇØÆŒ(["!?~`.,:;)[†‡§«»]

Gilgamesh Book Italic
*ABCDEFGHIJKLMNOPQRSTUVWXYZ
1234567890&fifl@*#%$¢£¥ÇØÆŒ(["!?~`.,:;)[†‡§«»]*

Gilgamesh Medium
ABCDEFGHIJKLMNOPQRSTUVWXYZ abcdefghijklmnopqrstuvwxyz
1234567890&fifl@*#%$¢£¥ÇØÆŒ(["!?~`.,:;)[†‡§«»]

Gilgamesh Bold
**ABCDEFGHIJKLMNOPQRSTUVWXYZ abcdefghijklmnopqrstuvwxyz
1234567890&fifl@*#%$¢£¥ÇØÆŒß(["!?~`.,:;)[†‡§«»]**

## FIGURAL™

**Michael Gills developed this text family
under the direction of Colin Brignall**
(who was, at the time, director of
Type Development at Letraset).
*FIGURAL IS BASED ON THE ORIGINAL
1940 DESIGN BY OLDRICH MENHART.
With Brignall's guidance, the face took
on a modern look without sacrificing
any of the calligraphic flair.*
Whether used in short pieces of advertising
text or in longer text settings for magazines
or books, Figural remains *highly legible.*
A choice of three weights, a delightful
angular italic and a set of small capitals
of classical roman proportions are available.

fake

Figural Book
ABCDEFGHIJKLMNOPQRSTUVWXYZ abcdefghijklmnopqrstuvwxyz
1234567890&@*#%$¢£¥ÇØÆŒß("!?~`.,:;)[†‡§«»]

Figural Book Italic
*ABCDEFGHIJKLMNOPQRSTUVWXYZ abcdefghijklmnopqrstuvwxyz
1234567890&@*#%$¢£¥ÇØÆŒß("!?~`.,:;)[†‡§«»]*

Figural Small Caps
ABCDEFGHIJKLMNOPQRSTUVWXYZ ABCDEFGHIJKLMNOPQRSTUVWXYZ
1234567890&@*#%$¢£¥ÇØÆŒß("!?~`.,:;)[†‡§«»]

Figural Medium
ABCDEFGHIJKLMNOPQRSTUVWXYZ abcdefghijklmnopqrstuvwxyz
1234567890&fifl@*#%$¢£¥ÇØÆŒß("!?~`.,:;)[†‡§«»]

Figural Bold
**ABCDEFGHIJKLMNOPQRSTUVWXYZ abcdefghijklmnopqrstuvwxyz
1234567890&fifl@*#%$¢£¥ÇØÆŒß("!?~`.,:;)[†‡§«»]**

49

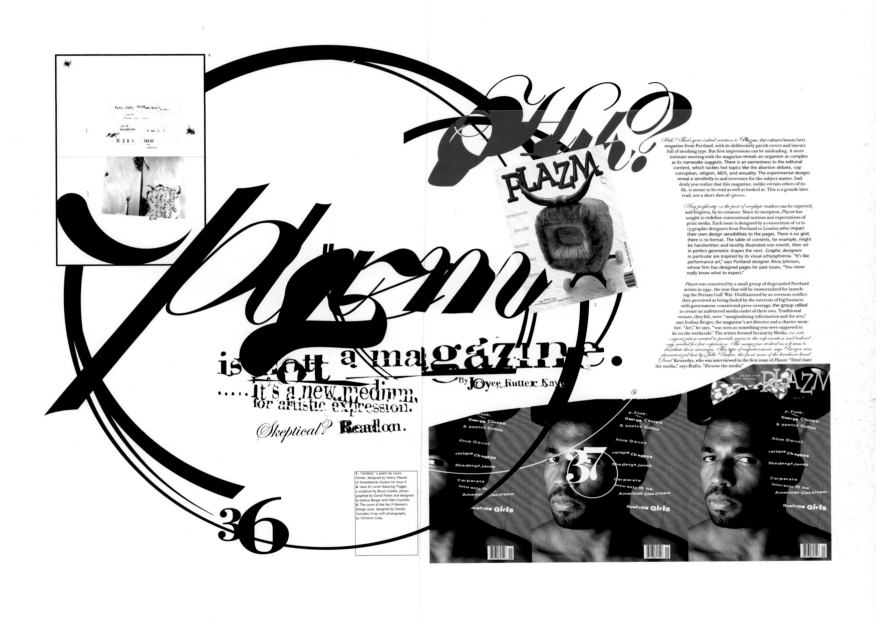

# Plazm *is not a magazine.* .....It's a new medium for artistic expression. *Skeptical?* **Read on.**

By Joyce Rutter Kaye

*Huh? That's your initial reaction to* Plazm, the culture/music/arts magazine from Portland, with its deliberately garish covers and layouts full of moshing type. But first impressions can be misleading. A more intimate meeting with the magazine reveals an organism as complex as its namesake suggests. There is an earnestness to the editorial content, which tackles hot topics like the abortion debate, cop corruption, religion, AIDS, and sexuality. The experimental designs reveal a sensitivity to and reverence for the subject matter. Suddenly you realize that this magazine, unlike certain others of its ilk, is meant to be read as well as looked at. This is a grande latte read, not a short shot of *espresso*.

*Any perplexity on the part of neophyte* readers can be expected, and forgiven, by its creators. Since its inception, *Plazm* has sought to redefine conventional notions and expectations of print media. Each issue is designed by a consortium of 12 to 15 graphic designers from Portland to London who impart their own design sensibilities to the pages. There is no grid; there is no format. The table of contents, for example, might be handwritten and lavishly illustrated one month, then set in perfect geometric shapes the next. Graphic designers in particular are inspired by its visual schizophrenia. "It's like performance art," says Portland designer Alicia Johnson, whose firm has designed pages for past issues. "You never really know what to expect."

*Plazm* was conceived by a small group of disgruntled Portland artists in 1991, the year that will be immortalized for launching the Persian Gulf War. Disillusioned by an overseas conflict they perceived as being fueled by the interests of big business with government-constricted press coverage, the group rallied to create an unfettered media outlet of their own. Traditional venues, they felt, were "marginalizing information and the arts," says Joshua Berger, the magazine's art director and a charter member. "Art," he says, "was seen as something you were supposed to do on the weekends." The artists formed Invararity Media, *an arts organization created to provide access to the information and technology needed for free expression. The magazine evolved as a forum to illustrate these messages. This type of empowerment, says Berger, was characterized best by Jello Biafra, the front man of the hardcore band Dead* Kennedys, who was interviewed in the first issue of *Plazm*: "Don't hate the media," says Biafra. "*Become the media.*"

**1.** "Untitled," a poem by Laura Winter, designed by Nancy Mazzei of Smokebomb Studios for Issue 9. **2.** Issue 6's cover featuring Trigger, a sculpture by Bruce Conkle, photographed by David Potter and designed by Joshua Berger and Niko Courtelis. **3.** The cover of the No. 9 Women's Design issue, designed by Denise Gonzales Crisp with photography by Christine Cody.

36

37

# Barking type!
## specimen sheets of the moderne era

In the context of America and Europe's economic boom,

by Steven Heller

American Type is the Product of American Craftsmen Who Take Great Pride in Doing Their Work WELL!

TYPE
type
TYPE
type
TYPE
type

## ARTS & LET-TERS
Karen S. Chambers

This use of the formal qualities of the letterform

The Brazilian-born Randolfo Rocha

furniture, minimalist sculpture, funerary monuments or garbage cans—

whatever enhances Dwyer's meaning.

For the Italian artist
Alighiero e Boetti,

grounded in computer technology and uses an alphabet of found letterforms on

Dwyer matches form and content
and content wins.

20

22

23

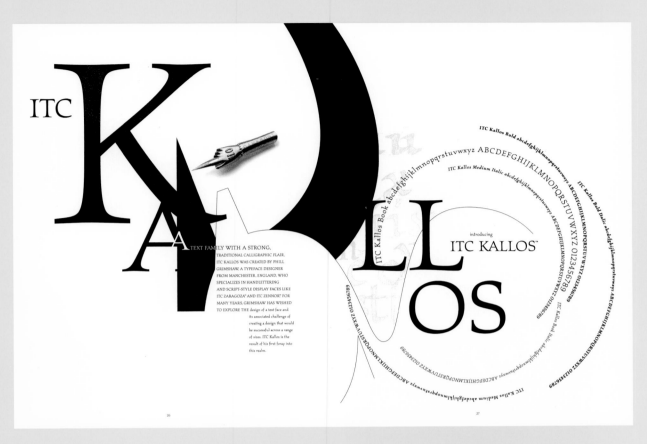

ITC **K**ALLOS

introducing
ITC KALLOS™

ITC Kallos Bold abcdefghijklmnopqrstuvwxyz ABCDEFGHIJKLMNOPQRSTUVWXYZ 0123456789

ITC Kallos Book abcdefghijklmnopqrstuvwxyz ABCDEFGHIJKLMNOPQRSTUVWXYZ 0123456789

ITC Kallos Medium Italic abcdefghijklmnopqrstuvwxyz ABCDEFGHIJKLMNOPQRSTUVWXYZ 0123456789

ITC Kallos Bold Italic abcdefghijklmnopqrstuvwxyz ABCDEFGHIJKLMNOPQRSTUVWXYZ 0123456789

ITC Kallos Book Italic abcdefghijklmnopqrstuvwxyz ABCDEFGHIJKLMNOPQRSTUVWXYZ 0123456789

ITC Kallos Medium abcdefghijklmnopqrstuvwxyz ABCDEFGHIJKLMNOPQRSTUVWXYZ 0123456789

A TEXT FAMILY WITH A STRONG,
TRADITIONAL CALLIGRAPHIC FLAIR,
ITC KALLOS WAS CREATED BY PHILL
GRIMSHAW, A TYPEFACE DESIGNER
FROM MANCHESTER, ENGLAND, WHO
SPECIALIZES IN HANDLETTERING
AND SCRIPT-STYLE DISPLAY FACES LIKE
ITC ZARAGOZA™ AND ITC ZENNOR,™ FOR
MANY YEARS GRIMSHAW HAS WISHED
TO EXPLORE THE design of a text face and
its associated challenge of
creating a design that would
be successful across a range
of sizes. ITC Kallos is the
result of his first foray into
this realm.

26

27

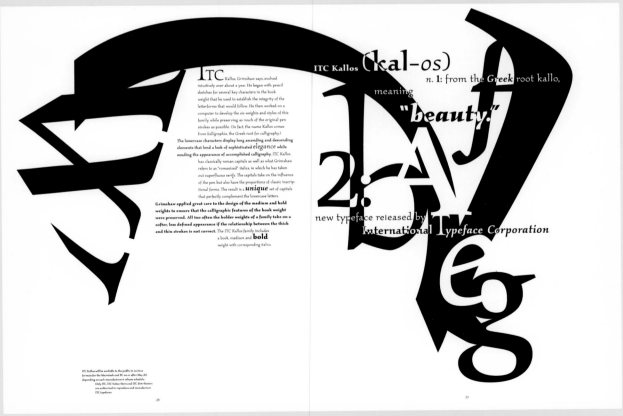

ITC Kallos, Grimshaw says, evolved
intuitively over about a year. He began with pencil
sketches for several key characters in the book
weight that he used to establish the integrity of the
letterforms that would follow. He then worked on a
computer to develop the six weights and styles of this
family, while preserving as much of the original pen
strokes as possible. (In fact, the name Kallos comes
from kalligraphia, the Greek root for calligraphy.)

The lowercase characters display long ascending and descending
elements that lend a look of sophisticated *elegance* while
exuding the appearance of accomplished calligraphy. ITC Kallos
has classically roman capitals as well as what Grimshaw
refers to as "romanized" italics, in which he has taken
out superfluous serifs. The capitals take on the influence
of the pen but also have the proportions of classic inscrip-
tional forms. The result is a **unique** set of capitals
that perfectly complement the lowercase letters.

**Grimshaw applied great care to the design of the medium and bold
weights to ensure that the calligraphic features of the book weight
were preserved. All too often the bolder weights of a family take on a
softer, less defined appearance if the relationship between the thick
and thin strokes is not correct.** The ITC Kallos family includes
a book, medium and **bold**
weight with corresponding italics.

ITC Kallos **(kal-os)**
n. 1: from the *Greek* root kallo,
meaning
*"beauty."*

2. A
new typeface released by
International Typeface Corporation

ITC Kallos will be available to the public in various
formats for the Macintosh and PC on or after May 20,
depending on each manufacturer's release schedule.
Only ITC Subscribers and ITC distributors
are authorized to reproduce and manufacture
ITC typefaces.

28

29

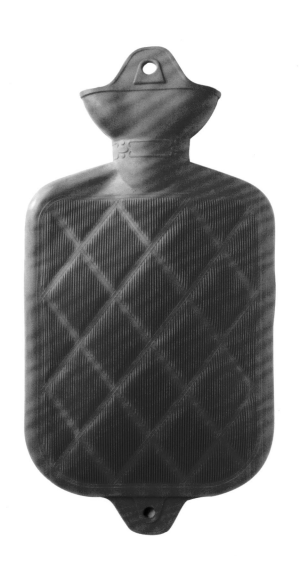 +

 =

WHY NOT ⑦ FILMS

STUDIO 5, 10–11 ARCHER STREET, LONDON W1V 7HG          TEL: 0171 287 3625  FAX: 0171 494 0678

WHY NOT ⑦ FILMS

WHY NOT ⑦ FILMS

STUDIO 5, 10–11 ARCHER STREET, LONDON W1V 7HG
TEL: 0171 287 3625  FAX: 0171 494 0678

WHY NOT ⑦ FILMS

STUDIO 5, 10–11 ARCHER STREET, LONDON W1V 7HG          TEL: 0171 287 3625  FAX: 0171 494 0678

this and previous spread. **why not films**
music video production company
corporate identity. stationery. video labels
photography: photodisc

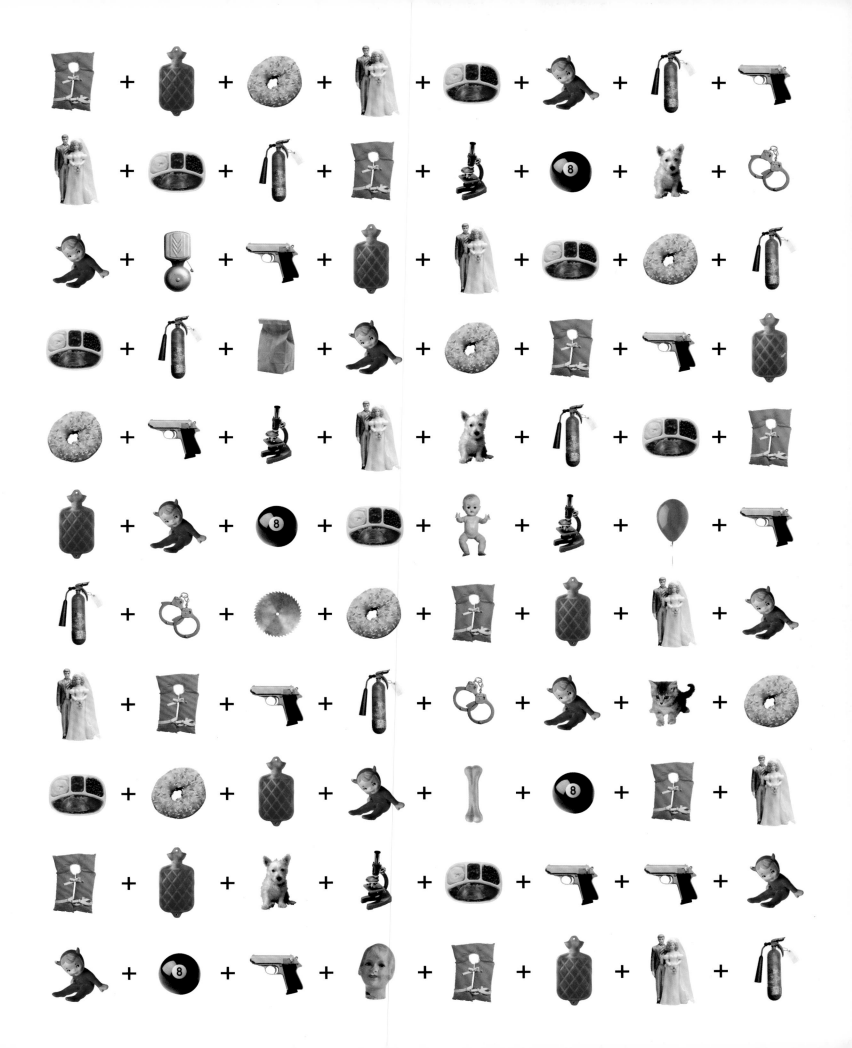

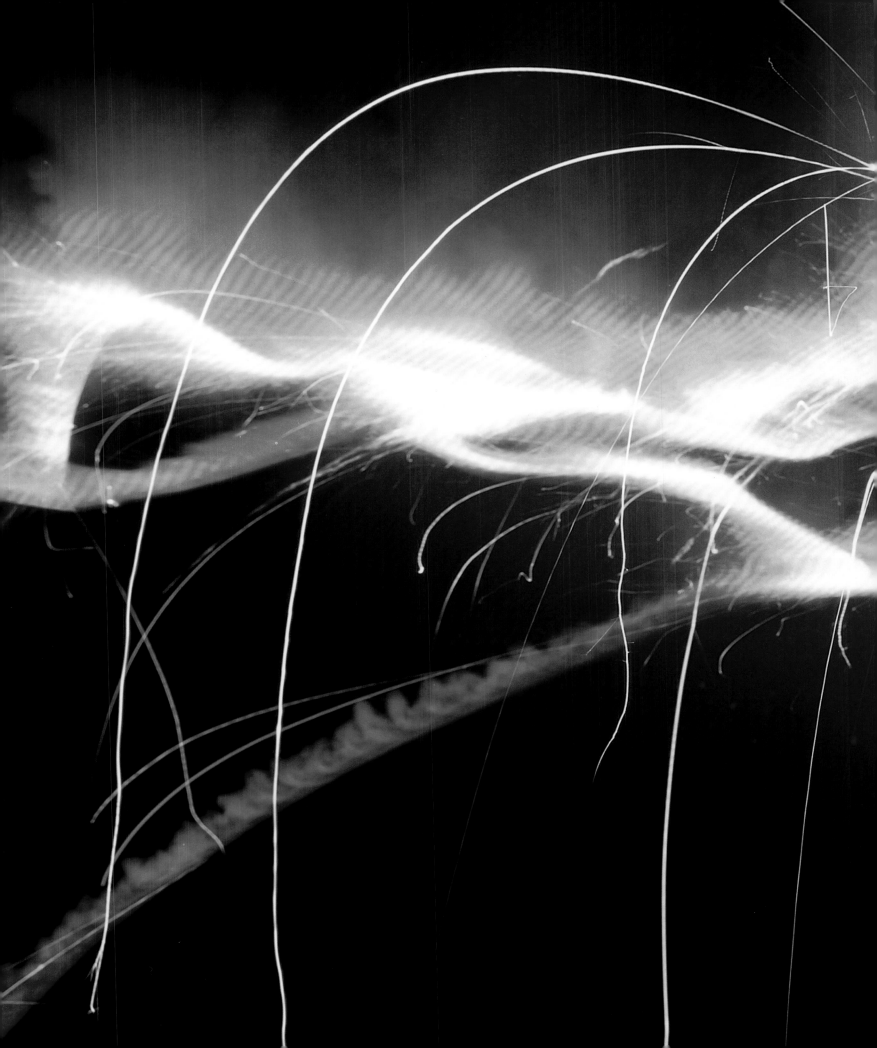

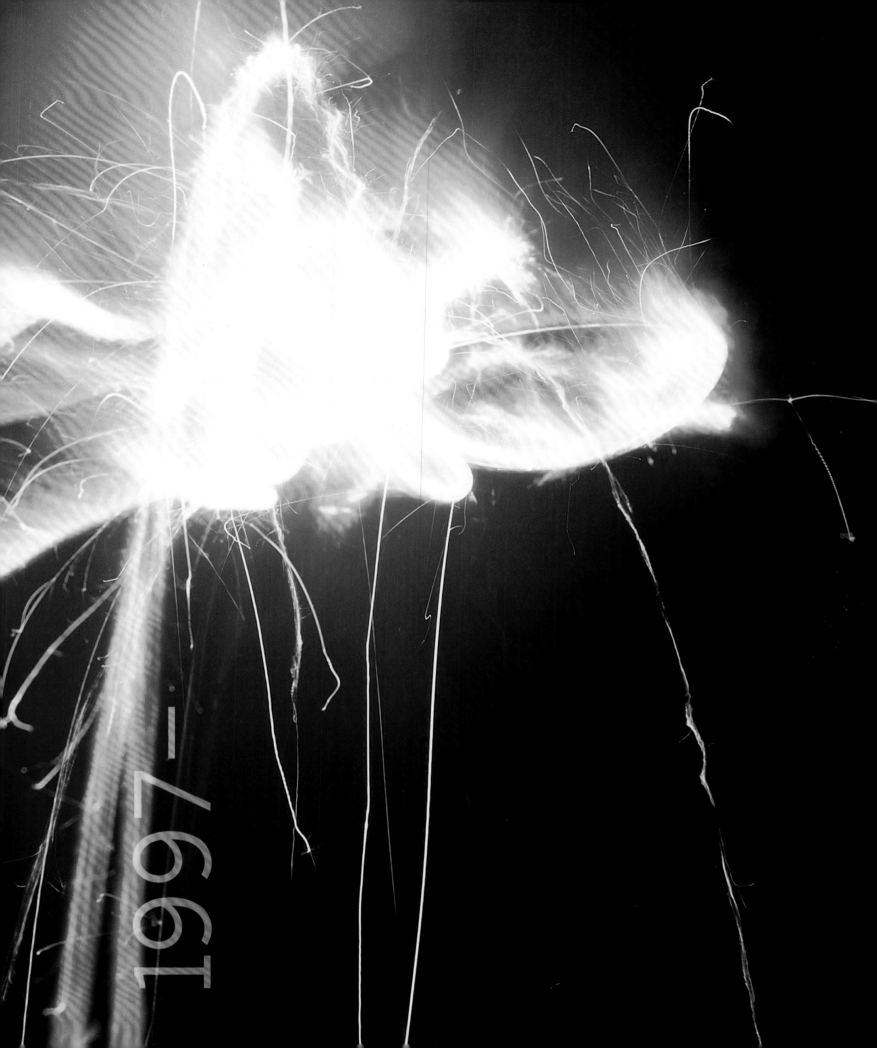

1997–

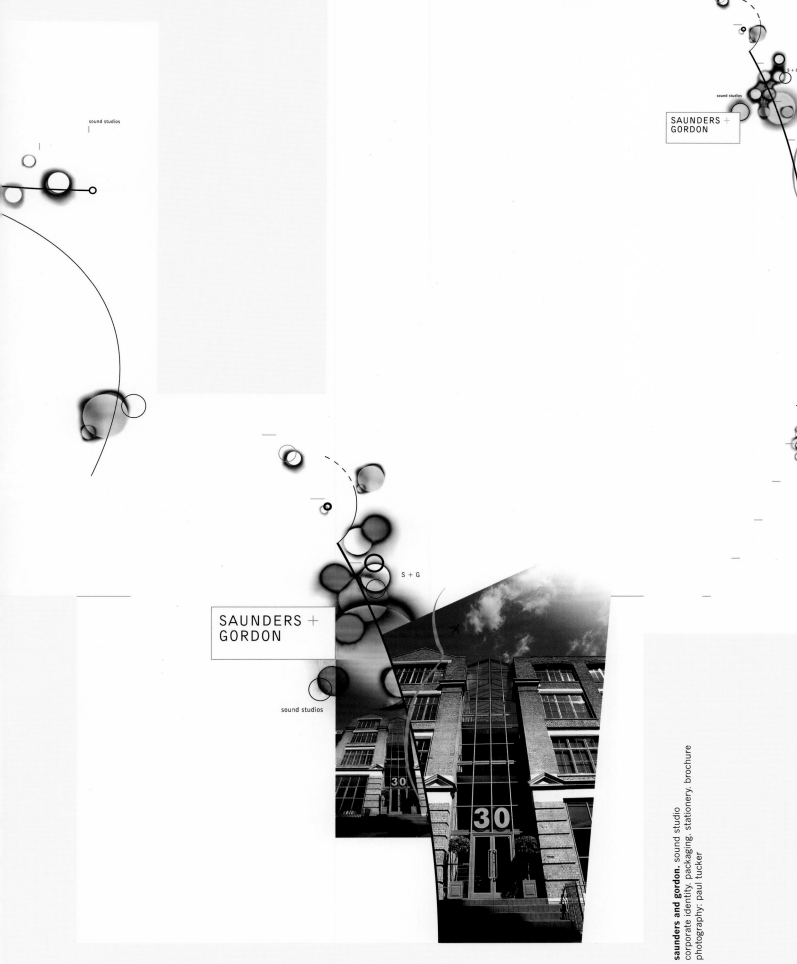

sound studios

SAUNDERS +
GORDON

S + G

sound studios

SAUNDERS +
GORDON

S + G

30 GRESSE STREET  LONDON W1P 1PN   tel +44 171 580 7316  fax +44 171 637 5085

**saunders and gordon.** sound studio
corporate identity. packaging. stationery. brochure
photography: paul tucker

ROYAL COLLEGE OF ART
DEPARTMENT OF ARCHITECTURAL DESIGN
TICKETS AND DETAILS 0171 590 4273

NIGEL COATES 8TH OCTOBER
GAETANO PESCE 29TH OCTOBER
BERNARD TSCHUMI 26TH NOVEMBER
MARK WIGLEY 14TH JANUARY 1997
REM KOOLhAAS 11TH FEBRUARY
MARC AUGÉ 11TH MARCH
ENRIC MIRALLES 15TH APRIL
BEATRIZ COLOMINA 13TH MAY
DANIEL LIBESKIND 3RD JUNE

DISTURBA

A SERIES OF LECTURES

TAXI

SUPPORTED BY THE BULLDOG TRUST IN ASSOCIATION WITH THE INDEPENDENT

**disturbanisms.** royal college of art. poster
photography: rocco redondo. photodisc

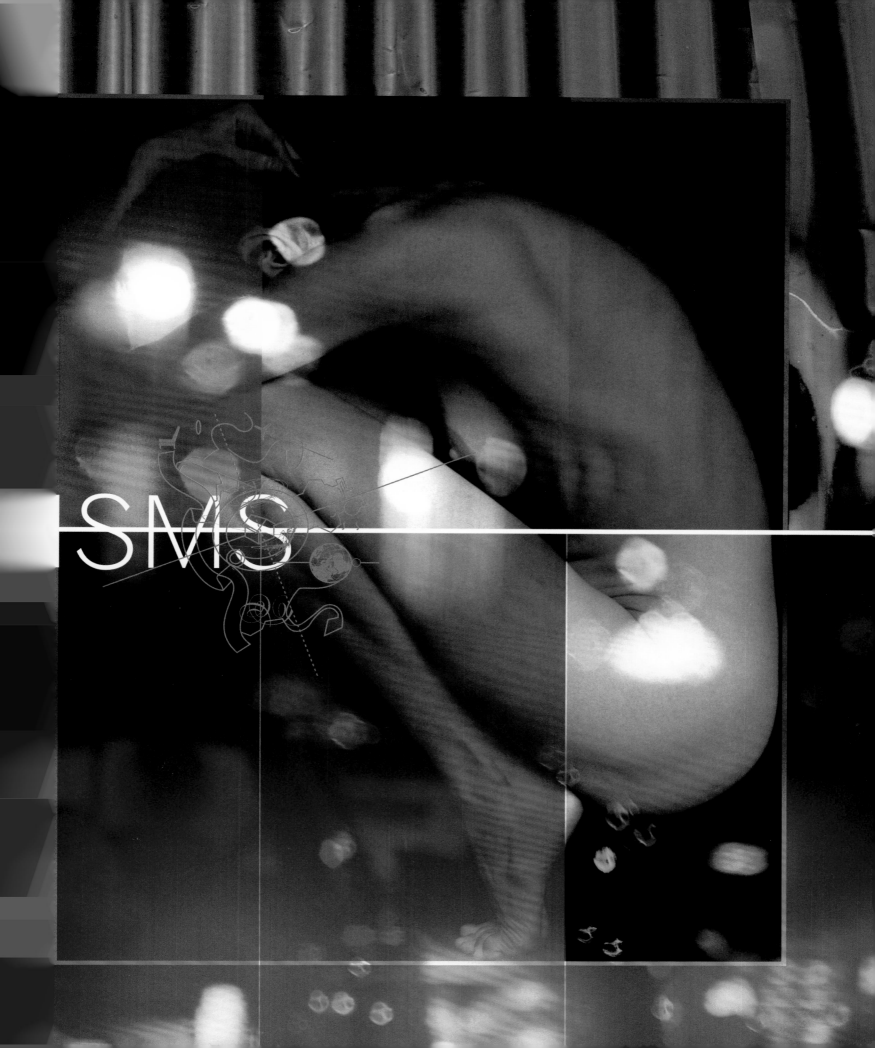

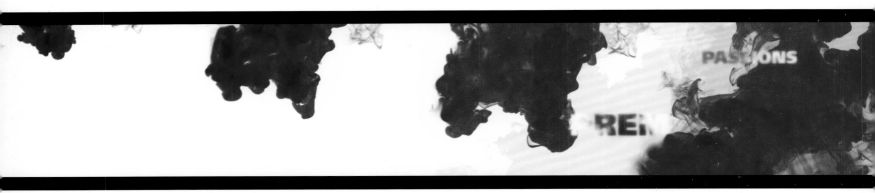

**bbc television.** programme titles
the system
the terror and the truth
premier passions

( 178 →    179 )

the syste **the system** 1 1system 1

THE NATURE OF THE BEAST

the system

THE
TERROR
+
THE
TRUTH

PREMIER
PASSIONS

PART
2

BBC

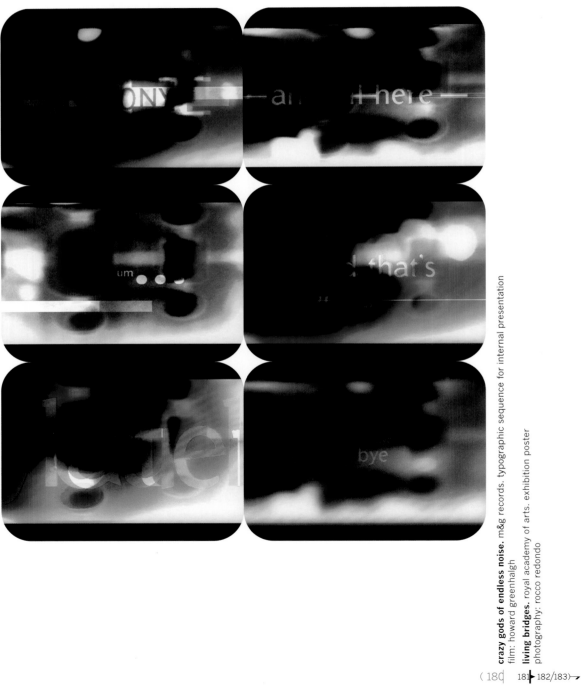

**crazy gods of endless noise.** m&g records. typographic sequence for internal presentation
film: howard greenhalgh

**living bridges.** royal academy of arts. exhibition poster
photography: rocco redondo

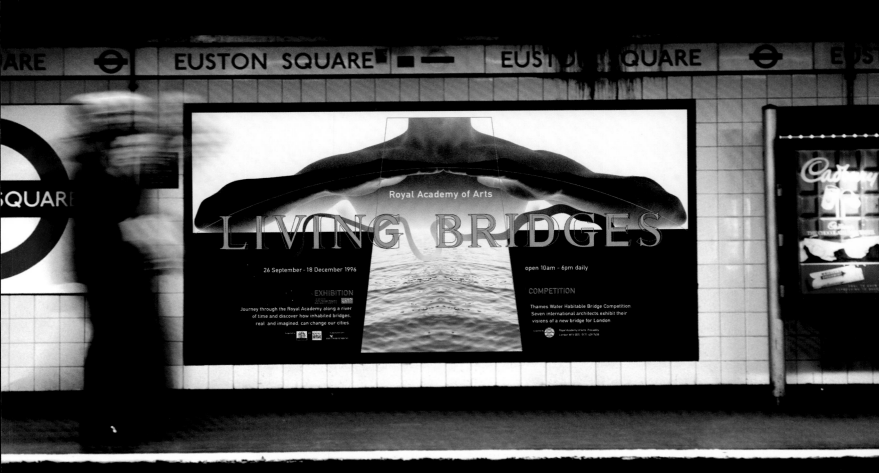

Royal Aca

# LIVING

## 26 September – 18 December 1996

### EXHIBITION

realised with the
Centre Georges Pompidou
Musée national d'art moderne, Paris

Journey through the Royal Academy along a river
of time and discover how inhabited bridges,
real and imagined, can change our cities.

Supported by  and  GENERALE DES EAUX GROUP    in association with  THE INDEPENDENT

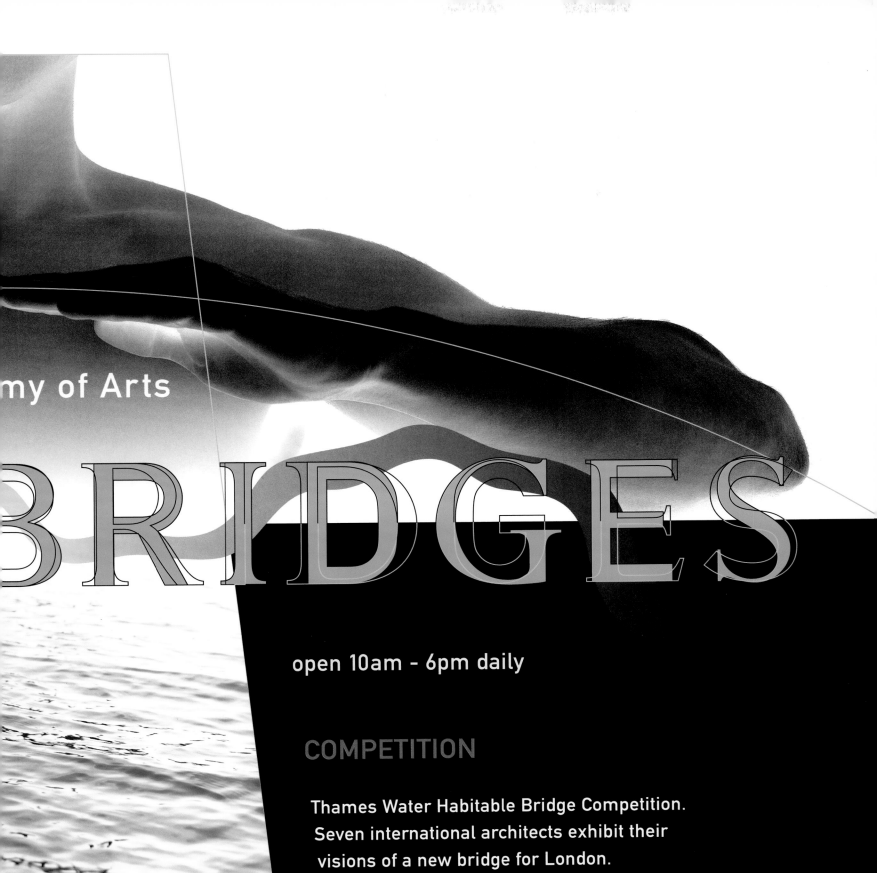

my of Arts

BRIDGES

open 10am - 6pm daily

COMPETITION

Thames Water Habitable Bridge Competition.
Seven international architects exhibit their
visions of a new bridge for London.

Supported by **Thames Water** Royal Academy of Arts, Piccadilly,
London W1V 0DS   0171-439 7438

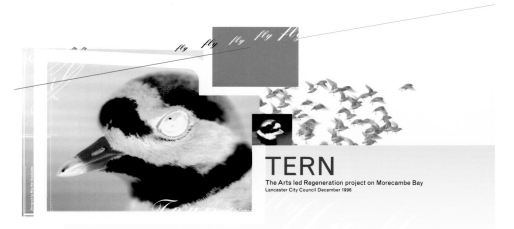

# TERN

**The Arts led Regeneration project on Morecambe Bay**

Lancaster City Council December 1996

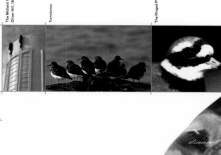

## PART 1

3/4

### The Inspiration

TERN was born out of the Council's determination to make the most of Government grant support and to weave into rebuilt sea front areas and new private sector developments a unique personality that would endure, make sense to a wide public and bring delight in it's obvious originality and imagination.

THE INSPIRATION

Morecambe Bay is a rich ecosystem and a bird habitat of international importance. It is the most important wintering site in the UK for dunlin, oyster catcher, curlew and turnstone and has a dependant population of more than 200,000 wildfowl and wading birds.

The bird life of Morecambe Bay is the inspiration for TERN.

POTENTIAL

TERN has brought sculpture and artist designed pavement games and street furniture to the initial phases of reconstruction. It has captured the hearts and minds of the local community and set Morecambe apart from its past and its competitors. TERN has won the design award of the Lancaster Civic Society and gained national recognition last year, as winner of the Arts Council's, Working for Cities Award in the Arts in Progress category.

TERN has the potential to;
expand outwards along Morecambe's seafront to the edge of the built up area and beyond;
create a very special signature on England's north west coastline;
transform a fading seaside resort into a proud town and a contemporary visitor destination; and
bring public art to large numbers of people.

To realise this exceptional potential TERN must continue to influence the rebuilding process in Morecambe, master plan by master plan, phase by phase and contract by contract over the entire rebuilding period, to 2001.
To do so it must secure exceptional capital funding on a scale provided only through the Arts Council Lottery Fund.

**tern.** lancaster city council. lottery bid document
introduction page. cover. selected spreads
photography: folly pictures. jon sparks. photodisc
illustration: david kemp

The Artists and their work

THE "ROCK IV" BIRD ROUNDABOUTS

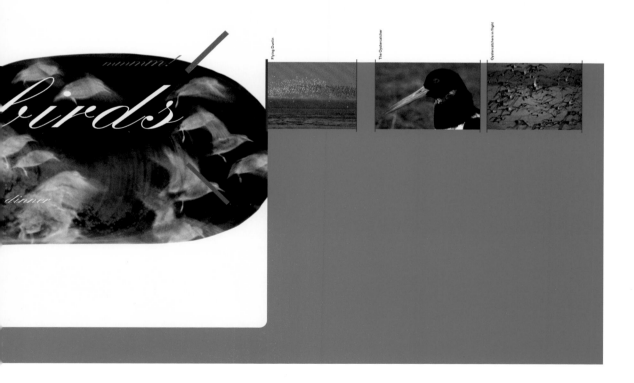

Gannet Roundabout
Brian Fell, Ann Kelly and Gordon Young

Cormorant Roundabout
Brian Fell, Ann Kelly
and Gordon Young
The commission roundabout on the
seaward end of the redevelopment
area is already a meeting up space
for visitors and a popular
postcard image

Gannet Roundabout
Brian Fell, Ann Kelly and Gordon Young
The "expanding" gannets at the landward
approach to the central redevelopment site

Plover(s) Roundabout
Brian Fell, Ann Kelly and Gordon Young

Flying Dunlin

The Oystercatcher

Oystercatchers in flight

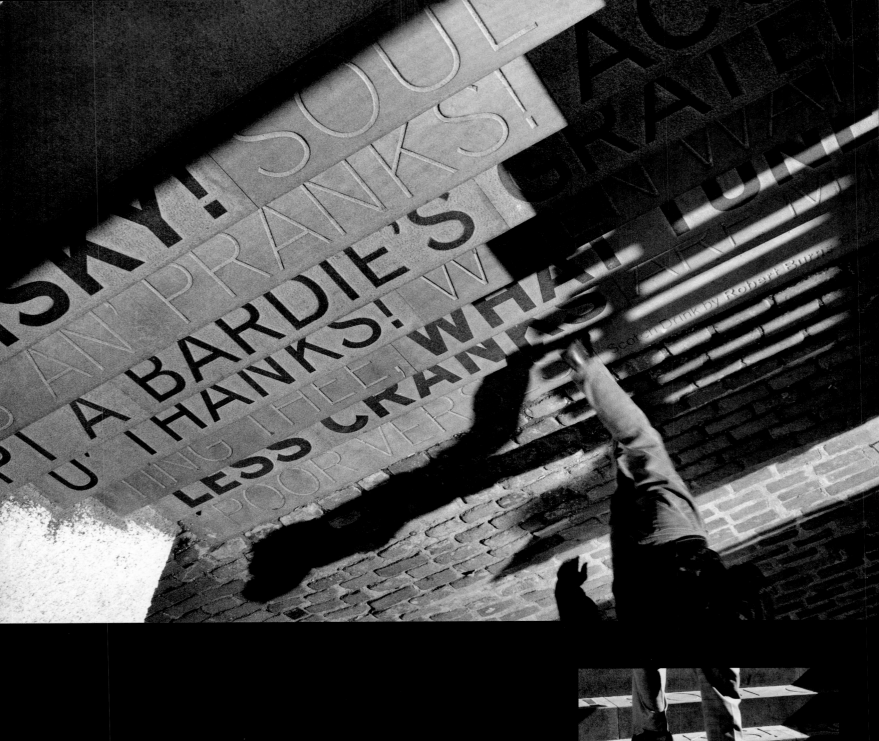
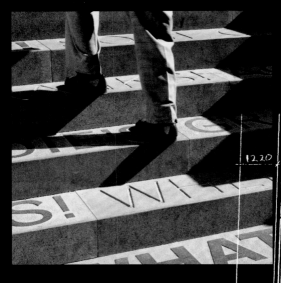

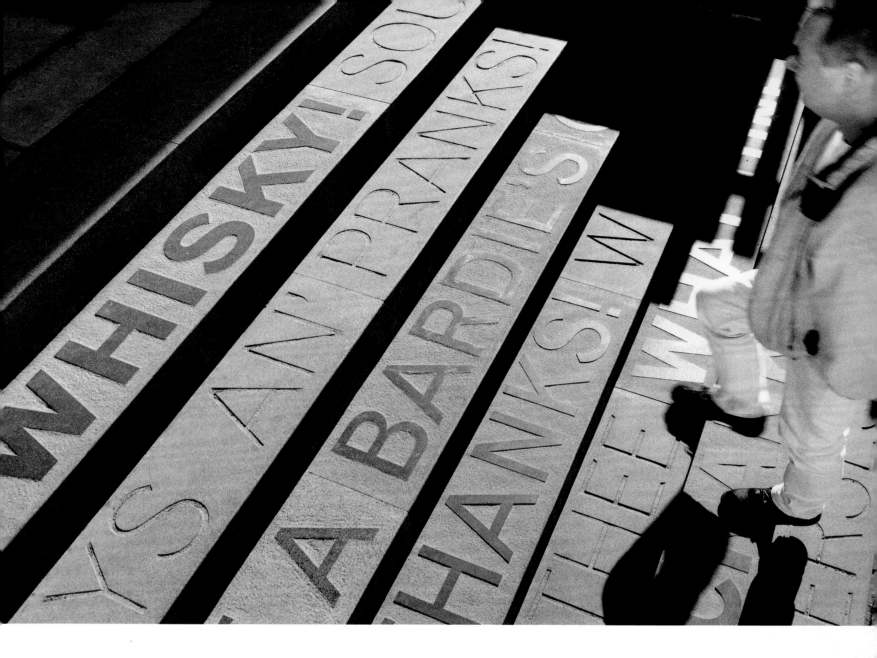

**tam o'shanter pub steps.** mill wynd. ayr. scotland
collaboration with gordon young. poem by rabbie burns
project co-ordinators: public art commissions and exhibitions
photography: andrew miller

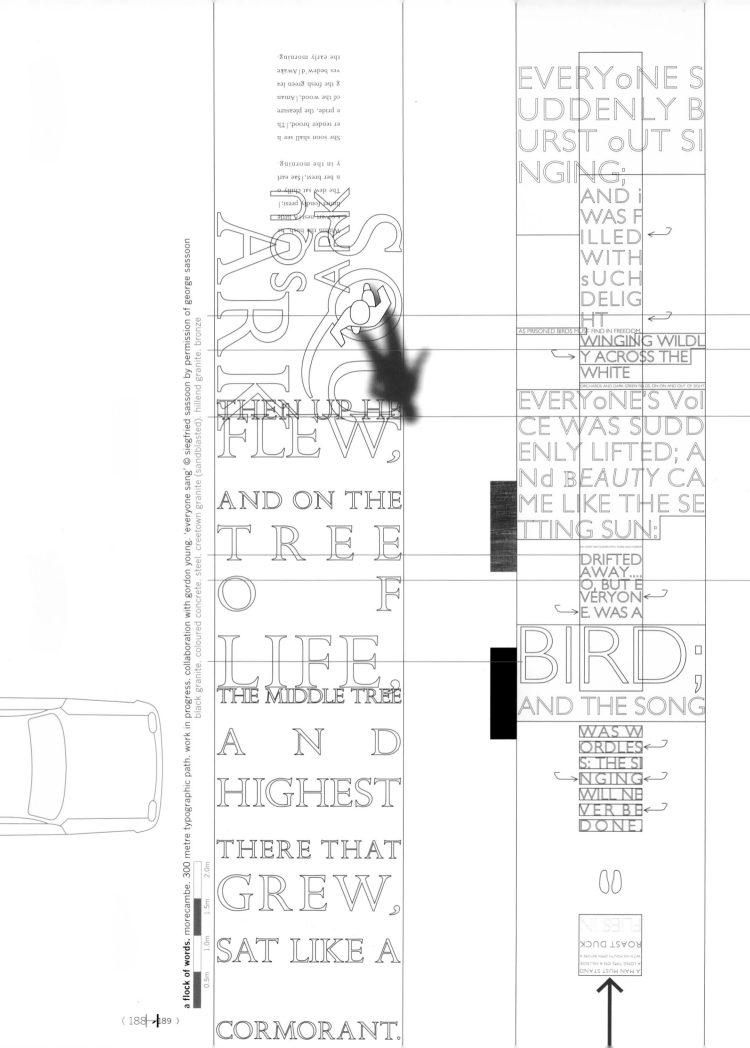

**a flock of words.** morecambe. 300 metre typographic path. work in progress. collaboration with gordon young. 'everyone sang' © siegfried sassoon by permission of george sassoon

black granite. coloured concrete. steel. creetown granite (sandblasted). hillend granite. bronze

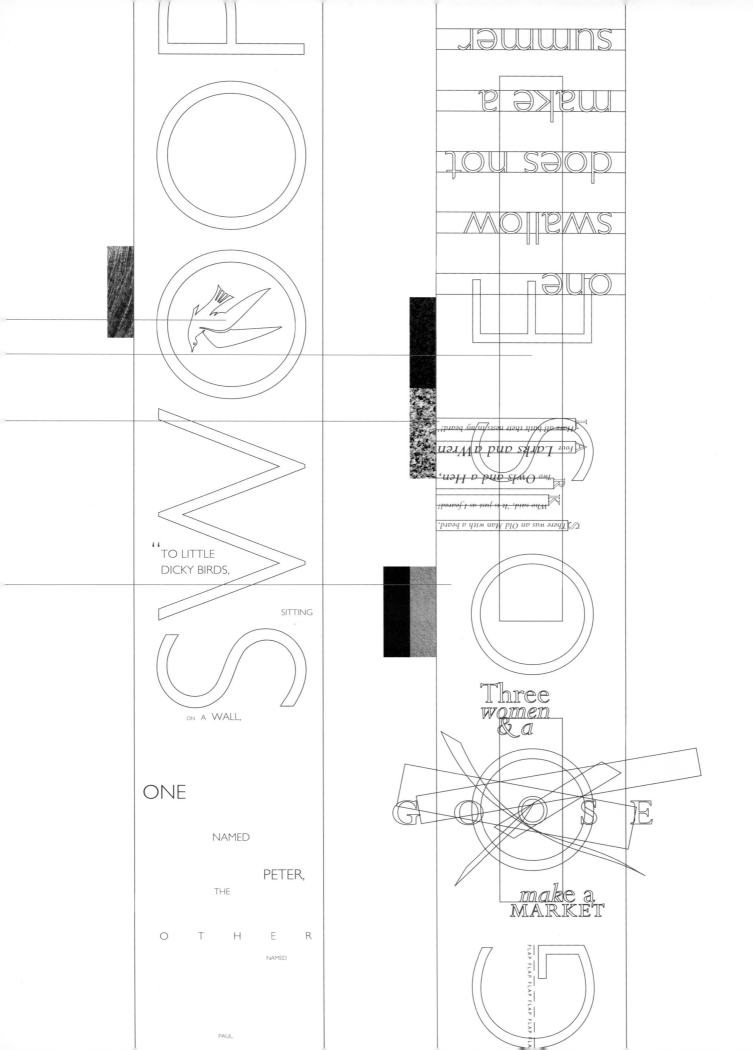

**1**

**2**

denial
*desire*

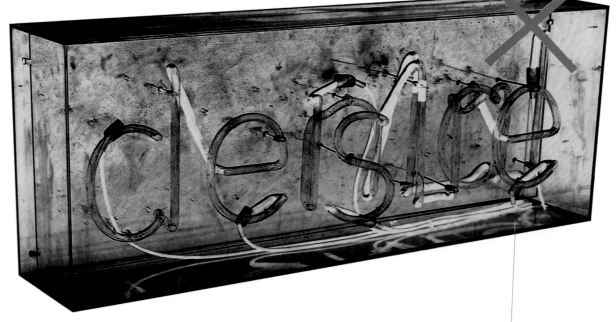

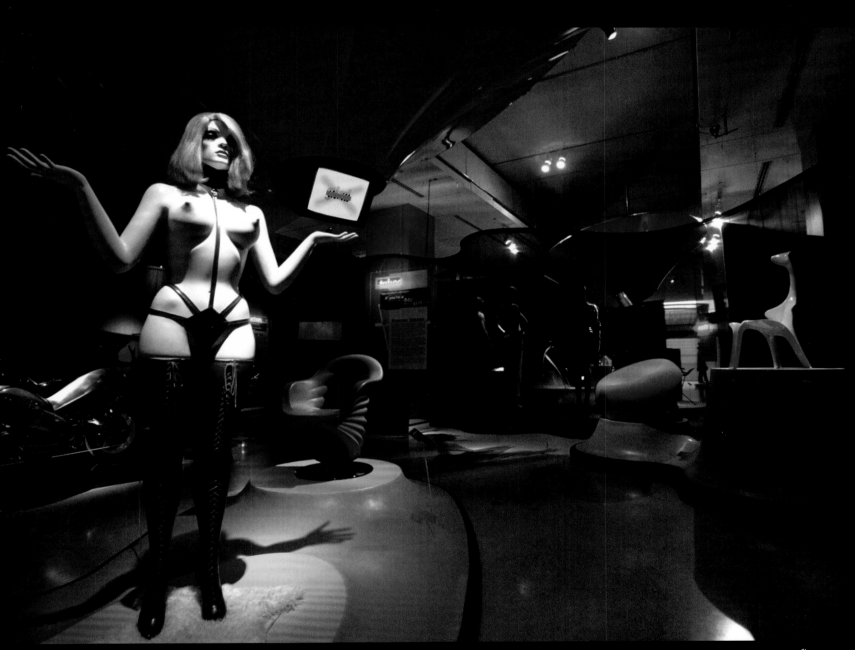

the power of erotic design. design museum
exhibition design: branson coates architecture
photography: phil sayer

(190 191 192/195)

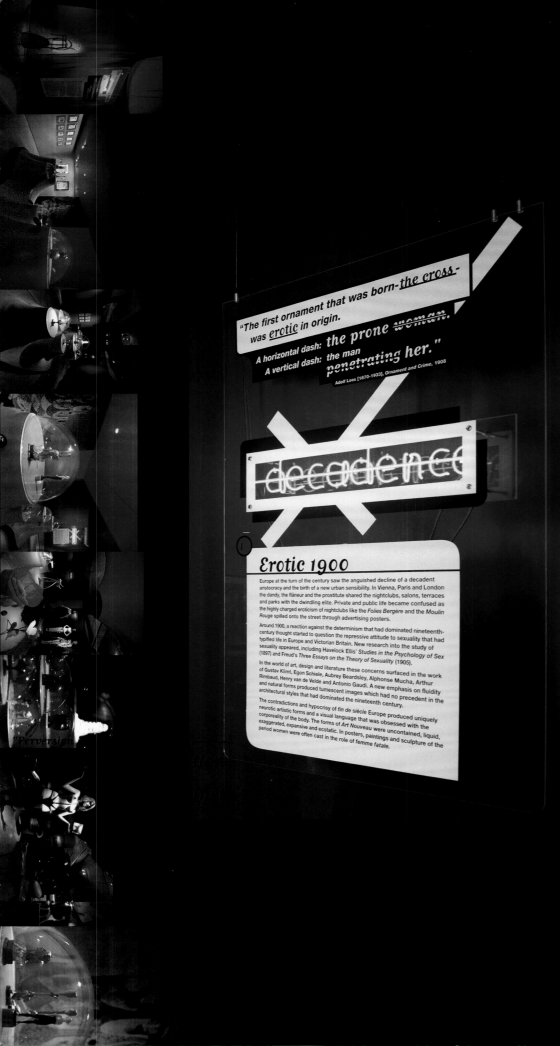

> "The first ornament that was born—the cross—was _erotic_ in origin.
> A horizontal dash: _the prone woman._
> A vertical dash: _the man penetrating her._"
>
> Adolf Loos [1870-1933], _Ornament and Crime_, 1908

decadence

## Erotic 1900

Europe at the turn of the century saw the anguished decline of a decadent aristocracy and the birth of a new urban sensibility. In Vienna, Paris and London the dandy, the flâneur and the prostitute shared the nightclubs, salons, terraces and parks with the dwindling elite. Private and public life became confused as the highly charged eroticism of nightclubs like the _Folies Bergère_ and the _Moulin Rouge_ spilled onto the street through advertising posters.

Around 1900, a reaction against the determinism that had dominated nineteenth-century thought started to question the repressive attitude to sexuality that had typified life in Europe and Victorian Britain. New research into the study of sexuality appeared, including Havelock Ellis' _Studies in the Psychology of Sex_ (1897) and Freud's _Three Essays on the Theory of Sexuality_ (1905).

In the world of art, design and literature these concerns surfaced in the work of Gustav Klimt, Egon Schiele, Aubrey Beardsley, Alphonse Mucha, Arthur Rimbaud, Henry van de Velde and Antonio Gaudi. A new emphasis on fluidity and natural forms produced tumescent images which had no precedent in the architectural styles that had dominated the nineteenth century.

The contradictions and hypocrisy of _fin de siècle_ Europe produced uniquely neurotic artistic forms and a visual language that was obsessed with the corporeality of the body. The forms of _Art Nouveau_ were uncontained, liquid, exaggerated, expansive and ecstatic. In posters, paintings and sculpture of the period women were often cast in the role of _femme fatale._

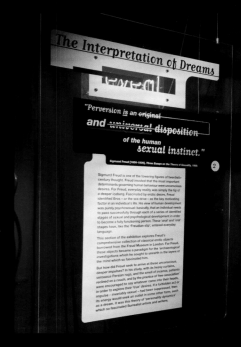

## The Interpretation of Dreams

> "Perversion _is_ an ~~original~~ and ~~universal~~ disposition of the human _sexual instinct._"
>
> Sigmund Freud [1856-1939], _Three Essays on the Theory of Sexuality_, 1905

2

Sigmund Freud is one of the towering figures of twentieth-century thought. Freud insisted that the most important determinants governing human behaviour were unconscious desires. For Freud, everyday reality was simply the tip of a deeper iceberg. Fascinated by erotic desire, Freud identified Eros – or the sex drive – as the key motivating factor in an individual's life. His view of human development was purely psychosexual: basically, that an individual needs to pass successfully through each of a series of identified stages of sexual and psychological development in order to become a fully functioning person. These 'anal' and 'oral' stages have, like the 'Freudian slip', entered everyday language.

This section of the exhibition explores Freud's comprehensive collection of classical erotic objects borrowed from the Freud Museum in London. For Freud, these objects became a paradigm for the 'archaeological' investigations which he sought to unearth in the layers of the mind which so fascinated him.

But how did Freud seek to arrive at these unconscious, deeper impulses? In his study, with its heavy curtains, sensuous Persian rugs, and the smell of incense, patients reclined on a couch, and by the practice of 'free association' were encouraged to say whatever came into their heads, in order to explore their 'true' desires. If a forbidden act or impulse – invariably sexual – had been suppressed, then its energy would seek an outlet in some other form, such as a dream. It was this theory of 'personality dynamics' which so fascinated Surrealist artists and writers.

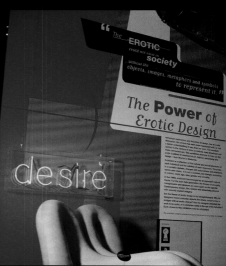

> " The EROTIC could not exist as a society without the objects, images, metaphors and symbols to represent it. "

## The **Power** of _Erotic Design_

desire

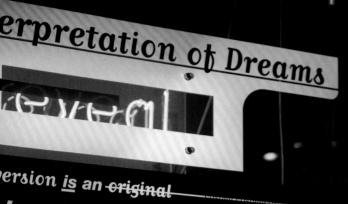

# erpretation of Dreams

ersion **is** an ~~original~~

~~universal~~ disposition

of the human

**sexual instinct."**

Sigmund Freud [1856-1939], *Three Essays on the Theory of Sexuality*, 1905

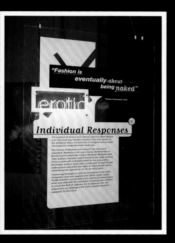

"Fashion is eventually about being naked"

erotic

**Individual Responses**

taboo

"Your mother's not sure if you're a boy or a girl"

**Separate Spheres**

" When he talks, Gillette blades, razors, bits of glass, enchanted gardens and monstrous flowers in colours never seen before come out of his mouth."

**Carlo Mollino [1905-1973]**

desire

exhibition interior
exhibition graphics. silkscreened perspex with neon
photography: phil sayer. rocco redondo

following spread: video installation
photography: rocco redondo. sandro sodano. photodisc

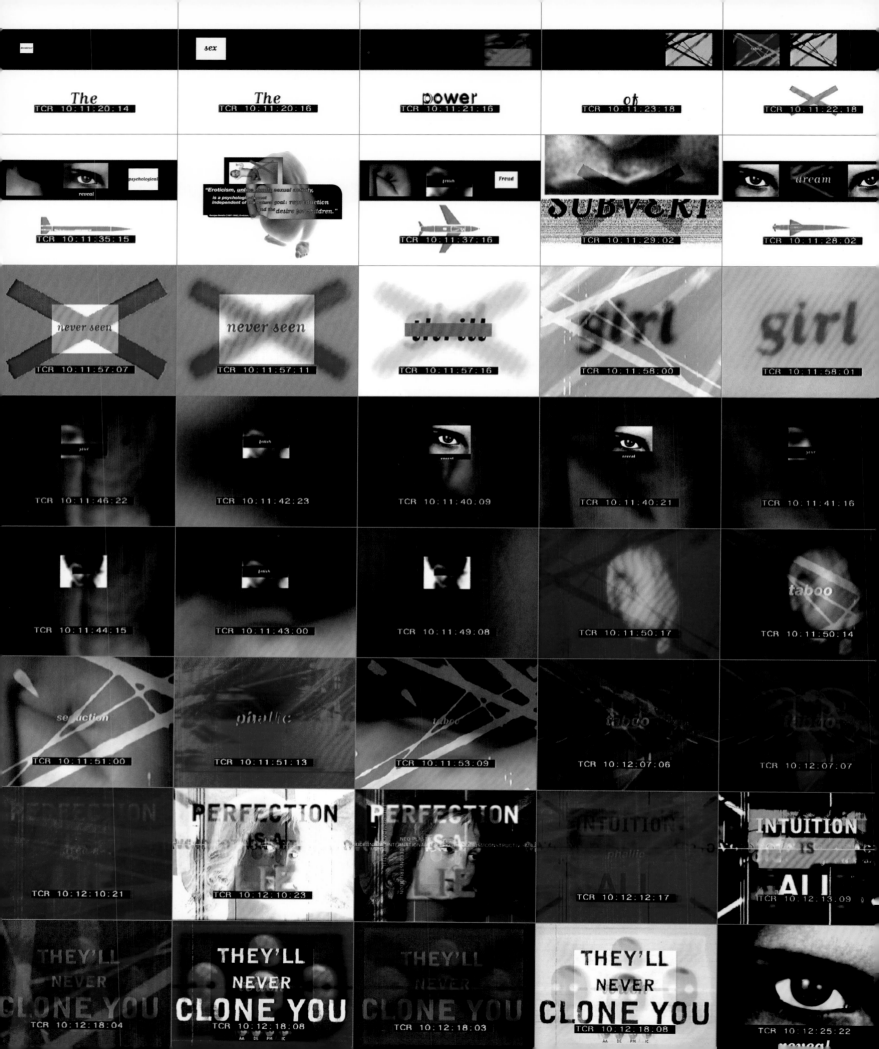

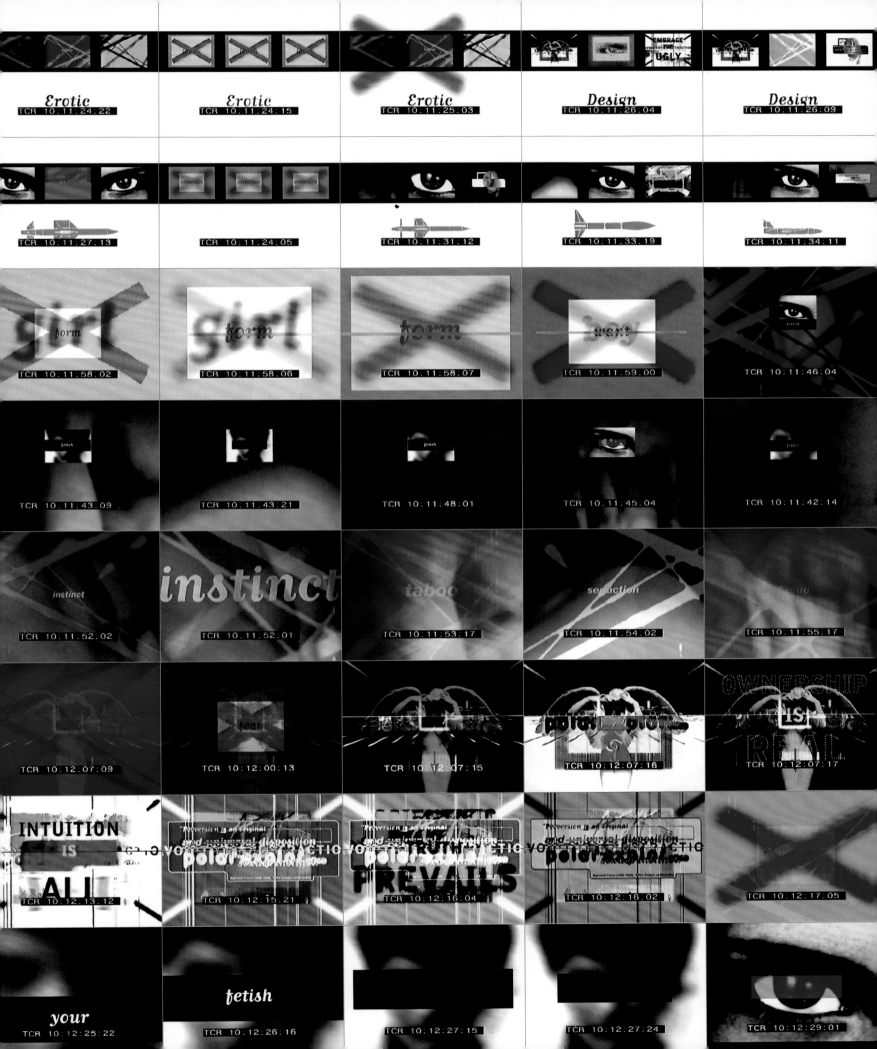

**shots.** magazine design

selected pages
photography: shaun bloodworth

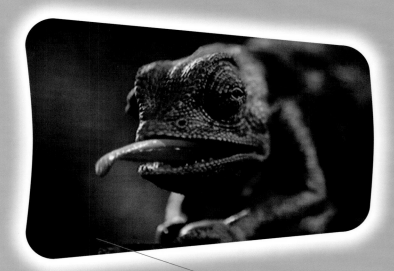

german special

N°.

42

SEPTEMBER 97

shots

ADVERTISING AND CREATIVITY WORLDWIDE

french special

visual fx round'up

N°

43

NOVEMBER 97

# shots

to black

silence

view

fade
e

diary and production yearbook 1998

shots

freeze

your reality
sameness
will kill
you

view

from
your
bus

your
minds
eye

nostalgia
PAST

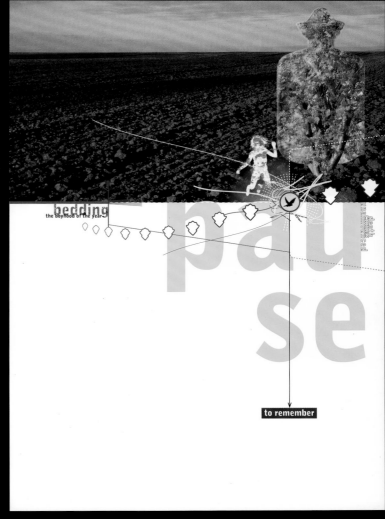

**sensation.** royal academy of arts
this page: bus sides. alternative posters

opposite page: poster. cinema commercial storyboard

photography: rocco redondo. photodisc

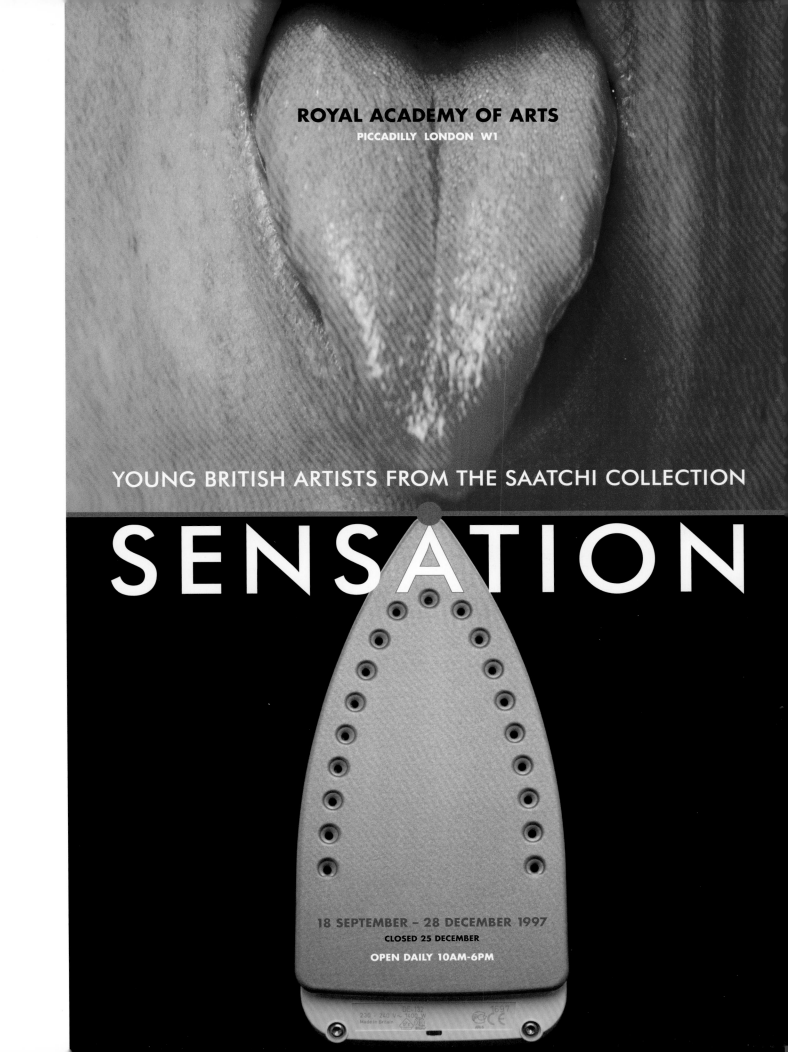

TIME
SPECIAL ISSUE

The New Age of
Discovery

A celebration of mankind's
exploration of the unknown

# Discovering the World Around Us

**There are still discoveries to
be made in our own backyard:
in the oceans and rain forests
as well as in outer space**

YOUNG DISCOVERERS NEED NOT DESPAIR—THOUGH THERE ARE few blanks left on today's map of the world, there are still unexplored realms to be charted in the depths of the oceans, the most remote recesses of the rain forests and the farthest reaches of outer space. Some scientists speculate there may be 10 million species—perhaps even 100 million—living on the ocean floor that are yet to be discovered. Recent research suggests that all told some 90% of the world's plants and animals still remain to be described and named (that is, if their habitats are not destroyed before they are even found). Given these remarkable statistics, it's clear that the physical world still offers intrepid explorers new frontiers of discovery.

In this section on recent discoveries of the world around us, TIME travels 500 m beneath the surface of the Pacific Ocean with Bruce Robison as he encounters a new species of luminous "jelly;" we make our way deep into the world's tropical rain forests, where more than half of all life-forms on the planet live; we look into outer space to examine the role asteroids may have played in mass extinctions of the past and the potential threat they pose to our own civilization; and we ask whether there is life—intelligent or otherwise—elsewhere in the universe.

John Hemming, former director of London's Royal Geographical Society, arguably the world's epicenter of exploration, defines an explorer as someone "who goes to the edge of knowledge and brings back something new." The people profiled in this section fit that description perfectly. The discoveries they have brought back from their explorations form new pieces in the puzzle of how the world works. As the pieces fit together, we get a glimpse of what a strange and beautiful mosaic it is. ∎

*A new electronic future* — *building a better world*

# Changing the World Through Discovery

*A new kind of living*

**The human race cannot
survive on discovery alone.
The knowledge gleaned from
new discoveries must be put
to work in new technologies.
Today's technological
workhorse is the computer,
and it is moving into our lives
in strange and surprising ways**

*Technology can enhance your lifestyle*

A THIN LINE SEPARATES A DISCOVERY FROM AN INVENTION. THE principles of electricity, for example, were *discovered* by William Gilbert in the 16th century. The electric light bulb, however, was an *invention*. Gilbert has been all but forgotten, despite his momentous discoveries; but Thomas Edison, inventor of the light bulb, won both fame and fortune for his electrical inventions.

Such seem to be the disparate fates of the discoverer and the inventor. Yet however opposed their ultimate destinies might seem, the one could not survive without the other. New discoveries fuel new inventions, which in turn fuel new discoveries. This has certainly been the case in the field of computer science, the area of discovery and invention that is having the most profound impact on the world today. A few decades ago no one could have imagined that the computer would be so all-pervasive and powerful. Certainly not Thomas Watson, then chairman of IBM, when he remarked in 1943: "I think there is a world market for maybe five computers." This section explores how the computer revolution is changing our world just as much as the agricultural and industrial revolutions changed theirs. ∎

time magazine. discovery special. art direction, design and illustrations

cover and spreads

photography: tim bieber/imagebank. photodisc. louise marray/still pictures. getty images. the complete encyclopedia of illustration by j.g. heck. vintage magazine company. advertising archives. science photo library. rocco redondo. quadrant picture library. mary evans picture library. akg london

opposite page: things that think. illustrations for discovery special

x ray photography: nick veasey

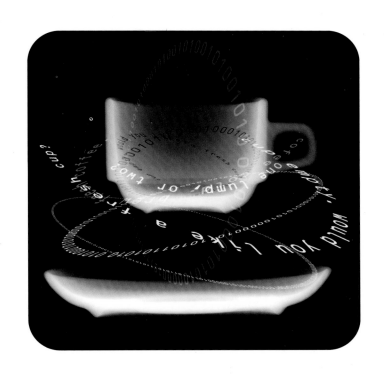

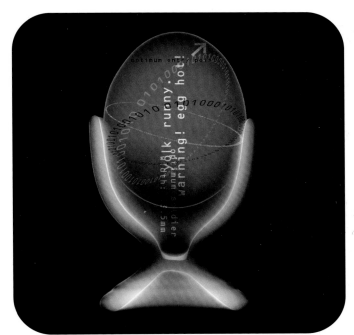

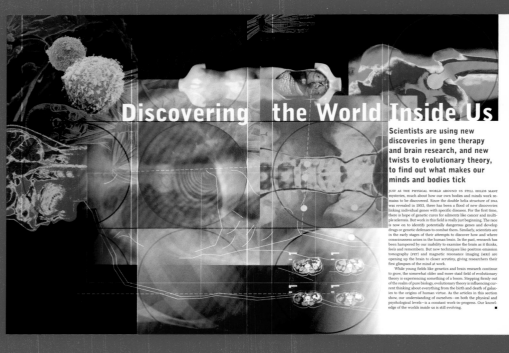

# Discovering the World Inside Us

**Scientists are using new discoveries in gene therapy and brain research, and new twists to evolutionary theory, to find out what makes our minds and bodies tick**

JUST AS THE PHYSICAL WORLD AROUND US STILL HOLDS MANY mysteries, much about how our own bodies and minds work remains to be discovered. Since the double helix structure of DNA was revealed in 1953, there has been a flood of new discoveries linking individual genes with specific diseases. For the first time, there is hope of genetic cures for ailments like cancer and multiple sclerosis. But work in this field is really just beginning. The race is now on to identify potentially dangerous genes and develop drugs or genetic defenses to combat them. Similarly, scientists are in the early stages of their attempts to discover how and where consciousness arises in the human brain. In the past, research has been hampered by our inability to examine the brain as it thinks, feels and remembers. But new techniques like positron emission tomography (PET) and magnetic resonance imaging (MRI) are opening up the brain to closer scrutiny, giving researchers their first glimpses of the mind at work.

While young fields like genetics and brain research continue to grow, the somewhat older and more staid field of evolutionary theory is experiencing something of a boom. Stepping firmly out of the realm of pure biology, evolutionary theory is influencing current thinking about everything from the birth and death of galaxies to the origins of human virtue. As the articles in this section show, our understanding of ourselves—on both the physical and psychological levels—is a constant work-in-progress. Our knowledge of the worlds inside us is still evolving. ∎

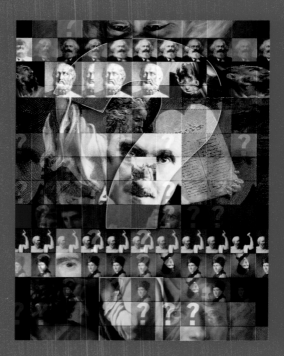

# New Worlds of Discovery

**The Theory of Relativity, the splitting of the atom, the discovery of the structure of DNA: these are some of the scientific and technological advances that shaped the history of the 20th century. What discoveries will change the way we live and work in the next millennium?**

ACCORDING TO FREEMAN DYSON, PROFESSOR EMERITUS AT THE Institute for Advanced Study in Princeton, New Jersey, scientists can be divided into two groups: lumpers and splitters. Lumpers, Dyson suggests, like to draw grand conclusions about the universe based on their study of the "Big Picture." Splitters, on the other hand, prefer more modest theories teased out from their observations of Nature's marvelous details. Both types of scientist are needed if science is to remain healthy—and TIME asked both types to write essays for this section on the future of discovery. On the following pages, some of science's best-known "lumpers and splitters" look at the world with a wide lens and in close-up, outlining the impact of discoveries made—and yet to be made—in fields as diverse as information technology, cosmology and genetics. TIME's authors peer into the 21st century to suggest where the next new worlds of discovery may lie. As futurist Charles F. Kettering once remarked, "My interest is in the future because I am going to spend the rest of my life there." ∎

# In the Realm of the Senses

Scientists are using advanced computer technologies to increase, enhance and extend the power of the senses

By James Geary

THE FIVE SENSES—VISION, HEARING, SMELL, taste and touch—are our only ways of knowing the world. Nothing enters our awareness, nothing affects our emotions, without first passing through one of these five portals. The senses are so essential to our knowledge of reality that language is steeped in their metaphors. A sensitive person is described as "in touch" with his feelings; an unpleasant experience leaves a "bad taste" in your mouth; we understand someone when we "see" what she means. It seems we only comprehend the world when it's phrased in the body's own vocabulary. That vocabulary is now being extended by wedding advanced computing technology to the human senses, a marriage that holds forth the promise of talking, smelling computers and devices that can restore sight to the blind. In the process we are taking one small step forward in the evolution of the man/machine.

hear

see

smell

touch

taste

thanks to all our families. especially: ceri, chrissy, sara, thomas, henry and eddy. howard greenhalgh without whom... rocco redondo for being so patient. chris priest for the "eventful" years. patrick morrissey and iain cadby for all their graft. jon getz for all his "production".
with thanks to all of the following: liz farrelly. mark molloy. simon svärd. robert and kay lobetta. mike nicholson. pip. julian germain. bernie edmunson. gordon young. rag zeo chavda. david greenwood. anjay patel. mike mccarthy. movin' jim. nigel coates. doug branson. gerrard o'carroll. richard greenwood. claire catterall. russell warren fisher. sandro sodano. alan aboud. renior tuahene. dan saimo. alistair lever. reg haslam. juliette dean. david halliday. andrew wood. clive stephens. derek birdsall. martin lee. margaret richardson. jane dibucci. joyce rutter kaye. dudley boots-johns. pirco wolfframm. claudia. graham "baa!" jones. martin brown. jonathan "cherry b" barnbrook. clare, wilson, trevor, darren (to all those students who have helped over the years, sorry, we can't remember all your names!) phil baines. ron miller. prof fritz friedl. tim stimpson. wilf crossland. leo smith. jonathan smith. katherine jones. tentacle. russell jobling. brian harwood. murray "too much technique" arbiter. simon green. vicky mcquire. megan holister. rebecca west. michael geoghegan. louise knight. nick harrington. barry robinson. jane ryan. rosemary and nigel butcher. jon barnes. andy haslam. jon greenhalgh. tom tercek. jean philipse. james geary. paul lussier. werner lippert. dave cadel. sam greenwood. paul sims. matthew giles. anthony frend. rod shelton. iwona blazwick. linda brown. edward and james booth-clibborn. vicky hayward. rowena and geoff swallow. peter "simon" higgins. john corcoran. gavin burridge. mick perry. harry greenaway. helen macve. hannah tofts. andrew whittle. richard doust. geof fowl. nick georghiou. peter dormer. julia hawkins. dodgy. gee thompson. gordon mcnulty. gert dumbar. andy archer. ally wallace. keizo matsui. koichi yano. toru horii. isao yoshida. toru momo. misao ono. john carson. gillian crampton-smith. lorenzo apicella. richard baker. heater easdon. will macdonald. ian macpherson. bob white. gary france. maggie molloy. jack daniels. neil mattingley. adrian bentley. liz moore. robin saunders. peter dale. stephen lambert. john alexander. gerard ford. paul thompson. colin brignall. john andrew. john pasche. paul trynka. richard lewis. richard woolf. mike daines. doug ferguson. jamie "flaps" helly. david harper. ken mackay. hue carrol. keith f.s. rogerson. pressdata. clive bruton. lol sargent. matthew waldman. rick poyner. jane austin. peter the barman r.i.p.